Etching and Engraving

Walter Chamberlain

Etching and Engraving

A Studio Book

The Viking Press · New York

I wish to thank the Trustees of the British Museum and the Victoria and Albert Museum for permission to reproduce prints from their Departments of Prints and Drawings; Lumley Cazalet Ltd; the Editions Alecto (London Gallery) and Eduardo Paolozzi, and Dennis M. Rowan, Associate Professor at the University of Illinois, and William Tillyer for permission to reproduce recent work; the Director of the Maritime Museum, Hull, for the illustration of scrimshaw.

Also, I am especially grateful to the following artists and students – I hesitate to use separate categories – who have generously allowed me to reproduce details of their prints: Richard Fozard, Gordon Senior, Rowland Box, Georges Levantis, Helen Taylor and Anthony Broomfield; my wife, Susan Chamberlain, for the line drawings; John Warwick for the black and white photographs; and John Edler for the colour photograph on the jacket.

My thanks are also due to Miss Jean Jackson for virtually translating, as well as typing out, my almost illegible notes.

Copyright © 1972
by Thames and Hudson Ltd.

Published in 1973
by The Viking Press, Inc.
625 Madison Avenue, New York,
N.Y. 10022

SBN 670–29827–1

Library of Congress catalog card
number: 72–11102

Printed in Great Britain

Contents

Introduction

When I first considered writing a book on the techniques of etching and engraving, it seemed that a concise guide to the traditional and recent methods and materials involved was all that was required. Most full-time students will obviously be able to refer to specialist teachers who are also practising printmakers, and gain practical experience with, in many cases, extremely well-equipped college or department facilities.

There are, however, a good many serious students – and I here use the term 'student' in the widest possible sense – who do not have constant access to instruction or facilities. They have little choice but to read up the theory, and pursue the practice, more or less independently. There are also full-time students – including my own, largely in Fine Art – who may find that the nature of present-day Fine Art departments is such that teachers tend to limit themselves less to their own particular territory and subject, and operate more generally throughout a constantly widening and less easily defined area, formerly known as 'painting and sculpture'.

How widespread this tendency is I do not know, but it does have certain advantages: within reason, it can develop in a determined student a more resourceful and individual approach – that is, providing he has an accessible and up-to-date source of general information. It may even partly relax the uniformity prevalent in the gallery-orientated work of several well-established groups or schools. The most significant disadvantage is that much of the crucial, but less exciting, groundwork may be dealt with superficially, often because of the understandable rush to get the effect or idea down on print. Also, the relatively inexperienced individual, if he is not a member of a thriving print group, may simply not know what are the best materials available locally, or where to buy them.

The last thing I set out to write was a manual on the standard, correct approach to making an intaglio plate from which to print. Yet clearly, a practical handbook of sorts was the first priority; a book primarily for reference in the actual workshop. On further reflection, having noticed that an increasing number of younger students have recently shown a decidedly more open-minded and inquiring interest in the subject, I felt that something more than a compiled list of methods, materials and formulae, old and new, was needed. I have, therefore, broadened the scope to include some

general and historical background information. For those who may already be well informed, or for those who do not wish to be over-conscious of the history of graphic art, it has been separated from the purely practical parts of the text. The historical sections can, in any case, be no more than an introduction, a starting-point for further study.

A surprising number of books on the subject already exist, and I was reluctant to add yet another to the pile. I no longer feel obliged to make the almost routine apology for having done so. For few books on the techniques of etching and engraving fail to contribute something of value, even if it is only a different interpretation of long-accepted methods. And each ensures that the subject is constantly reassessed.

Not surprisingly, some of the more comprehensive and authoritative books on techniques can also be the most intimidating to the creative student. I have tried to simplify some of the contemporary and often extremely elaborate methods; for instance, printing with several colours from a single plate, intaglio and relief-surface, and the application of photographic images. The various stages involved in making a complex black and white plate (mostly using traditional processes) are described in much greater detail.

It is, of course, quite possible to arrive at the most effective of plates and take from it the most perfect of printed impressions with the absolute minimum of knowledge and materials. It has been pointed out often enough that the principles of etching can indeed be taught in a morning. But to extend the range of one's skills, to cope with developing ideas, and to control, if necessary, the most complex (or deceptively simple) of plates, may require numerous attempts, and perhaps even a few disasters.

Most of the methods and materials I have described may be regarded as traditional; that is, they have long been widely used – in some cases for centuries – and are still the most practical, reliable and flexible. I have added to these any recent development or innovation that I consider relevant. Obviously, numerous other alternative methods must exist, just as there are countless variations on every main stage involved in the normal process of making a plate. Inevitably, every creative engraver will develop his own particular approach.

I am aware of the familiar charge that creative printmakers should make prints instead of writing about them. For the most part, I would agree; but I do not feel (at least from the teaching point of view) that the time and effort required to write down one's accumulated technical knowledge and experience is necessarily wasted. Also, in spite of the regular appearance of new books on intaglio printmaking, I cannot accept that any single book can cover all aspects equally well; nor can any book – least of all this – presume to be the last word on the subject.

Rather curiously, over the past few years or so in England, the undoubted interest in nearly all forms of printmaking –

as shown by the number of excellent books and print exhibitions – has not resulted in a corresponding increase in the amount or quality of original intaglio work produced. It has not been, for the intaglio print, a particularly vital period, if compared, for instance, with the screen print. There is, however, little convincing evidence to suggest that the most important individual and original intaglio work has been achieved only during the periodic revivals.

I have never managed to rid myself entirely of the notion that the techniques of etching and engraving are essentially ways and means of drawing, though in the broadest sense. Relying on characteristic qualities and effects from incised, scored or corroded line or texture for its own sake, however brilliant the execution, has never been quite enough.

Few of the basic methods still in use can be attributed to any individual etcher. But where a comparatively recent technical innovation, or perhaps a more realistic formula, has been introduced and specifically described by an individual etcher, then I hope I have acknowledged this, with full reference whenever possible.

Over the years, the authoritative published sources that I have found most useful for reference have been, first, E. S. Lumsden's *The Art of Etching* and later, the books of Buckland-Wright, Hayter, Peterdi and, of recent etchers, Anthony Gross. I am greatly indebted to these and to many other writers and printmakers. Yet, in spite of fairly extensive reading on the subject, I have only rarely come across a technical point of real interest that was not patiently explained to me by Julian Trevelyan and Richard Fozard at the Royal College of Art, during the years 1958 to 1961.

The photographs of various processes are not intended to demonstrate the 'correct' action or sequence, but merely to indicate a straightforward, workable approach. The drawings of tools illustrate, for the most part, typical examples – but many other versions may exist and may be just as useful.

Several contemporary etching methods are illustrated by details of prints, rather than the complete work. My intention was to emphasize as much as possible the various technical aspects, rather than to present the prints first and foremost as art. In any case, a number of these prints were taken by first-year students from plates that were made purely as test plates, and they do not pretend to be anything other than experimental.

Hull, 1971

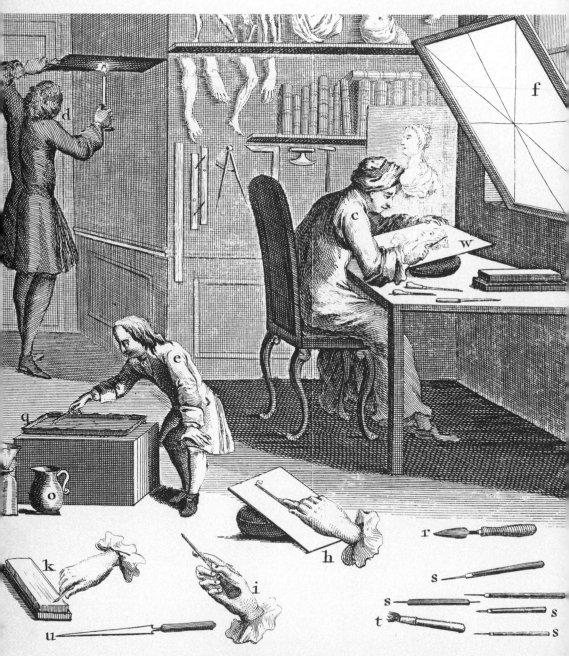

Engraving: 'The Art of Etching and Engraving', from Diderot's
Encyclopédie, 1751–52.

1 The history and development of etching

In the context of intaglio printmaking, the term 'etching' normally refers to both the action of corroding lines, etc. into a metal plate with acid, and the inked, paper impression taken from the surface of the plate. Wherever possible, this term will be used in a general sense to describe the various methods involved in corroding the plate, and not, as a rule, the completed print itself. Etching also includes a number of closely related, but often quite independently used processes, such as soft-ground etching and aquatint. It does not include burin engraving, drypoint or mezzotint, nor a number of other intaglio and relief techniques not requiring acid.

The term 'engraving', especially in graphic art terminology, is often used – supposedly for convenience – as a collective heading, or even as a loose definition for all forms of intaglio work. To clarify these terms – and since engraving is, in fact, a separate technique in itself – 'engraving' will be used to refer specifically to the act of incising directly into a surface with a burin. (See Chapter 10.)

The process of etching as we know it originated largely as a faster and less demanding alternative to burin engraving. There is evidence that acids were used well before the sixteenth century by jewellers and particularly by armourers. But etching was probably not employed as a means of corroding images into metal plates, solely to print from, until the beginning of the sixteenth century. By then, printing from copper plates worked by the burin (engravings) was well established in Europe.

Etching seems to have been developed in both Germany and Italy at about the same time. There are in existence a few isolated examples of prints taken from drawn and entirely etched plates (usually of iron), made in the first quarter of the sixteenth century, by Urs Graf (c. 1485–1527/8) and Daniel Hopfer (c. 1493–1536). These were preceded by prints taken from drypoints and from engraved plates. One of the earliest was the Master of the Housebook, active in the last quarter of the fifteenth century.

Albrecht Dürer (1471–1528) also made a number of drypoints and a few etchings on iron between 1515 and 1518. It is more than likely that Dürer's plates would have been drawn onto one ground and bitten with one immersion in the acid; it is doubtful whether any stopping out was involved. Practically all the early sixteenth-century etching on iron, including Dürer's, was lacking in tonal depth and

variation in line. The printed line generally betrayed the effect of having been drawn with one point and bitten uniformly.

Lucas van Leyden (1494–1533) also used etching (significantly on copper), but most often to supplement his burin engravings. He, like Dürer, tended to use the point as if he were engraving.

Very little etched work produced before the mid seventeenth century could compare in quality with the work of engravers such as Schöngauer, Mantegna, Dürer and van Leyden. But generally, line-engraving of the mid sixteenth century was already becoming a technique for reproducing other work.

The availability of reliable mordants suitable for etching into copper (although these had been developed long before) increased the range and flexibility of etching. The comparative ease with which an apparently engraved line could be made by simply drawing onto a smooth waxed surface was soon realized. This was exploited increasingly by the emerging reproductive engravers. Until well into the seventeenth century the emphasis was much more on imitating the characteristic clean-cut and swelling line made by the burin; hence the use of the échoppe. But gradually, throughout the sixteenth century, etching became more seriously considered as an expressive technique in itself, and the process was explored further.

The use of the etched line became noticeably freer (even on iron), for instance in the landscape etchings of Albrecht Altdorfer (c. 1485–1538) and possibly, to an even greater extent, with the more deliberately varied line of Hirschvogel's (1503–53) landscapes. The free use of line applied equally to Italian etching of the period, as for example in the work of Parmigianino (c. 1503–40).

During the early seventeenth century, the drawn line became more consciously varied, mordants improved, plates were bitten successively in stages by stopping out, and copper became increasingly and more widely employed.

In France, Jacques Callot (1592/3–1635) made much use of the swelling line produced by the échoppe and repeated bitings to vary the lines. He also employed additional burin work. Callot is particularly interesting, not just because of his technique (which was acclaimed and much publicized by Bosse in his technical treatise on etching), his innovations and his prolific output, but also for his choice of subject-matter. This included much theatrical work, studies of beggars and hunchbacks and, perhaps most significant of all, his famous series (large and small), the *Miseries of War*. In these he used his exceptional draughtsmanship and etching technique to illustrate, apparently quite dispassionately, but with graphic detail, numerous scenes, such as *Hanged Men in a Tree* or *The Firing Squad*. These are among the earliest examples of the print used essentially to communicate to as wide (and probably as unsuspecting) a public as possible the

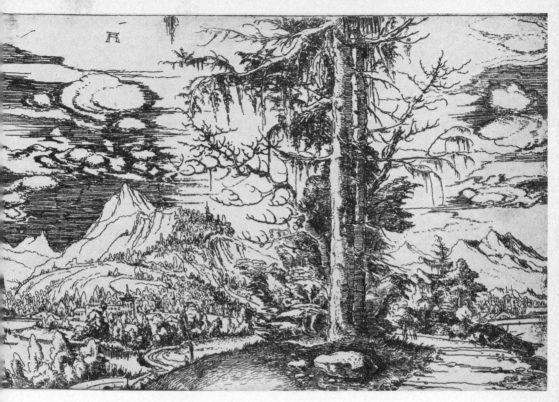

hing: *Landscape* by Albrecht Altdorfer. 6$\frac{5}{16}$ in. × 4$\frac{5}{16}$ in. *British Museum,*
don.

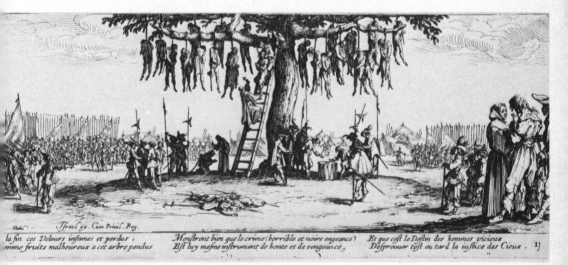

hing from *Les Misères de la Guerre* by Jacques Callot. 3$\frac{3}{4}$ in. × 7$\frac{1}{4}$ in.
ish Museum, London.

Etching: 'Spring', from *The Four Seasons* by Wenceslaus Hollar. 9¾ in. × 7⅛ in. Detail. *Victoria and Albert Museum, London.*

effect of the ravages of war, the moral issues, social conditions and political evils then prevailing.

Hercules Seghers (1589/90–c. 1635) used an assortment of personal materials and methods with great resourcefulness and invention to produce a highly individual output of coloured etchings. These were predominantly imaginative compositions involving densely textured mountain scenery. His influence at that time appears to have been negligible, but his work was of some interest to Rembrandt, who actually owned several of his prints.

Another contemporary of Rembrandt's was Wenceslaus Hollar (1607–77), a Bohemian working in London. Hollar's etched work is of some importance; it contained a large number of plates, carefully observed and drawn, depicting details of contemporary life, architectural views and numerous small landscapes. His extremely formal approach and technique is very much that of an engraver.

Apart from the work of these few exceptional artists, the art of etching came into its own and flourished as never before in the Netherlands in the mid seventeenth century,

and was from then on dominated by possibly the greatest etcher of all, Rembrandt.

An enormous amount has been written on the subject of Rembrandt's etchings, and a great deal is known about his approach, his methods and, to a lesser extent, the materials he used. A number of extremely well-documented catalogues of Rembrandt's etchings have been published, covering his entire output. These are referred to in Ludwig Munz's critical catalogue, which also contains an account of the artist's methods.

Rembrandt's relatively free and spontaneous use of etching was almost entirely unprecedented, even in the Netherlands. His etchings were first and foremost line-drawings made directly onto waxed copper; that the printed impressions were taken from the intaglio copper-plate is their only similarity with engraving, for Rembrandt was never, in any sense, an engraver. His draughtsmanship with the needle and drypoint was truly astonishing; the range of his line was immense and his technique as an etcher was more than equal to the most ambitious and complex of his plates.

His subjects varied constantly between the lifelong series of exquisitely modelled portrait heads (especially self-portraits); the more expansive, open landscape studies (some of which were in pure drypoint); the elemental and intensely atmospheric landscapes such as the *Three Trees* of 1640 (etched over a Seghers landscape); plate after plate of studies from the figure, and the commonplace everyday world around him; and the Biblical compositions, vast in conception though quite modest in size, such as *Christ healing the sick* (1650) and, five years later, *The Three Crosses*. The printed states of this latter plate reveal the fluctuating combination of line-etching and drypoint, which seems technically inconceivable on a single plate (his copperplates were usually surprisingly thin). Rembrandt's painterly absorption with chiaroscuro, and his use of tonal variation suggested by the massing of lines, is unique in the history of graphic art. Yet his influence on many subsequent etchers, especially during the nineteenth-century revival of etching, was not wholly beneficial.

Several of Rembrandt's Dutch contemporaries produced work not altogether dissimilar to his more earthy peasant studies. Prominent among these was Adriaen van Ostade (1610–84) and his pupil, Cornelis Bega (1620–64). Later influences from Italy, particularly the idealized 'heroic' landscapes of Claude (1600–82), impressive and innovatory enough in themselves, did more harm than good to Dutch etching – if not painting. A few Dutchmen continued to make landscape and animal studies, but largely in the much earlier, pre-Rembrandt, manner. Claude, through his etched landscapes, also had a certain influence on the English landscape-etchers, Gainsborough, Crome, Cotman and Turner. Later, Samuel Palmer continued this etching tradition, but

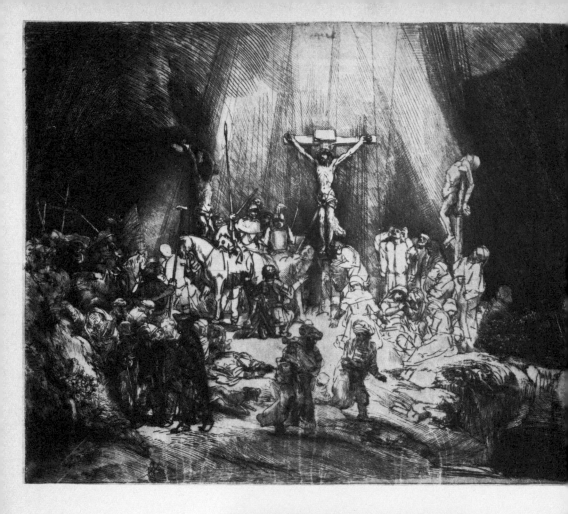

Etching and drypoint: *The Three Crosses* by Rembrandt. 15¼ in. × 17¾ in. *Above:* first version, 1653; *opposite:* second version (fourth state), *c.* 1661. Both *British Museum, London.*

Etching: *Interior with Peasants* by Adriaen van Ostade. 6⅞ in. × 6¹⁄₁₆ in. Detail. *British Museum, London.*

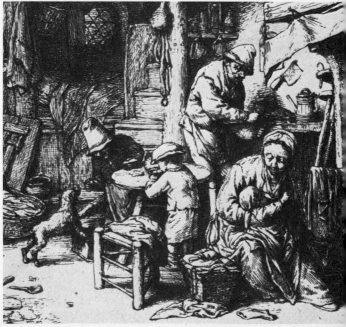

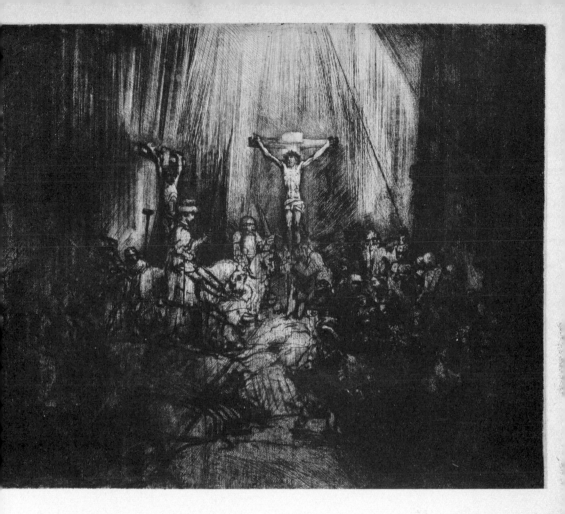

in a characteristically personal and poetic form. Although he made relatively few plates, they were serious and ambitious works.

The most original etched work of the eighteenth century was Italian. Both Giovanni Battista Tiepolo (1727–1804) and his son Domenico, well known for their decorative and allegorical compositions in painting, produced etched work, technically extremely accomplished, and altogether more eerie, in spite of the graceful drawing and spacious designs, than the paintings. The *Scherzi di Fantasia* set by the Tiepolos, who later moved to Spain, are thought to have influenced Goya in *Los Caprichos* (see p. 21).

Another Italian painter also working on pure etching was Canaletto (1697–1768) whose thirty-nine plates consisted almost entirely of architectural views. They were drawn with great simplicity and honesty, without any display of elaborate technique. The effect of the Venetian light on the buildings is beautifully conveyed by a remarkably restrained and controlled use of the needle-point.

The most dramatic contribution to eighteenth-century etching was the architectural compositions of Giovanni Battista Piranesi (1720–78) who was, significantly, an etcher

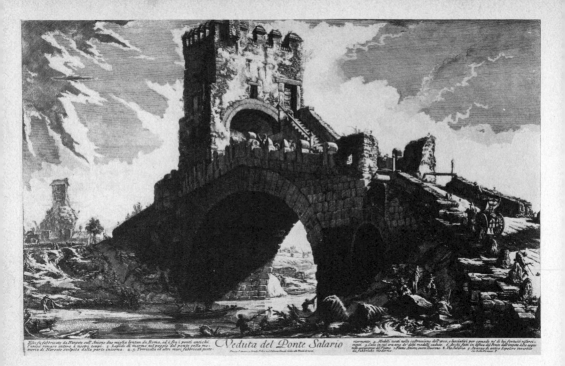

Engraving, partially etched:
Ponte Salario by Giovanni Battista
Piranesi. 15⅞ in. × 24¼ in.

and at no time a painter. A contemporary of Canaletto and also a Venetian, Piranesi produced a vast number of impressively drawn plates, principally of the monumental ruins and antiquities of Rome, called the *Vedute di Roma*. His total output approached nearly two thousand worked plates, many of which were large, even by modern standards. He frequently employed assistants to carry out the more laborious and less vital drawing.

But Piranesi's most outstanding achievement and undoubtedly one of the greatest individual achievements in the history of etching is the *Carceri d'Invenzione* (Prisons). This consists of sixteen huge plates, freely but forcefully drawn line-etchings of massive vaulted arches, spiral staircases and gloomy, cavernous halls, that made up his fantastic prisons. It is inconceivable that the apparently frenzied, but in fact well-controlled use of the needle on these plates, and the whole awesome conception could be executed in any medium other than etching.

Elsewhere in Europe, the newly discovered tonal processes of soft ground and aquatint were being developed, perhaps less proficiently, but more imaginatively, by the English landscape school. Mezzotint had already been extensively employed for the reproduction of paintings for many years. Little, if any, original work of any consequence had been achieved.

Apart from the emerging landscape school of eighteenth-century England there was William Hogarth, who used the print, both etched and engraved, as no one else had before (except Callot), to satirize and moralize. Hogarth's example was soon followed by artists such as Rowlandson and Gillray. Their work is important because of its content, rather than

(Opposite)

Etching: from the *Carceri* series
by Giovanni Battista Piranesi.
21⅝ in. × 16⅛ in. Detail. *British
Museum, London.*

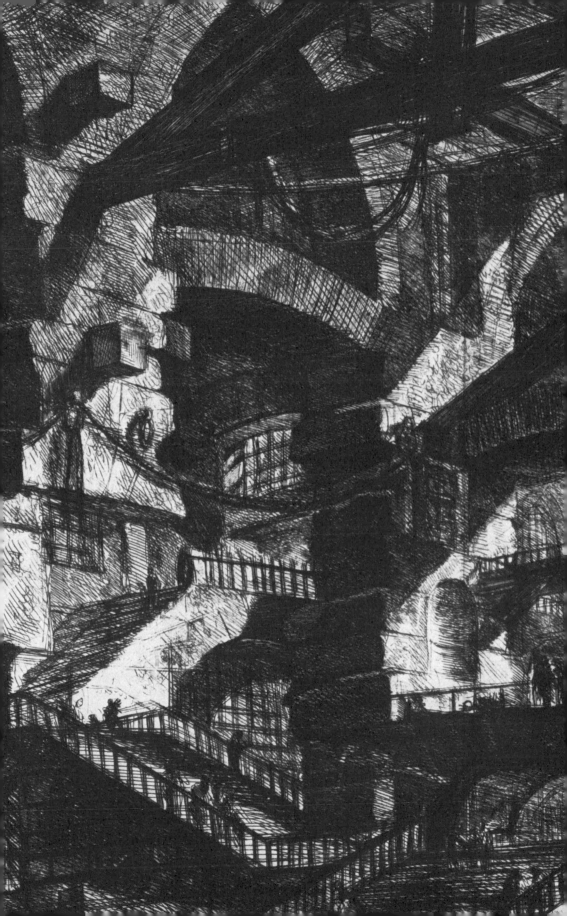

its technique, which was mostly straightforward and often executed by others.

The greatest figure in etching during the late eighteenth and early nineteenth centuries – and since Rembrandt – was Goya (1746–1828), who made exceptional use of the then totally new process of aquatint. This was displayed most obviously in his famous *Por que fue sensible*, executed without recourse to etched line, but was used more purposefully later. Apart from this, Goya's etching technique was in no sense remarkable, though it served his purpose admirably.

Goya made several single, extremely interesting plates outside his main series, e.g. *Colossus*. Of the main series, *Los Caprichos* (social and political satire), *Los Desastres de la Guerra*, and the *La Tauromaquia* are, in their various ways, the most compelling. *Los Disparates* are less obviously dramatic, particularly if compared with *Los Proverbios* or *Los Desastres*.

In much of his work Goya, like Callot and Hogarth before him, constantly used the print to confront society on many levels with its own decadence. But in his *Los Desastres* series (begun in 1810, but not published until thirty-five years after his death) he portrayed with unequalled draughtsmanship and the most profound compassion, on no fewer than eighty plates, the hideous, bestial and tragic incidents of war, and particularly the suffering that inevitably follows defeat and occupation.

The *Tauromaquia* are not as highly regarded as *Los Desastres* but, nevertheless, they contain some fearsomely convincing drawings of events in the bull-ring.

Line etching and aquatint: 'Ni por esas' from the *Desastres de la Guerra* series by Goya. 7⅜ in. × 5½ in. *British Museum, London*.

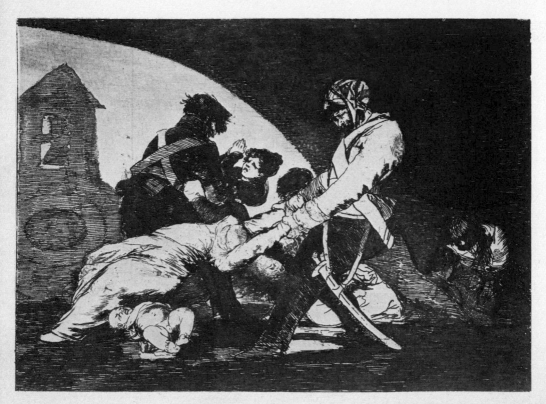

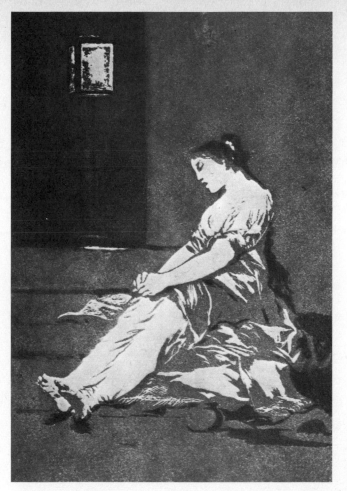

(*Left*) Aquatint: *Por que fue sensible* by Goya. 7 in. × 4¾ in. *British Museum, London.*

(*Below*) Etching drypoint and burin: *Fiero Monstruo* by Goya. 6⅞ in. × 8⅝ in. *British Museum, London.*

Unlike Rembrandt's, Goya's prints had little immediate or even gradual influence on subsequent etching. He was too solitary a figure; his technique was too stark and incisive to be of use to men with less to say.

In 1850, the etcher Charles Meryon produced the first, and one of the most important, of his immensely influential views of Paris – *Le Petit Pont*. Within four years he had completed a number of plates, among them *La Galerie*, *Le Stryge* and *La Morgue*. No other original etched work since Rembrandt's had a more lasting effect on nineteenth-century etching, for the dramatized architectural and topographical view was becoming one of the standard themes of etching. Predictably, in spite of the widespread plagiarizing of his highly individual approach, Meryon's architectural etchings have never been seriously rivalled.

During the 1850s, there was a growing interest in the print generally, no doubt fostered by the black and white lithographic drawings by artists such as Delacroix, Géricault and Daumier. A renewed interest in original etching led to a movement known as the 'French Revival'. Prominent in the early stages of this movement were Charles Jacque (1813–94), often called the 'father of modern etching', Félix Braquemond (1833–1919) and Alphonse Legros (1837–1911), who later moved to England with Seymour Haden and Whistler. By the 1880s, the revival in etching was fully established; many of the French artists of the later nineteenth century made etched or drypointed prints, among them Pissarro, Mary Cassat, Van Gogh, Rodin and Monet.

The most interesting etched work of the period was not always found in the mainstream development of French printmaking; for instance, the strange, dreamlike, mixed-method prints of Rodolphe Bresdin (1822–85) and the superbly drawn etchings of the Belgian Félicien Rops (1833–98), long considered too erotic for public exhibition. Rops also apparently worked on plates that had been photographically etched, presumably by photogravure. Of considerable interest is the work of another Belgian, James Ensor.

Relief etching from *Jerusalem*, page 37, by William Blake. 8¾ in. × 6¼ in. *British Museum, London.*

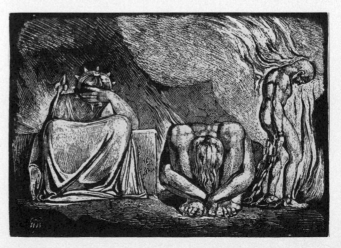

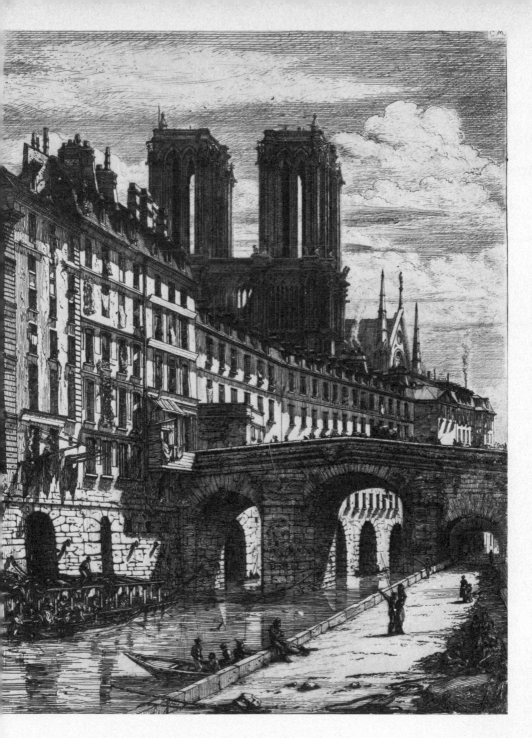

Etching: *Le Petit Pont* by Charles Meryon. 10¼ in. × 7½ in. *British Museum, London.*

The development of original etching in England had, since the later landscape work already referred to, remained somewhat static, with the single exception of William Blake (1757–1827). (See also p. 73.) Blake's main technical contribution to etching was his invention of a relief process used to print a combination of text and illustration on one page, seen at its best in his *Jerusalem*.

The revival of etching in late nineteenth-century England was due more than anything to the efforts of Seymour Haden (1818–1910), the first President of the new Society of Painter Etchers, and to the work of J. M. Whistler (1834–1903). Haden himself was a gifted and influential etcher. His work – mostly simple, direct studies in line of riverside landscapes – was highly regarded by many of his contemporaries (and especially, it appears, by Lumsden).

It was, however, Whistler, with his remarkable, if deliberate, displays of draughtsmanship and technique, who dominated the etching scene. His much-praised series of sixteen plates known as the *Thames Set*, containing the famous *Black Lion Wharf* print, is one of the most accomplished achievements of English graphic art.

Notable among the many prolific etchers to follow Whistler were Walter Sickert and Frank Brangwyn. Both were essentially painter-etchers; both produced highly individual work. The often vast plates and the powerfully drawn, dramatic compositions of Brangwyn had a conspicuous, though somewhat brief, influence on contemporary etching.

Etching continued to be popular in England until the early 1930s. With a few exceptions, etchers such as Short, Muirhead Bone, Strang and Cameron were primarily concerned with architectural and topographical landscape studies.

Not unexpectedly, it was in France that the best prints of the period were ma de, although important, individual work was carried out elsewhere in Europe; for example, prints by Käthe Kollwitz and others in Germany, Munch in Norway, and the prints of Nevinson and Pennell in England.

The conception of etching as essentially linear, black and white, persisted well into the twentieth century, with artists such as Dunoyer de Segonzac (particularly in his prints for Virgil's *Georgics*, published by Vollard) and Picasso – in the latter's case, even within the past few years. Characteristically, Picasso has been one of the most creative and prolific of twentieth-century printmakers. Prominent among his best etched work are the line and sugar aquatint illustrations to Buffon's *Histoire Naturelle*, the *Vollard Suite* and the *Minotauromachy*.

One of the greatest individual achievements in twentieth-century etching has been made by Georges Rouault, in such works as the *Miserere* and *Guerre* (made between 1916 and 1927), the *Réincarnation du Père Ubu* (published by Vollard in 1932), and the *Passion* (1939). Rouault worked on his plates for many years, often in collaboration with the master printer Roger Lacourière. Apart from the fact that the plates are supreme works of art, they are technically of considerable interest for Rouault's methods involve photogravure processes and a combination of several intaglio techniques.

Practically every major painter and sculptor working in Paris made prints in one medium or another; of particular

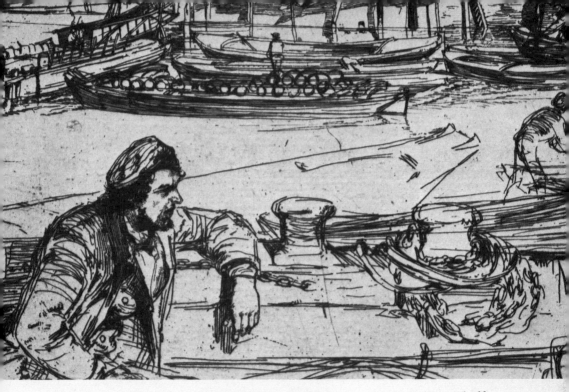

Etching: *Black Lion Wharf* from the *Thames Set* by James McNeill Whistler. 6 in. × 8⅞ in. Detail. *British Museum, London.*

(*Left*) Etching: *Fernande les Mains croisées* by Dunoyer de Segonzac. 5⅛ in. × 6⅞ in. *British Museum, London.*

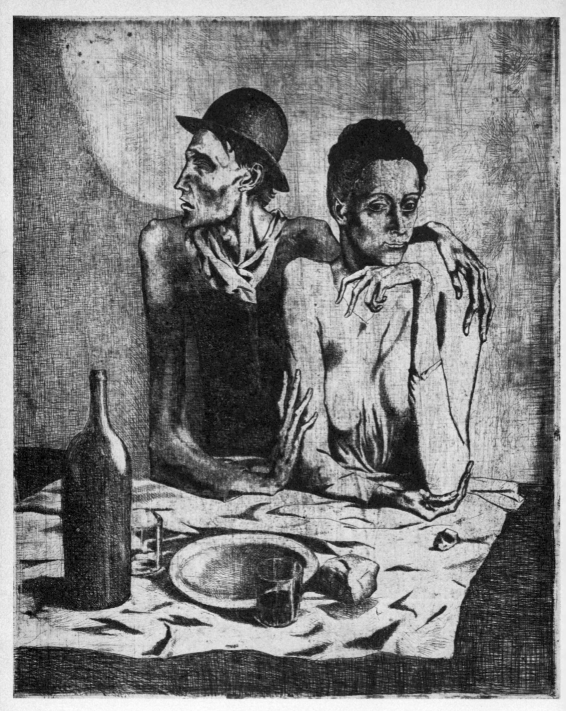

Etching: *The frugal repast* by Pablo Picasso. 18¼ in. × 14¾ in. *British Museum, London.*

interest is the intaglio work of Miró, Chagall, Matisse and Ernst.

Since the turn of the century, the situation in France for the creative printmaker has been much healthier than anywhere else in Europe. There has long been a much greater interest in the print – both original prints and, significantly, reproductions as well, signed by the artist and the printer.

In the 1920s, Jacques Villon was employed as a professional intaglio printer in the Chalcographie of the Louvre. It was Villon as much as any artist who, largely through his more personal as opposed to his professional work, did so much to broaden the conception of etching.

After Villon, experimental work in all aspects of the etching and engraving processes increased, and etching, in particular, began to relate much more to contemporary art generally. The main centre of activity was Hayter's

Line etching and aquatint: *Quarters* by William Tillyer, 1969. *British Council Collection.*

27

Atelier 17 in Paris. Since the late 1920s, Atelier 17 has been the most inventive, productive and influential centre in the field of original intaglio printmaking.

Original etching in England – like all the printmaking processes – suffered a marked decline in the late 1920s. The great era of the 'conservative' collector was rapidly ending and with it the legacy of Whistler, still perpetuated by the popular etchers of the time, such as McBey.

One of the few truly individual and outstanding English artists who has been working since the thirties principally in drawn, black and white etching is Anthony Gross.

Between the wars, interest in intaglio printmaking increased steadily, until by the 1950s, etching, particularly colour etching and – though rather less – engraving, were firmly re-established among contemporary techniques in graphic art in England and America. To a large extent this was due to the work of teacher-printmakers such as John Buckland-Wright at the Slade, and Julian Trevelyan at the Royal College of Art in London; and in America, Gabor Peterdi, Mauricio Lasansky, Frederick Becker and many others, mostly associated at some time with Atelier 17. The influence of Atelier 17 has undoubtedly been felt more strongly in America than in England.

An independent intaglio workshop was opened in Charlotte Street, London by the Swedish artist Birgit Skiold, and has since functioned as a studio-workshop in which artists could print their own plates.

During the late 1950s there was a significant increase in the number of print exhibitions in London. Both Zwemmers and the St George's Gallery were extremely active. A little later, Editions Alecto and the Petersburg Press began to commission editions or 'projects' from artists. Prominent among several London galleries dealing – in such cases almost exclusively – with modern prints are Lumley Cazalet and, more recently, Marlborough Graphics.

The Royal Society of Painter-Etchers and Engravers (founded in 1880, its first President was Seymour Haden) continues to hold an annual exhibition – at its gallery in Conduit Street, London – of work by members and non-members. Candidates for associateship of the Society are asked to submit intaglio or relief prints and drawings; lithographs and screen prints are not admissible.

The formation of the Printmakers Council of Great Britain and the biennial print exhibition at Bradford (which follows a succession of newly formed, specialized exhibitions, originally in Switzerland in the early 1950s, then at Ljubljana, Tokyo and Cracow) have considerably improved the opportunities for practising printmakers, especially the younger artists.

At present, few of the leading or senior British printmakers work predominantly in the intaglio process. A great deal of the more vigorous and inventive work is, as one might expect, produced by students.

The situation in America continues to be much more sympathetic to the printmaker, young or old. A large number of colleges and University Fine Art Departments have well-established and well-equipped printmaking centres. Prominent among the numerous organizations and institutions which serve to encourage creative printmaking in all its forms are the Print Council of America, the Philadelphia Print Club, the Society of American Graphic Artists and the Pratt Graphics Center in New York.

Judging by the amount and variety of work in the recent biennials, printmaking generally is becoming increasingly active in many other countries. Argentina and Yugoslavia particularly (Sergio Gonzalez Tornero and Riko Debenjak) have long had a very progressive outlook towards all the graphic processes.

2 The technique of etching

To etch is to corrode metal and dissolve it with acid. In order to control and confine the action of the acid, for instance when sinking a line into a metal plate, the line must in some way be both isolated and exposed. This is done by first protecting the plate with an acid-resistant coating or ground – wax on the front or working surface, varnish on the back. A line is drawn cleanly through the wax ground, onto rather than into the metal with a light point or needle. The plate is then immersed in a bath of acid solution and the exposed line is bitten. The depth of the line depends mainly on the strength of the solution used and the length of time the plate is allowed to etch. Generally, the heavier and deeper the line, the darker the eventual printed line will be.

Etching a plate is very much a chemical process; however carefully a line is drawn through the ground, it is seldom possible to predict and control exactly the behaviour of the acid and consequently the quality of the line; acid is so easily affected by other factors – temperature, its age, the quality and structure, often unknown, of the metal.

After etching, the plate is cleaned with a solvent and a thickish black ink is worked down into the bitten line. By repeatedly wiping across the surface of the plate evenly, in all directions, the ink is cleaned from the plate, except in the line; the wider the line, the less it will retain ink and the paler it will print. A printed impression is made by placing the plate, face up and centrally, on the flat metal bed of a copper-plate (intaglio) printing-press. A sheet of damp, but not sodden, paper is laid over the plate and both are covered with a number of felt blankets. The bed is moved slowly and smoothly between two heavy rollers; these are closely set and the upper roller is tightly adjusted to exert great pressure down onto the softened paper and the etched plate. The paper is thus forced into the ink-filled line and, when taken from the press, retains an exact, but reversed image of the plate surface – inked and embossed. Each time a new print is made the plate has to be re-inked, wiped and again taken through the press.

It has been fairly common practice for centuries to combine various intaglio techniques on a single plate. More recently, a variety of techniques and a number of plates have been frequently used to produce a single 'composite' print.

The art of etching – as a means of making plates for printing – has been practised extensively, if not consistently, since before Rembrandt; not unexpectedly, there has

accumulated a massive history of what is usually termed 'craft'. In each process, or variation on a process, there are so many possible stages to follow, so many methods to perfect, and a confusing assortment of materials to select from and try out. It is easy to become fascinated (or repelled) by and preoccupied with the intricacies of the craft itself. There can be little doubt that one of the particular attractions of etching has been the crude chemistry involved. But, in spite of a multitude of recipes and formulas, ancient and modern, only a few, simple materials are actually needed when making even the most complex of etchings. Provided one has metal, acid, paper and press, no single substance is absolutely in-dispensable, nor is there a special brand of material or unique item of equipment without which an effect cannot be made. The few materials that could be called basic – wax, pigments and oils – are, in most cases, either identical to, or refined and improved versions of, those in use over three hundred years ago, and have proved to be the most reliable, durable and versatile. Practically all of the more commonly or tradi-tionally used etching materials can now be bought ready-made, although it is not necessary to rely solely on the generally accepted, approved materials. There is every opportunity in etching for personal experiment and for improvising materials and tools.

The essential qualities of an etched line (in the traditional sense) are first and foremost those of a naturally drawn line. There is little or no resistance when drawing with a point on a wax ground. Within reason, and provided, for instance, the materials are sympathetically considered, the possible variation of line is immense, depending almost entirely on the adequacy of technique and the manipulative skill of the artist. The line is also conditioned subtly (or drastically) by other factors; for example, by the type and quality of the metal, even the consistency of the wax ground, but most particularly by the action of the acid.

A line, of sorts, can be bitten simply by leaving the drawn plate in a strong solution of one of several acids. To etch lines sensitively and accurately, deliberately controlling the appropriate solution in order to retain the quality of the drawing, requires knowledge and skill. In creative etching, the object is not to reproduce exactly the particular effect of an original pen- or pencil-drawing; this would be just as pointless as trying to imitate an engraved line. A charac-teristic, bitten line, however swiftly or assertively it has been drawn through the wax, generally betrays the effects of having been bitten downwards into the metal. As the needle-point is moved across the plate, it cuts through and scrapes out the wax, leaving behind it a line of exposed metal. When magnified, the wax edges of the line are seen to be fractionally crumbled; this renders them more vulnerable to the sideways action of the acid. If examined from a normal 'reading' distance this printed line (seen as a fine, slightly raised thread of ink on the paper) invariably has a faintly

intermittent appearance. This, in itself, is usually (but not always) far too imperceptible to influence either the weight or the direction of the drawn line. But it does invest the line with a character unlike that of a typical, clean-cut, engraved line, or a more fluid pen-drawing.

A familiar, almost standard interpretation of what is considered to be the characteristic etched line resorts to words such as 'nervous' and 'spidery'. This is correct, inasmuch as it caricatures a certain kind of line, but serves equally well to caricature an approach to etching. But in no way does it adequately suggest the full variation of line that is possible; and which need not be, in any sense, 'nervous' or 'spidery'. Lines of the utmost delicacy and intricacy can be drawn and bitten; so too can lines of great force, vitality and roughness. Ultimately, especially with regard to the study of intaglio line – etched, engraved or scored – the degree of essential quality is relative, usually visible only on close examination. It is seldom glaringly obvious and indeed, in a print of any real significance, has never been of major importance. Yet careful consideration of these 'finer points' can be helpful, if only in a technical sense, in understanding the processes of etching metal for printing.

It is not at all necessary that one's first approach to etching should automatically begin with the line; line, especially that made by the stroke of an etching point, is only one of an infinite number of marks made possible by many processes.

A broad and shallow bitten line will not hold sufficient ink to print as a solid black. The middle portion of the line will normally wipe clean, and print as a pale grey. It can be made to retain ink either by biting the line deeper (which is seldom practical) or, in the case of an extremely wide line, by regrounding the area and 'needling' inside the line. If the wide line is extended into a more expansive area or shape and is shallow bitten, it becomes an open bite. Open areas are often used with other kinds of mark, line or texture, to create flat, tonal areas or to soften existing work.

Deep etch is used primarily to enrich the print with heavier darks and more obvious embossing, and also as a method of etching down negative areas in order to leave the positive shapes standing in relief. The raised surface is rolled up with black ink; the intaglio areas are left uninked to print white. In a tonal sense, a relief print is the reverse of an intaglio print. A more complex version involves normal (intaglio) inking of the etched portions of the plate in a colour, and rolling a second colour over the intact relief surface. Contemporary experiments with this form of colour printing have become incredibly elaborate.

By far the quickest and most satisfactory method of achieving an over-all, uniformly dark tone on the plate is by aquatint. This is usually powdered rosin, dropped onto the surface and 'fixed' by heating. The plate is immersed in acid, and biting occurs only on the exposed metal surrounding each minute particle of rosin. A considerable range of finely

textured tone, from the palest grey to the richest black, can be otained by controlled biting, by stopping out in successive stages, or simply by scraping into the bitten ground.

Another way to create either tone or texture is to use softground etching, a process originally used to reproduce a crayon- or pencil-drawing. A thin layer of soft wax is rolled onto the plate surface and the drawing is made by pressing a point gently through a sheet of paper placed over the wax. The plate is then etched and printed in the normal way, the printed line having a soft, grainy quality, more typical of a chalk-drawing than a hard, intaglio line. The textural possibilities of soft-ground etching are immense. All kinds of materials and surfaces can be impressed through the wax and onto the plate by utilizing the pressure of the printingpress.

One of the most difficult, and in a sense, uncharacteristic, printed effects to achieve is that of tonal gradation, but this can be done by scraping into a closely textured, bitten surface, particularly aquatint.

Uninked and heavily embossed prints can also be taken; plates can be built up or cut into any shape, etched and reassembled in countless ways. The use of colour alone in etching has been developed to an unprecedented degree over the past twenty years or so.

If approached with an open mind, and if practised with reasonable workmanship, the established, conventional methods provide the means of making an extraordinary range of marks. This is not to suggest that unconventional or apparently untried methods or materials should be avoided; on the contrary, every conceivable means of controlling a mark or effect bitten into the metal ought to be considered and, whenever possible, tried out. But it must also be realized that because a certain method has become in a sense a standard procedure (whether 'traditional' or 'contemporary'), it does not mean that the results should necessarily be standard, predictable or even technically accountable.

Etching the plate is very much a means to an end; it is the quality of the eventual print that counts. In one sense, it is largely immaterial what condition the plate is in, or how the effects were obtained, as long as an edition of identical prints can be taken from it. Yet regard for the print presupposes a regard for the plate; above all, it demands respect for the materials.

METALS

Copper and zinc* are by far the most commonly used metals for etching, and indeed for all the intaglio processes. Other serviceable metals include iron, soft steel, aluminium, brass and magnesium; of these, iron or steel would seem to be the best all-round metal.

The usual thickness of a plate is either 16 or 18 gauge ($\frac{1}{16}$ in. or $\frac{1}{18}$ in.). At less than 18 WG. (22 is the usual minimum)

*Zinc has been replaced in the United States with micro-metal, an alloy coated on one side with a tough, acid-resistant surface. The nature and handling of micro-metal are identical to those of zinc, and wherever in this text zinc is mentioned, unless stated otherwise, it should be assumed that micro-metal is also meant.

both copper and zinc are inclined to bend and buckle under printing pressure and are generally more inconvenient to work with. This applies rather less to iron, which is harder and tougher. Plates thicker than 16 WG. (14 is the maximum thickness) are not recommended for normal printmaking purposes. They are excessively difficult to print and the thick plate edge, even when bevelled, severely strains the fibres of the printing papers. And as most plates, especially copper, are sold by weight, really thick, heavy metals are unnecessarily expensive. Most dealers in etching materials supply copper and zinc plates, with either a polished or a slightly dulled surface.

Larger sheets of copper and zinc can often be bought more economically from a local metal-dealer (who would also supply the much cheaper sheets of iron and steel), although the metal is usually rather thin (e.g. 20 to 22 gauge) and nearly always unsurfaced or unpolished. These sheets can easily be cut to the required plate size on a metal-cutter or guillotine. If this is not available, alternative methods of cutting are by hacksaw, bench saw or band-saw, or failing all else, by scoring or engraving a line deeply into the metal and bending it repeatedly until it breaks along the incision:

To 'break' a metal plate, particularly copper and zinc, a steel rule (or even another plate) is positioned on the plate and both are firmly clamped down onto a table-bench top. The line is made either by pulling a 'draw' tool (as used by commercial engravers) along the rule until the plate is severed, or driving a burin repeatedly alongside the rule until the line is at least halfway through the metal. To avoid bending the plate when actually breaking it, the plate can be clamped down with the opened cut parallel with, and directly above, the table edge.

Copper is probably the most useful metal for nearly all intaglio processes and techniques. It is excellent for fine, closely drawn lines, and for tonal and textural areas; soft enough to score or cut into, yet hard enough to stand up to many printings without undue wear. Unlike zinc, copper has a perfectly clean and reliable printing surface for most coloured inks, leaving the colour unaffected by the metal.

At one time, copper plates were all hand-hammered; this gave them a fine, dense, even texture. Hammered plates can still be obtained, but are naturally more expensive. Nearly all copper plates used now are 'cold rolled'. The structure of these differs from that of the hammered; this is sometimes revealed during etching, but is rarely a problem. It becomes more noticeable when engraving and is, therefore, described more fully in later chapters.

*Zinc** is a less versatile metal than copper, being too soft for most engraving and drypoint; but for vigorous line- and open-bite etching, it is equally as good as, if not better than, copper.

The most obvious advantage of zinc is that, while for most etching purposes it compares very favourably with copper,

Draw tool.

* See note on micro-metal, p. 33.

it costs much less. (Unpolished zinc is even cheaper, especially when bought in sheets, rather than prepared plates.)

The softer, coarser structure of zinc makes it easier and quicker to bite, but it also makes it more prone to foul biting, partly because a wax ground does not hold quite as well on the surface of zinc as on copper. Wax ground, when drawn into with a point, has a very slight tendency to crumble at the edges of the line; this depends on several factors, but mainly on the thickness and evenness of the ground and on the strength of the acid. As a result, the printed line is somewhat heavier than the drawn line. This can be deliberately encouraged and exaggerated; at the same time, a finely drawn line can, if carefully controlled, be cleanly and accurately bitten.

Open areas, lightly etched into copper, will usually withstand many printings, whereas with the softer zinc, shallow areas are soon pressed flat under repeated printing pressure.

Zinc is now widely used for practically all contemporary etching processes, yet it is not entirely successful for colour printing; for example, a yellow ink can be quite drastically affected by zinc, often printing as a rather dirty green.

Iron and soft (mild) steel are cheap, reliable and, compared with copper and zinc, extremely hard metals. This hardness is both an advantage and a disadvantage. They are slow to bite in the acid, but the bitten mark, especially the line, if positive, is somewhat coarse. Iron or steel plates are strong enough to sustain editions of literally hundreds of prints, although editions of over seventy-five are infrequent anyway.

Any mark etched into steel is difficult to remove, or even to alter, so much so that it makes zinc, which is much easier to scrape, burnish and polish, seem almost a malleable substance. Steel also has a slightly roughened surface which, if left, holds a certain amount of ink and prints with an overall grey 'plate-tone'. The surface can, if necessary, be polished smooth with a mechanical buffer; or it can be left, and pale or white areas scraped into it and wiped clean. If used as a tonal open bite it should wear extremely well for a considerable number of prints. This 'background' colour does rather inhibit fine, close, delicate work. Steel is, however, excellent for colour printing and does not discolour the inks.

Apart from being relatively cheap, both iron and steel can usually be readily obtained locally. When not in use, they must be protected from rust (frequently caused by acid fumes) by being varnished, oiled or even wrapped in greaseproof paper.

Aluminium is a cheap, but coarse, metal for biting.

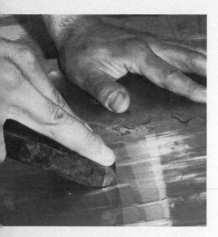

Planing with snakestone and water.

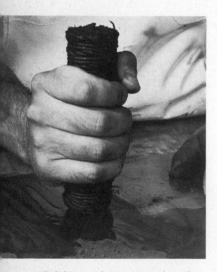

Polishing with crocus powder, oil and rubber.

It may, at times, become necessary to salvage an old, previously worked plate (especially copper), and utilize the invariably scratched and pitted back surface. This can mean having to regrind and repolish the entire surface, obliterating as much of the foul biting as possible. It often happens, after etching a plate, that details, even whole areas, have to be cleaned out and the work redone. Before the new work is possible, faulty areas have to be thoroughly scraped and the resultant harsh, hollowed surface made flat and smooth again. There are, therefore, at least two stages at which extensive resurfacing may be necessary: when preparing an old, used plate, prior to new work, and – usually less extensively – after scraping and correcting work. In both cases the methods are much the same.

Correcting a deep-etched plate where the use of callipers or repoussage is involved is described in Chapter 9; correcting an engraved plate is referred to in Chapter 11.

The first step is to grind or plane down the entire surface with snakestone and water. It helps if the snakestone (preferably water of ayr stone or Scotch hone) is of a reasonable size, that is, suitable for holding and working with, and also for covering as much of the plate surface as possible. The snakestone should be worked back and forwards, and generally in the same direction, across the surface, steadily and rhythmically, not unlike the action used when planing wood. This is continued until the unwanted bitten marks are gradually worn away.

Pumice-stone is sometimes used before the snakestone, but not as an alternative.

The next step is to repeat the planing action, preferably in a different direction from that of the snakestone, but using charcoal and water. This is necessary to remove the roughness left by the snakestone. For this purpose, the most commonly used form is engraver's charcoal, made from willow. Two pieces are advisable, a fairly coarse-grained piece to begin with and a finer one for finishing.

Oil can be applied instead at a later stage for polishing; in this case, the portion of charcoal used must be reserved for oil only and never for water. Ordinary machine-oil is perfectly adequate, although olive-oil is considered better. It is not vital to add any lubricant to the charcoal, but if used dry at this stage, it is apt to polish rather than grind or cut. The piece used should, in any case, be flat and preferably bevelled to facilitate the planing action.

Even after charcoal rubbing, the surface is still not perfect. A further and final polishing is necessary before an absolutely smooth surface is obtained.

There are several traditional powders suitable for this – emery, pumice, jeweller's rouge, crocus and rottenstone. The old way to employ these powders – most of which can still be purchased from dealers – was with an oil rubber. This

too can be bought, but is easily made. It consists of a tightly rolled strip of canvas or felt blanket (e.g. fronting, p. 158), fully bound with twine. The exact dimensions are not important, but the majority of oil rubbers seem to be about 6 in. long and about $1\frac{1}{2}$ in. wide; in fact, suitable to be held and used comfortably in a vertical position. The rubber can be made so that one or both ends can be used, but either way, the coiled working surface must be really tight and flat. The flat end is then soaked in oil and rubbed firmly over the powdered plate.

Solid felt pads are also sold, but do not grip on the plate as well as the coiled, felt rubber; although they can be quite usefully employed for particularly large areas.

Whether coiled or solid, the contact or working surface must be constantly checked to ensure that no fragment of metal or grit has become embedded in it. Even a tiny fragment of metal, such as a filing, could ruin the previous work.

Finally, the plate can be additionally rubbed over with a non-gritty, liquid metal polish, such as Brasso. Most, if not all, of these materials are obtainable at an etching suppliers; powders and charcoal can also be bought from wholesale jewellers and snakestones from local tool-shops.

Cleaning plate with whiting and ammonia.

Bitten surfaces can be mechanically ground down and polished smooth on a buffing machine (or electric drill), but unless expertly done, this method can easily produce an uneven surface. However, grinding by snakestone and charcoal need not be laborious or slow.

CLEANING THE PLATE

The surface of all plates, old and new, should be thoroughly cleaned before the actual drawn work is begun, and especially before a hard wax ground is applied. The slightest trace of grease under the hard wax can cause it to lift during the biting. Grease can also prevent an aquatint from biting evenly.

The most effective and least harmful way to clean a plate is to wash it carefully with a clean rag and a thin paste of whiting powder and diluted ammonia (half water, half ammonia, if ordinary household ammonia, otherwise a teaspoonful of full-strength ammonia to a pint of water is sufficient to clean a large plate). After the plate has been well cleaned, it should then be thoroughly rinsed under the tap. No whiting powder should be allowed to remain on any part of the plate.

Rinsing also serves as a good test of whether or not the plate really is clean and free of grease. If a moderate flow of water runs off the polished surface of the plate in rivulets and drops, and not as a spreading, unbroken film, the surface is obviously still greasy and the cleaning process will have to be repeated.

Other useful cleaning liquids used with whiting powder

Grease on the plate during rinsing.

include spirits of turpentine (turpentine substitute), vinegar and methylated spirits; acetic acid, alcohol and petrol are quite adequate without whiting. Household detergent is another alternative.

French chalk may also be used for the paste instead of whiting powder. It can be mixed with water or water plus a drop of ammonia, or with either methylated spirit or 3 per cent caustic soda.

The plate can be dried with blotting-paper, although it is perhaps safer and cleaner to dry it on the heater or hot-plate. Drying with a rag, however clean the rag may appear to be, is not advisable. Care should also be taken when handling a newly cleaned plate to avoid leaving fingermarks round the edges of the surface.

If a dulled working surface is preferred, the plate can be cleaned and briefly etched in a mild solution of nitric acid (12 parts water to 1 part acid).

A polished plate that has become tarnished can easily be cleaned with metal polish. An already etched plate may require a mixture of household salt and acetic acid or vinegar; this must not be left on the plate for long and should be washed off before drying.

BEVELLING THE PLATE

The edges and corners of a plate must be bevelled by filing before any proofs are taken. The main reason for this is to protect the blankets during printing; a sharp, right-angled edge, under heavy, direct pressure, can easily slice through a full set. A correctly bevelled edge allows the blankets to move smoothly through the press and safely over the plate. Another less crucial, but still important, reason is that printing an unbevelled plate puts a tremendous strain on the paper, and can cause it to split along the plate edge. A bevelled plate is also more convenient and safer to handle during the inking, wiping and final cleaning; a sharp corner will constantly catch and tear the tarlatan. There is little doubt that the qualities of many intaglio prints are much enhanced by a clean, impressed plate edge.

There seems to be some uncertainty regarding the actual stage at which the plate should be bevelled; some etchers file before etching, while others file only after all work in the acid is completed. It really does not matter, except that in most cases, a plate filed before etching will have to be refiled later. If it is done before, then the edges must be very carefully protected with varnish.

Bevelling is normally carried out by placing the plate flat on a table, so that the edge overhangs slightly and filing down each edge fully, to an angle of approximately 45°. Each corner is also slightly rounded off.

With a conventionally shaped plate, e.g. rectangular or square, each outer edge, when correctly bevelled, should be

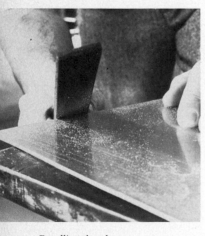

Bevelling the plate.

perfectly straight. Excessive filing all round the plate edge can sometimes result in a slightly convex shape. This is due to a natural tendency to bevel more towards the corners – especially on a smaller plate. To counteract this, it may be necessary to deliberately bevel the middle of each edge rather more; in fact, producing a very slightly concave-shaped plate.

All metal plates or fragments of plates, regardless of their shape, should be bevelled, with the possible exception of thin steel. A flat, moderately coarse file is required and perhaps a finer one to complete the work. The edges can also be bevelled and polished by scraping and burnishing. A consistent, 45° bevel is quickly and more easily achieved by moving the file both across and along the plate edge and not simply with an up and down motion. The under-edges of the plate are also lightly filed.

Filings should never be left on the plate surface or on an already etched plate, e.g. in deep lines; even the smallest particle of metal can cause the most irritating surface scratches. Nor should they be brushed onto working material, such as rags, muslin or dabber.

WAX GROUNDS

A line-etching is normally made on a plate covered with a thin, even layer of hard ground. In order to confine the biting to the drawn, exposed line only, the ground must be impervious to acid and thoroughly cover the entire plate surface. It needs to be sufficiently consistent and durable to withstand lengthy periods in acid, and resilient enough to adhere to the metal and permit fine, close and naturally drawn lines to be made in any direction, without flaking or cracking. If the wax is too soft or greasy, the needle cannot fully and evenly penetrate through to the metal. Softer wax also tends to cling to the needle-point, and to some extent rubs off onto the hand. In fact, with a good ground, the wax cleaned out by the point can actually be blown or dusted off the plate surface. If it is too hard and resists the point, it can severely limit the expressive quality of the line. The old textbooks list many recipes for hard grounds, but the one most widely used consists simply of the following:

 2 parts bitumen
 2 parts beeswax
 1 part rosin

There may be slight variations on this recipe, depending on availability of materials; for instance, bitumen can be asphaltum – Syrian or Egyptian – in preference to 'commercial' bitumen, which makes the wax too soft; beeswax can be virgin or Gambia, and the rosin preferably colophony.

Excellent hard grounds in solid form, based mostly on this composition, can be bought from dealers. These grounds

are manufactured and sold in flat, round cakes or balls. They can, if necessary, be fairly easily made by first melting the beeswax into liquid by heating it in a container, then slowly adding and stirring well a crushed and mixed proportion of bitumen and rosin. The mixture can be poured into warm water and moulded into serviceable shapes.

Seventeenth-century grounds were far harder than the modern ground. Etching was then largely regarded as a substitute for burin engraving; lines were often carefully contrived to imitate the more flowing engraved line. These were cut into the wax with tools such as the échoppe needle, which had a point sharpened on one side. Compared with these early grounds, the modern version is really quite soft, though it should not be confused with the type used solely for soft-ground etching, which contains a large proportion of tallow.

E. S. Lumsden (in his book *The Art of Etching*) lists several kinds of wax grounds; most of these are taken from the early 'manuals' of Bosse, Faithorne and Hammerton. A ground similar to that used by Rembrandt was made as follows:

> 1 oz. virgin wax
> $\frac{1}{2}$ oz. mastic (or rosin)
> $\frac{1}{2}$ oz. asphaltum (or amber)

A thin coating of finely ground white lead diluted with a gum solution was often painted over the ground, giving a surface similar to white paper.

A typical seventeenth-century ground – referred to at that time as 'soft ground' – would comprise:

> 2 oz. virgin wax
> 2 oz. asphaltum
> $\frac{1}{2}$ oz. black pitch
> $\frac{1}{2}$ oz. burgundy pitch

A further $\frac{1}{2}$ oz. of wax was added in cold weather. Burgundy pitch is in fact a rosin; ordinary black pitch is a refined tar-like substance.

An eighteenth-century variation on this (later used by Sir Frank Short) was similar, except that common pitch was substituted for black pitch.

These mixtures are melted together by heating and are stirred constantly. The asphaltum is generally added last, although, since asphaltum requires a more intense heat to become fluid, some authorities advise melting it before the wax and pitch. The whole mixture is then brought to boiling-point, perhaps two or three times, before being cooled and shaped in water. A clean double-boiler makes an ideal container for heating.

Both transparent and white wax (more commonly a white lead-coating) are sometimes applied to the plate, but for most drawing purposes, neither is as satisfactory as the dark, hard wax. A transparent ground does, however, have

the advantage of revealing clearly and immediately the bitten line when working in the acid, especially in Dutch mordant.

Hammerton's transparent ground was made up of just two substances:

> 5 parts (in weight) white wax
> 3 parts (in weight) mastic rosin

A white-coated ground enables the drawing to appear more positively on the plate surface, the exposed lines being dark on a white background.

Ground is also obtainable in liquid form and is sold by most dealers. This is usually the ordinary solid, hard ground dissolved in chloroform or ether. This gives an excellent working surface, but is a little more difficult to apply really well, being volatile and particularly vulnerable to dust particles. On the whole, it is safer and certainly more convenient to buy the made-up form, rather than rely on the home-made variety.

However, Anthony Gross (*Etching, Engraving and Intaglio Printing*) recommends an interesting liquid ground, made by melting hard wax, then using turpentine substitute to keep it from solidifying again and adding Xylene to maintain the correct fluidity.

The simplest way to apply liquid ground is to put the plate in a clean bath or tray, preferably tilted at a slight angle, and pour the liquid onto the dust-free plate surface; the excess is then poured back, through a funnel, into the container. Another method that ensures a more even covering is simply to lower the plate on two lengths of string into a shallow bath or tray of liquid. A liquid ground can also be brushed onto the plate, using a broad, 2 to 3 in. soft brush, but it is more difficult to achieve an evenly laid surface than with either of the previous methods.

APPLYING THE GROUND

A hard ground in solid form is normally applied to the plate surface by roller or dabber. First, the plate needs to be warmed up on a metal hot-plate. This is usually a kind of flat-topped iron box, perhaps 18 in. × 24 in. but preferably no smaller, and standing a few inches high on a bench or table. The hot-plates can be heated by gas-rings or by electricity (a plate can be, if necessary, heated and grounded on an ordinary kitchen stove). The hot-plate should be gently and thoroughly heated, well before a plate is placed on it.

Iron hotplate with gas-ring.

Before applying the ground, it is advisable, though not essential, to protect the plate surface by wrapping the wax ball in fine silk; this helps to prevent any grit it may contain from spoiling the ground or the surface.

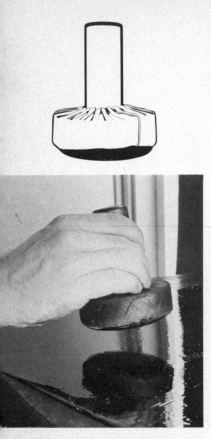

(*Top*) Leather dabber; (*above*) applying a wax ground with a dabber.

Wax will melt and begin to spread immediately as it comes into contact with the hot metal. The entire plate surface is then evenly coated with the almost fluid wax. It is important to avoid a fierce and constant heat, especially in the centre of the plate.

The dabber is a light, round pad, a few inches across; the upper parts are drawn together and tied in the centre for gripping, or tied round a central wooden handle. The whole shape is rather like an inverted mushroom. Normally, the round pad is of thin leather (e.g. white kid) and should be firm, but not hard, and as smooth and even as possible.

Dabbers can be bought (usually shaped round a wooden core or handle), but are easily made. A serviceable and hard-wearing dabber can be made by tightly packing a piece of fine silk, nylon or thin wash-leather with bits of rag; or, better still, by padding a cardboard disc with horsehair and cotton-wool and enveloping these in a piece of soft kid. The loose ends of the kid are pulled and stretched over the pad until the actual dabbing surface is taut; the ends are then tied with string. If a round, wooden core is used, the stuffing under it must be adequate, otherwise the wood can work through and spoil the even surface of the dabber. This applies equally to bought as well as home-made ones.

The ground, already smeared onto the heated plate, is spread more consistently by 'rocking' the dabber over the whole surface. It is then finally evened out by dabbing repeatedly downwards, quickly and lightly; a large plate may have to be continually manœuvred on the heater to prevent overheating of any one area. If the plate is allowed to become too hot the ground tends to disperse and form bubbles and when very hot, scorches, smokes and burns. The brittle wax must then be completely removed with solvent, cleaned, and a new ground relaid.

A plate that has cooled prematurely can cause the wax to cling to the dabber and to thicken and become patchy on the plate surface. A ground that has been applied too thinly is apt to break down at its weakest points, such as dust spots and imperfections – some of which are inevitable, despite precautions; should it be too thick, it is inclined to crack and, in any case, is difficult to draw through. The whole process depends very much on manipulation and timing. Before a perfect ground is achieved, the plate may often have to be reheated and the ground relaid. Lumsden advises leaving the plate very briefly on the heater immediately after the dabbing is completed, until the rather dull ground remelts and becomes shiny and smooth.

The roller. Probably the most popular way to lay a wax ground on a plate is with a roller. It is generally considered to be an easier and quicker method, although the relative slowness of dabbing is usually exaggerated. The main advantage of the roller is that it enables an adequate ground to be laid on a very large plate. The larger the plate, the more difficult it is to ground it really well. If available, a second hot-plate,

placed adjacent to the first, can be used to give a larger heating surface.

It is quite possible to ground a large plate with a dabber, but it can be exasperating work trying to maintain a consistent layer over the entire surface. The dabber is much more useful for relaying small, confined areas.

Previously etched lines or deeply scraped areas need careful filling in with a wax ball, otherwise the roller tends to leave them partially exposed.

The actual roller is usually covered in leather, although various synthetic rubbers are also used. Under normal circumstances it would be pointless trying to make a roller; this is one item of equipment much better bought from a reputable dealer. Its leather casing or sleeve must be expertly fitted. No seam or stitching should protrude to disrupt the evenness of the ground. The outer case conceals an inner core of wood, wrapped in two layers of felt.

Once the heated plate is smeared with wax, the roller (which, like the dabber, should be absolutely clean) is run onto the waxed surface. The ground is then rolled out, as evenly as possible, over the whole surface or, with a large plate, in sections. This is continued until a slightly transparent, rich, dark, brown colour is obtained; if it is too thin and obviously very transparent, the acid will soon penetrate through to the metal. Slow, deliberate rolling will produce a thick ground; a quicker, lighter roll will leave a thinner coating.

A rather low heat is preferable to a fierce heat; a very hot ground will liquefy and bubble. It should not be too cold, however, or the wax will thicken and build up, especially round the edges of the plate and on the roller.

Whether a ground is applied by roller or dabber, the result should be the same; and, with practice, perfect grounds can be laid by either method.

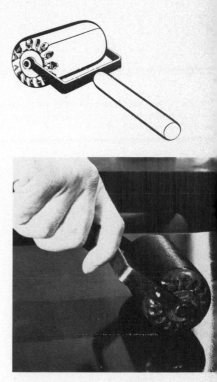

(*Top*) leather roller; (*above*) laying ground with a roller.

SMOKING THE GROUND

Solid hard grounds are sometimes smoked, primarily to make the surface darker, and therefore the drawn line more clearly visible. Smoking is also supposed to harden the wax further, but this, in itself, is not enough to justify this far from necessary operation.

Smoking is mostly done while the plate is hot, preferably (but not necessarily) immediately after grounding, so that the hot, shiny wax absorbs the carbon. A cold ground can be reheated on the hot-plate, but in any case, the heat from the taper will soften the wax and allow the smoke to penetrate.

The plate – unless really large – is held by a single hand-vice, clamped at a corner or in the middle of an edge; the surface being protected from the metal jaws of the vice by a fold of paper padding.

A few wax tapers, perhaps a dozen or so (a candle is a

Hand vice and plate.

rough substitute), tied or even twisted together are lit, and the very tip of the flame is moved steadily to and fro, or with circular movements, over the waxed surface of the plate, which is held upside down and just above eye-level. The flame should be kept constantly moving to prevent over-heating and scorching on any part. Neither the full flame nor the wick should actually touch the ground; if this does happen, the wax will certainly mark, and possibly blister, and the ground may well have to be completely relaid.

An excessive amount of soot – usually due to the ground being smoked when too cold – will smudge and wipe off. If this happens, then both heating and smoking must be repeated. A correctly smoked ground should be black and shiny; when cold, it may lose some of its shine, but is still black and hard, rather like dull enamel. Some etchers leave the smoked ground to set for at least twenty-four hours before working into it.

Any apparent defects in the ground, such as holes, can be retouched with a fine brush dipped in stopping-out varnish or a thick solution of turpentine and hard wax.

Hard ground does not have to be used solely as a flat, surface coating for line-etching. A lump of hard ground can, on a heated plate, be used directly as an actual drawing material. On really hot metal, ground can be moved over the surface with great facility and fluidity. A moderately hot surface allows time for the wax to be applied with some deliberation. The ground is quick to harden and the most spontaneous effects, provided they are clear and positive enough, can be bitten, often deeply, with complete accuracy.

A hard wax ground can also be worked into, and areas of it removed, with a brush or rag and a solvent such as turpentine substitute, paraffin or petrol. For example, a line made with a fine brush dipped in turpentine can be drawn freely onto the wax. For a very few seconds the turpentine is left to dis-solve the ground, which is then wiped away with a clean rag, leaving the line exposed.

This is obviously not a method for producing hard, wiry lines, or clearly defined edges, but there are times when it can be well used, for example in broad, rough, open-bite lines or tonal areas. In fact, all these 'wax drawing' methods can so easily be messy and indeterminate if the materials are handled clumsily and with indecision.

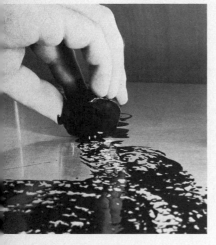

Drawing on a warm plate with hard wax.

TRACING

It is perhaps worth mentioning at this point, that unless one has a very clear, definite plan of work, requiring a precise out-line, there is absolutely no reason why a line-drawing cannot be made directly onto the ground with a needle-point. But if some form of tracing on the plate is thought to be necessary before penetrating into the wax, whichever is the most appropriate of the following methods can be used.

A very rough suggestion of the main areas can be made on the bare plate with a brush and stopping-out varnish, either as a fine, positive line or by painting round an 'exposed' line, although any form of direct drawing will of course, subsequently print in reverse.

A moderately soft pencil-drawing on paper can be transferred onto the grounded plate by running the plate, overlaid with the paper, through the printing-press. Rather less pressure than that normally used for printing is needed: removing one blanket will suffice. Pencil-drawings made on tracing-paper, which is then soaked, can also be transferred by this 'printing' method. Drawing through white, waxed or carbon paper is yet another method.

WORKING INTO THE GROUND

The most complex and varied line-etching can be made with one point or needle and one immersion in acid. Etching-needles can be bought, and are mostly inexpensive; but any tool or instrument that is practical to handle and draw with can be used to make marks or lines, provided it penetrates the wax ground, exposing, but not scoring into, the metal.

A traditional way to make a serviceable etching-point is to fix a thickish steel sewing- or darning-needle or even old (78 rpm) phonograph needle into a wooden holder, such as a pen or brush handle. The steel point can be firmly secured by melting sealing-wax over the end of the holder, leaving perhaps $\frac{3}{4}$ in. of point projecting.

An etching-needle should be light, and the point round and smooth, without any facets; a heavy, sharp point (see drypoint) will constantly scratch into the surface of the plate. If the point is too blunt, or if it is used with insufficient or inconsistent pressure, it will not fully draw through the wax and open up the line. It should be possible to move the point through the wax in any direction with the utmost freedom. The échoppe point – mostly employed by the early seventeenth- and eighteenth-century etchers, notably Callot – was deliberately bevelled so that a swelling line, similar to an engraved line, could be made. Generally, the needle is held in a rather upright position, or perpendicular to the plate; this helps to ensure that the line is clean and well defined. This applies especially to reopening previous or under-bitten lines for further biting. Strong pressure on the point is totally unnecessary.

In order to achieve certain effects, it may be necessary to make use of a variety of points, and many of these will obviously have to be improvised.

When drawing on the plate, the hand may be constantly moving back and forwards across the wax ground. Even on a hard, smoked ground, the hand is inclined to spread a trace of wax or grease into the lines already drawn, to some extent sealing them off from the acid. The slightest smear of

(*Top*) etching point or needle; (*above*) échoppe point.

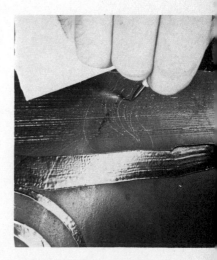

Drawing into a hard wax ground with a needle.

wax remaining in the drawn lines will delay the biting, possibly resulting in vague, broken lines; it may even resist the acid altogether. This can, to a varying degree, be successfully removed by washing the plate with acetic acid or vinegar and salt. Depending on the kind of drawing involved, the spread of wax can, within reason, be prevented by covering sections of completed work with a sheet of paper; this also serves to protect the ground from being worn or scratched. The metal surface should be clearly visible in all drawn lines; any ground remaining will show up as a pale, brown film. Further needling within these 'incomplete' lines is possible, but it can soon destroy the original directness of drawing.

Lines can be varied by drawing with one point only – grouping the lines closer together for the dark, and further apart for lighter areas – or with different thicknesses of point. Either way, the plate can be completely bitten with one immersion in the acid.

Lines can also be varied by biting in successive stages. This is done by selective stopping out, that is, by varnishing over those lines that are adequately bitten and leaving the remainder to bite progressively deeper, and therefore stronger and darker.

Yet another approach is to draw only the darkest lines first, bite these to a moderate depth, then remove the plate from the acid and draw the next darkest lines. This is repeated until all subsequent lines are drawn and bitten – the darkest (and therefore deepest) having remained exposed to the acid throughout. With this approach, it is obviously not necessary to rely on stopping-out varnish, except, perhaps, for 'touching up'. The main problem, as usual, occurs when estimating the timing of the linear and tonal variations.

A line-etching can, however, be made by using a combination of several of these, for example by using various thicknesses of points, or by biting in successive stages – the finer, lighter work being stopped out first and the heavier, darker work being left to bite longer on the same ground, or bitten separately on a new ground.

A wax ground will need to be extremely well laid to withstand constant redrawing and rebiting. It is often necessary to continue the work on a fresh ground. For instance, after the first etch, the wax and varnish are cleaned off, a ground is relaid and more drawing is added. The whole process is repeated, perhaps several times, building up areas and tones of overlapping lines. Previously bitten work can easily be seen through a correctly laid hard ground. Every time the plate is reground, this earlier work will need careful covering with the ground; lines are so easily left uncovered by the roller or dabber, and further, unintentional biting can completely alter the quality of a line. It is advisable to take proofs of each main stage in the plate's development.

At first, the bitten lines, especially when seen on the first proofs, are apt to appear disappointingly thin. A surprising

Stopping out bitten lines.

amount of drawing may be needed before any degree of density or richness is achieved.

STOPPING OUT

Before immersing a drawn plate into the acid, the back and edges must be fully protected.* The normal method is to apply one or more coats of liquid varnish. It is obviously not practical to use hard wax or even liquid ground on the back of a plate. Complete protection of the plate is vital, especially when biting for lengthy periods or in strong acid.

When etching in successive stages, biting progressively deeper, the varnish is used to paint over or stop out lines that are sufficiently etched. Mistakes, scratches, imperfections in the ground can all be stopped out before or between the stages of biting. If stopping out is necessary during the process of biting, the plate should be taken from the acid, washed in clean water and dried before varnishing. The varnish should also be allowed to dry before returning the plate to the bath.

A plate that has already been bitten may require two, even three, layers of varnish (each layer is thoroughly dried before the next is applied) prior to further etching. One layer of varnish is seldom enough to fill in the etched intaglio work and preserve the crucial, but rather vulnerable, sharp edges of the bitten lines.

The back of the plate can be varnished either before or after the drawing is completed; if done before drawing, scratches are bound to have accumulated by the time the plate is ready to be etched and the varnish will need touching up. A warm plate (e.g. immediately after a ground has been laid) helps the varnish to dry much more quickly; but re-heating a grounded and drawn plate for this purpose is too risky and should be avoided.

It is not advisable to lay the plate face down on a flat working surface when stopping out the back and edges; this can easily cause scratches and smudging on the waxed surface. Also, varnish, particularly in a very liquid form, generously applied, is apt to seep under the edge of the plate and onto the surface. It is preferable, when brushing on the varnish, to lean the plate at an angle (facing inwards) against some support. Even in this position, unless carefully applied and of a suitable consistency, varnish is inclined to trickle down the face of the plate.

Many of the ready-made 'black' varnishes are relatively slow-drying and, if used from an open jar or container, are inclined to thicken; in which case, unless they are further diluted with the appropriate solvent, they become very difficult to apply. Varnish should be thin enough to be painted on with a fine brush, filling in the finest lines, but not so thin that it cannot be properly prevented from spreading along the bitten lines. Usually, varnish is painted onto the

* Zinc already coated on one side with an acid resist, on the lines of the American micro-metal, is also available in the UK. Although this resist stands up well to light etches, when corroding into the metal for lengthy periods in strong acid, an additional coating of stopping-out varnish is necessary.

back of a plate with a fairly broad brush, e.g. 2 to 3 in.; but it can, when suitably thinned down, be sprayed on, even with an ordinary fixative spray.

There are several kinds of *stopping-out varnish*, more or less equally efficient and reliable, but with different characteristics. The two most commonly used are the transparent (rosin, alcohol, methylated spirit, etc.) and the black (asphaltum, bitumen, Brunswick black, and shellac, etc.).

Transparent varnish is extremely useful for stopping out parts of the drawing. It enables one to assess and compare the biting, which is visible at all stages; the work can then be developed and, if necessary, the biting continued still further. One problem with transparent varnish is that it is sometimes difficult to see where the varnish has or has not been applied.

A typical transparent varnish may consist simply of 1 part common or white rosin and 3 parts methylated spirit or alcohol. A small amount of methyl violet dye added to the mixture makes it more clearly visible on the plate surface. An alternative formula, used more by process etchers, consists of:

> 4 oz. shellac
> 8 oz. methylated spirit
> $\frac{1}{4}$ fl. oz. or 2 drachms methyl violet dye

Several versions of black, opaque stopping-out varnishes can be obtained from normal suppliers.

A useful varnish can be made by dissolving asphaltum powder in turpentine; asphaltum (1 part) dissolved in petrol (2 parts) dries more quickly. The asphaltum used is usually Syrian, Egyptian or gilsonite, or similar to that used in lithography.

A stronger version (recommended by Anthony Gross) can be made by adding 4 parts of Syrian bitumen to 1 part melted rosin. This highly inflammable mixture is stirred over a flame for about twenty minutes. When thoroughly mixed, it is allowed to cool; turpentine substitute can then be added to maintain its liquid state. It is best kept for a month before being used. Xylene can also be added at intervals to prevent it from becoming too thick. An amount of wax can also be added in case the varnish is too brittle when dried on the plate:

> 1 part wax
> 1 part rosin
> 3 parts commercial (less brittle) bitumen

Brunswick black (as sold in England by many paint or hardware stores) is a strong, reliable acid resist, slow to dry, but well worth using for lengthy and deep relief etching. It does not spread uncontrollably into the bitten work and is, therefore, especially useful on rosin-dust aquatint.

Shellac varnishes are frequently made up commercially and are also sold by many etching-suppliers as 'straw-hat'

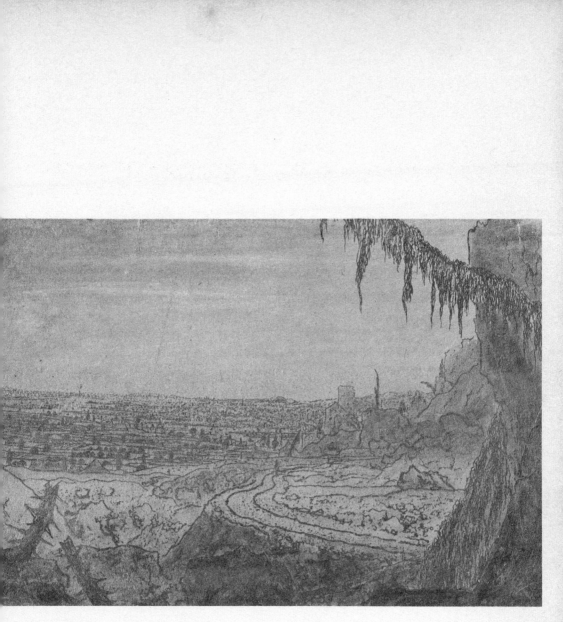

Colour etching: *Landscape* by Hercules Seghers. 5 in. × 7 in. *British Museum, London.*

varnish. They dry much more quickly than any other varnish and, on the whole, give reliable protection. Straw-hat varnish has a slight tendency to spread into the bitten areas of a plate, particularly where there is no wax ground, e.g. in open bite and aquatint (before and after biting). It can also be awkward to remove from the etched surface of an ungrounded plate.

Numerous trade-names exist apart from 'straw hat', but basically these varnishes consist largely of orange shellac dissolved in alcohol, with a black dye or pigment added. They are soluble in methylated spirit. The advantage of this is that the varnish can be removed in small areas from a plate, without also removing the wax ground underneath.

Varnish can be painted directly onto a clean metal surface, as a straightforward brush-drawing. But it must not be forgotten that when used in this way, the acid will obviously bite only the exposed metal, leaving the drawing untouched and raised, as a 'relief' etching. This will, as with all direct drawing, be reversed on print.

A varnished plate can also be employed as a kind of hard ground. Most varnishes that have dried on bare metal will flake and chip when needled, making a precise line-drawing virtually impossible. A deliberately splintered effect can be obtained, especially with 'straw hat', provided not too much of the varnish lifts off the plate. The thicker, more tacky varnishes (e.g. bitumen and Brunswick black) are less inclined to flake, but are generally too thick to allow the point to move through freely.

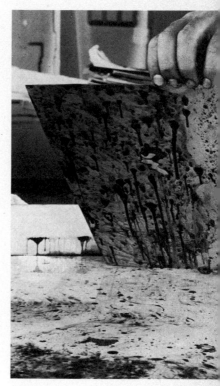

Marbling.

Any means of using varnish to achieve a certain effect is justified, if the effect can be 'fixed' on the plate; for instance, by transferring a wet, varnished, textured material onto the metal surface by firm pressure with a hard roller.

Elaborate 'marbling' effects are easily obtained by sprinkling a little varnish into a tray containing clean water, then gently and very briefly laying the plate, face down, onto the stained surface of the water. When the plate is removed, the water is drained off, leaving the varnish to dry. The plate is then bitten as usual, after stopping out the back.

A little size can be added to the water, before the varnish, to create a more responsive surface.

Colour aquatint: *Le Cirque de l'Etoile Filante: Master Arthur* by Georges Rouault. 12 in. × 8¼ in. *British Museum, London.*

3 Soft-ground etching

No matter how inventively the needle – or drypoint or burin – is used to suggest tone and texture by line and dot, etc., there are two other essentially etching processes that offer an infinitely greater range. These are aquatint and soft-ground etching. Although both are complete processes in themselves and can be used quite independently, they are much more frequently combined with line-etching. Soft-ground etching – unlike aquatint, which is a purely tonal process – can be employed equally well for texture and line.

A soft ground is a non-drying acid resist. It is simply hard wax ground (see p. 39) melted by heating and mixed with either grease (particularly axle-grease), tallow or vaseline. The proportion is usually 2 parts ground to 1 part grease, or approximately equal parts if tallow or vaseline is used. Most dealers sell excellent ready-make soft grounds, usually shaped and wrapped like the hard grounds. They may, therefore, look the same, but are easily distinguished by testing them with the thumb-nail; the soft wax has little, and the hard wax quite considerable, resistance.

The wax is applied to the moderately heated plate in the same way as hard ground; that is, by roller (leather or rubber) or dabber. (After applying a soft ground, the roller or dabber should be well cleaned before being used with hard wax. Separate tools are preferable.) The plate need not be spotlessly clean, since the ground itself is greasy. Once the surface of the plate is well covered with the melted wax, the plate should be removed from the heater, and the rolling completed as the plate becomes cold. On an overheated plate (a soft wax melts more quickly than hard) the roller will slide through, rather than roll over, the liquefied wax.

The ground should be thin, even and dark brown in colour. The wax, if too dark and thickly applied, will not, under any form of pressure, lift cleanly from the metal; biting will, at best, be irregular, and the printed impression patchy and poorly defined. A slightly more elaborate version of this involves waxing and rolling out one plate, then running the 'prepared', thinly coated roller onto a second, warmed plate. This should give a perfectly smooth ground for textured impressions. It may also help if the plate is warmed up a little after grounding; the slight melting will fill in any imperfections left by the roller. Smoking the ground is unnecessary.

Stopping out – corrections, partial blacking out of 'white' areas – is carried out as on a hard ground, except that even

greater care is needed when handling the plate, to avoid smudging the wax surface. Avoid also heating the drawn or textured and varnished plate when drying, otherwise the wax will run into the exposed lines.

The original (eighteenth-century) purpose of the soft-ground method was to imitate the appearance of a pencil- or crayon-drawing; in fact, to actually reproduce the drawing. The reproduction was often extremely accurate and utterly convincing. This crayon effect is obtained by covering a grounded plate with a sheet of paper and drawing onto it with a hard, but not sharp, point. Texture and density of lines or shading depends largely on the pressure of the point and the quality of the paper. The paper needs to be reasonably well grained and neither waxy nor too thick. Soft wax clings to the paper texture wherever the drawing has been impressed. When the paper with its offset wax ground is peeled off the plate, the drawing should be visible as exposed metal.

Before drawing onto a reversed tracing (pinned over the top edge of the plate), place a second thin sheet under the tracing; otherwise graphite may prevent the soft wax from lifting cleanly. The eventual printed line will be somewhat thickened by the double layer of paper.

When applied as an ordinary etching ground, soft wax can be drawn, scraped and opened up with a variety of improvised points. As a soft wax ground never really dries, it lacks the firm, consistent, clean surface of the hard ground, and is therefore hardly suitable for detailed, precise drawing. On the other hand, because of its greasy composition, it adheres extremely well to a metal surface, and can be freely and vigorously worked into without any risk of flaking. Also, since the drawing hand cannot be rested on the greasy surface without disturbing the wax or smearing the drawing, the lines tend to be more fluid and forceful than those normally made by the needle on hard wax.

The smooth, pointed needle, so essential on a hard ground, is probably the least appropriate tool for soft wax. Unless the lines are firmly and positively drawn, the comparative slipperiness of the ground is inclined to make the point – especially a wooden point – slide into, but not cleanly through, the wax. Consequently, the actual bitten area may appear disappointingly grey and intermittent.

If the drawing proves to be unsatisfactory, it is easily removed by reheating the plate and evening out the ground with the roller. For this reason, it is best, when drawing, to avoid scoring into the metal surface under the wax.

SOFT-GROUND IMPRESSIONS

In contemporary etching, soft ground has now become much more than a means of obtaining a certain quality of line. The two predominantly linear methods already

described are, on the whole, rarely used, even in conjunction with other processes. Most soft-ground work seems to be confined to etching impressions from textured surfaces. Even so, the earlier method, i.e. drawing through paper onto a waxed plate, is far from exhausted.

A textured surface can be manually pressed directly into a soft ground, leaving an impression on metal clean enough to etch. The most familiar mark is the thumb-print, often made inadvertently. But to ensure a really precise, over-all, positive impression from material which may range, for example, from the most delicate fabric to the crudest and most obviously patterned wire mesh, requires the heavy but controlled pressure of the printing-press.

The choice of materials would seem to be enormous. It is first, however, limited to those materials that can be laid over the grounded plate and taken smoothly through the press, without damaging the plate, or more important, the blankets; and second, the materials must be textured in such a way that when peeled off the plate, they will retain the corresponding amount of soft wax, leaving a clean, exposed impression on the metal. These limitations are all too often allowed to be unnecessarily restricting. An extremely soft material, such as wool, will tend to flatten out into the wax; it will be difficult to remove and the impression left, if any, is often hopelessly vague. From a textural point of view, nylon is an ideal substance, having a fine, yet strong, distinct thread, unaffected by pressure. But there are numerous other materials, both natural and artificial, neither too flabby or soft, nor too brittle or hard.

The method employed is not too dissimilar, in principle, to the original one of drawing through paper. A flattened, textured material, such as paper or cloth, with a distinct fibre or weave – however faint – is laid upon the waxed plate. Both are covered with a fairly stiff, waxed or coated paper, otherwise the wax not covered by texture would be offset onto the blanket. (A soft, thin paper, a tissue for example, is inadequate as a blanket protection, and can be difficult to remove in one piece from the soft wax.) The covered plate is taken through the printing-press, as if taking a proof. A middle blanket can be removed and the normal printing pressure should be somewhat reduced.

The covering paper is then removed and the material, with its clinging, offset wax, is peeled carefully off the ground. The metal should be clearly exposed where the pressure was greatest, i.e. under the actual texture. Although the rest of the ground should be intact, it will have been weakened; to prevent foul bite, it is safer to varnish all the untextured surface before etching. The ground must be completely dry before stop-out varnish is applied. (Transparent varnish may be used.)

Biting, as usual, can be done with one immersion or in stages; tonal variations are conditioned by the nature of the material, by the type of acid used and by controlled biting.

Strong nitric acid will concentrate on opening up the heavily marked areas, but will have only a mild effect on really fine work. A slow Dutch bath is more appropriate for precise biting of each subtle shade or detail (see Chapter 7).

After biting, a new ground can be laid and further textures added, either superimposed over the first texture, or on the unetched surface. A delicate imprint on a soft, thin ground can be badly scratched or smeared, even when 'feathering' in the acid; it can be destroyed by heavy-handed use of blotting-paper when drying off a rinsed plate.

The composition of a soft waxed ground can be varied according to the type of textured material used and the required printed effect. For instance, a thin, finely grained paper will need a much softer layer than a strand of fine wire. The same paper would be quite lost on a soft wax, too thickly applied.

S. W. Hayter has also employed a slightly warmed hard ground on which he has impressed materials such as silk to create a mainly tonal effect. This is certainly useful for a large consistent area of tone. The textured ground, when dried, can be freely handled and worked upon. When removing a material, especially a fragile one, from the ground, it may be necessary to release it by very gently heating the plate.

When delicate materials are placed well within the plate edge they may require tweezers to remove them without destroying the impression.

When this textural method is to be combined with other processes or techniques, for example line-etching or burin engraving, it is advisable to carry out any linear work first; in any case, soft-ground work is not usually successful on an etched surface. Bitten areas can be worked into with the needle (re-etching on hard ground), and to a much lesser extent drypoint or burin, although it is practically impossible to control the movement of a burin accurately through even a faintly irregular surface. Most textures print as transparent areas or screens, and any lines made earlier should be clearly visible.

It is essential when working with soft-ground textures to be ingenious, inventive and discriminating, both in the choice of materials and in their use. To rely always on the obvious and well-proven textures to create instant effects may be technically safe, but it will invariably result in an equally safe, predictable print. There are times when a quite commonplace material, tissue-paper for instance, is the most suitable; this is usually when the material is used to create tonal rather than textural areas.

In theory, it is possible to impress a particular material in order to create an area of both texture and tone, but in practice this seldom works out. Soft-ground impressions can, with care, be well used for tonal purposes, but in etching, it is unsurpassed as a means of creating varied textures.

It may prove difficult to achieve with soft ground a dark tonal area comparable with one made by aquatint; it may

not be as rich and dense but, if correctly etched, it will last longer. A textural impression etched into metal is actually made up of minute pits, scattered about the surface; aquatint is almost the reverse, being generally an area of corroded surface containing islands or points of unetched metal, and these are much more vulnerable to wear.

When peeled off the plate, a particularly strong, positively textured material can be re-used by transferring it onto a second, new plate. Both material and ground are covered with paper and taken through the press, as before. When the material is removed, the surface of the plate will still be clean, except for the offset, waxed impression of the material. This wax should resist the acid and the remainder of the plate can be etched down. There are a number of variations on this negative-positive method, re-using both texture and protective paper, but this is (as with relief writing) a subject where it is advisable to experiment and find one's own methods.

4 Aquatint

Of all the traditional etching processes, aquatint is the one most widely and extensively employed for creating areas of pure tone. The term 'aquatint' is commonly used to describe a specific method, i.e. dropping powdered rosin onto the surface of a plate, heating the plate until the layer of rosin is 'fixed', and biting, usually in tonal stages, aided by stopping out. Each grain of clear rosin on the plate acts as a minute point or 'island' of acid resist; the unprotected metal round each point will corrode down. Varnish and rosin are then removed with solvent. The area is revealed as a more or less congested mass of fine metal points, rising from a corroded, sunken surface.

Copperplate (intaglio) ink is worked well down into the textured ground and wiped evenly from the plate. The metal formerly covered by rosin will print as tiny white points; the bitten metal retains the ink and provides the dark background. Generally, the greater the amount of rosin applied to the plate, the paler or finer the print will be; and in reverse, less rosin protection will mean a darker or coarser print. In fact, when hardly any rosin is applied, the corroded area will virtually be rough open bite.

The original purpose of aquatint was to imitate the appearance of a wash-drawing, by adding transparent tints and passages of light and shade to a line-etching. It is still chiefly used in conjunction with other processes, especially line-etching, and in recent times, has been only very occasionally used by itself. Aquatint also includes a number of other methods of obtaining porous-type grounds.

It has been shown that a soft-ground texture can serve perfectly well as a tonal area; indeed, an impressed material such as tissue-paper may, for certain purposes, be the most appropriate method. Generally, however, a soft-ground texture is effective only on an unbitten surface. This could be seen as an irksome limitation, especially when working on a complex multi-process plate, but with careful planning, this need not necessarily be a problem. Also, a soft-ground texture will seldom print as a particularly rich, dense black on any surface, etched or unetched. The various technical factors involved in obtaining tones either by aquatint or a soft-ground texture may, or may not, be significant: the really crucial difference lies in the essential quality of the tone produced, the character of the surface and, most especially, the density of the black.

Aquatint is a porous ground through which acid penetrates, creating a pitted or granulated surface. A mezzotint ground is cut into a plate with a hard tool, and no acid is ever involved; tones are then scraped out of the black background. When examined closely, the etched and the rocked surfaces are quite dissimilar, on plate and print; but they are comparable in the sense that both can give a heavy, intense and uniform black.

Basically, aquatint is worked from light to dark, and mezzotint from dark to light, but both can also be worked either way. It is, however, much more practical to apply a dark tone to a small area of the plate with aquatint, and just as easy to scrape a paler tone out of a dark area – which is the normal mezzotint method.

As a technical process, aquatint is incomparably faster, easier and, above all, more flexible than mezzotint; it is a simple matter to modify aquatint tones by scraping, but the tones can, if necessary, be varied more evenly and quickly by the amount of rosin applied, by stopping out and by controlled biting.

Aquatint is also the most reliable method for introducing tone to an irregular corroded surface, such as a large open bite or wide crevé, but not to a mass of coarse, cross-hatched lines.

TECHNIQUE

The tonal quality of an aquatint depends on several controllable factors, but primarily on the application of the rosin to the plate. It is necessary to regulate the density and distribution of the rosin on the plate surface; this is normally done in a specially made aquatint box or it can be done manually, by using a silk, nylon or muslin-type bag. By alternating the size of the mesh or the layer of material making up the bag, the fall of rosin can be reasonably well controlled. The main advantage of the rosin bag over the aquatint box is that it is possible to vary, quite accurately, the fall of rosin onto the plate surface, thus obtaining a deliberately inconsistent or graduated tone. It is almost impossible to do this with the box, the whole purpose of which is to ensure the application of a completely uniform layer.

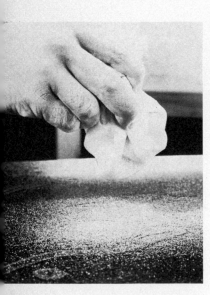

Laying rosin dust aquatint ground.

Rosin bags can be made from various materials, each with a different size of mesh, and temporarily secured with string. If the bags are kept well maintained (i.e. free of ink and oil, etc.), they can be refilled and used over and over again. The bag containing the crushed rosin is simply shaken, jolted or tapped over the (absolutely clean) plate area. Naturally, a draught-proof corner or screened-off cubicle is essential for this operation. A relatively even, uniform ground is made by constantly moving and directing the fall of dust over the plate, never concentrating on one section and allowing the dust to accumulate. A few trial runs may be necessary before a consistent layer is deposited. Dust is easily removed but

the plate surface should be thoroughly wiped with a clean rag before a new ground is attempted.

J. Brunsden (*The Technique of Etching and Engraving*) employs tins in preference to bags. The bottom of a tin can is cut out and is replaced by several layers of fine mesh, such as muslin or gauze, etc. Each layer is stretched in a different direction. Three or more tins or sieves can be used – a fine, medium and coarse, each gauge determined by the amount of gauze used. Tins are more easily labelled and may be more practical for communal studio use.

A thickly coated area of rosin will mean a white area on the print. A heavy application over the entire plate will simply defeat the purpose of aquatint. If the rosin is thinly applied and well dispersed, the result, when etched, will be open bite broken by a few unetched surface spots; these will very soon wear out. A strong, lasting, coarsely packed ground needs a coverage of at least 50 per cent rosin. For an even, close-grained surface – printing as a uniform grey or black – the correct coverage needs to be approximately 40 per cent.

As a general rule, where a complex, tonal plate is being worked, it is advisable to bite the more open, coarse tones first; fine, close grounds can be laid more effectively onto coarse ground, where plenty of surface metal remains.

A fine aquatint ground can also be made by using asphaltum powder (which is finer and also more adhesive) instead of rosin. Grains of different sizes, or small lumps of rosin, can be dropped onto the surface by separate applications, creating a deliberately mixed, blotchy effect.

Once the correct distribution of rosin dust has been established, the plate must never be jolted, otherwise the fine separate grains will form into clots. A layer of rosin can, however, be worked upon before heating, by drawing into, and rearranging it with a light, non-scratching tool. The eventual printed effect should be quite unlike that produced by either drawing with varnish on a grounded plate before biting or by a bitten ground that has been worked into with the scraper.

The *aquatint dust box* contains an amount of rosin dust which is activated by various methods, but mainly by controlled draughts, such as the action of bellows or an integral, revolving shutter. The rosin is applied to the plate first by vigorously disturbing the dust and, after a momentary pause – depending on the kind of ground required – by inserting the plate face up into the box. The surface is soon covered with the falling dust. When sufficient dust has fallen and settled (this should take no more than a minute or two) the plate is removed and the dust reactivated. The sequence is then repeated, perhaps two or three times, until the plate is well covered with fine dust. The greatest care must be taken at all times to avoid knocking or jarring the plate when handling it.

By using a dust or rosin box, a fine and absolutely uniform ground, printing as consistent tone and, if necessary, a perfect

black, can be obtained. The most crucial factor is the timing. Exact timing, particularly with regard to the number and length of times the plate is exposed to the fall of rosin dust, depends entirely on personal experience, gained as each new plate is tackled. Or it can be gained, perhaps more painlessly, by conscious, carefully observed experiments on old plates.

Aquatint boxes vary considerably in size and complexity from simple wooden boxes and improvised packing-cases, to the most elaborate cabinets, complete with electric motor. The inside dimensions of the aquatint box clearly determine the maximum size of the plate.

Probably the simplest form of improvised box is the hat-box type. A large hat-box containing rosin is shaken, the lid opened and the plate laid inside (preferably on a small support to facilitate easy removal of the plate). When finely coated, the plate is taken out and the process, if necessary, is repeated. It is a primitive enough method but, with practice, quite acceptable grounds (often of greater uniformity than those made by rosin bags) can be achieved.

An improved version of this (but still necessarily limited in size and weight) can be made of light wood and completely enclosed, except for a sliding plate tray or grid, made of wire mesh fitted above the dust tray. A quantity of rosin is placed in the dust tray and the whole box is thoroughly shaken. (Such a box can also be fixed on a pivot and turned rapidly.) The box is placed firmly down and the dust allowed to fall. After a moment or two, when the coarse grains have fallen, the plate is placed inside onto the wire tray. All this may be repeated until the plate is completely and evenly covered.

The *bellows-type box*, not being hand-shaken, is normally much larger (4 to 5 ft. high). It consists of an enclosed, upright box, with a sliding grid, accessible through a trap-door placed in the lower half of the box. The interior can be zinc-lined. Dust is kept on the bottom or in a sunken trough. A hole just above the dust layer enables a pair of bellows (or foot-pump) to be inserted. With a little ingenuity, this type of box can be adapted to work off a small motor, such as that fitted in domestic vacuum-cleaners, made for blowing as well as drawing in air.

The *fan-type box* is now perhaps the most commonly used large box; formerly it was the bellows type, although both still seem to be in general use. As a rule, this is a relatively large, solidly built, enclosed box, standing upright, often 6 ft. high. Powdered rosin is activated by draughts caused by a revolving fan turned by a handle projecting outside the box. The fan can also serve as a plate tray, otherwise a wire grid is fitted. The plate is inserted through a narrow trap-door placed across the box. Rosin dust is placed in the lower part of the box, which is often a semicircular tin or zinc container – even part of a steel drum – shaped to hold a quantity of dust and to accommodate the full turning circle of the shutter. The fan is turned rapidly a number of times until the

Rosin dust aquatint box, 'bellows' type.

rosin dust rises to the top of the box. If a wire tray is not fitted, the fan can usually be locked in a horizontal position to support the plate. The coarse, heavier grains tend to fall to the bottom first; therefore, if a fine ground is needed, it is again necessary to wait a moment before inserting the plate (for perhaps two to five minutes, depending on the rosin used). If a fine, but densely covered aquatint is required, the operation is repeated, perhaps two, three or even four times. A single exposure to the dust fall may be sufficient for a fine but open ground.

The rosin layer is then fused onto the plate by heating. Heat is applied only to the underside of the plate. This is normally done by holding the plate with a hand-vice and moving it slowly round over a moderately hot gas-ring (an electric hot-plate is sometimes used, or even a bunsen-burner). Alternatively, the plate can be placed on a wire-mesh tray (essential with a large plate), and heated by moving the gas-ring around under the plate. Whichever method is used, it is vital that all movements should be steady and unhurried.

The heat is applied evenly over the entire surface of the plate and never held for too long in any one spot or too close to the plate. At a certain temperature the white rosin powder will suddenly turn yellow; it has then melted and is stuck to the metal. When all the rosin has yellowed and fused, the heat should be removed or the rosin will liquefy, forming a more or less unbroken, yet unreliable coating. Excessive heat will simply scorch the rosin, rendering it unsatisfactory as tonal aquatint. Rosin that is not sufficiently heated (and can still be seen as white powder) is equally useless, since it will soon wash or flake off in the acid bath. As the plate cools, each particle of rosin will solidify again, rather like tiny drops of clear gum arabic, and when completely cold is quite firm and stable upon the plate. Areas can, if necessary, be painted out with stop-out varnish or liquid hard ground.

When aquatint is to be used on a plate with other etching processes, such as line, open bite or engraving, the aquatint tones (being nearly always the most vulnerable surfaces) are generally added last. Stopping out, which is necessary if the tones are to be varied, will then be quite straightforward. Most previous work will serve, if not as a precise outline, then at least as a rough guide, for the stopping-out varnish.

Where there is no previous work, if for instance the entire plate is to be completed by aquatint alone, then stopping out will be much more complicated. In this case, a fine soft-ground line can be used as an outline and need not detract from the over-all tonal quality. A line made through a soft ground may well be more applicable to aquatint than a line drawn through hard ground and etched, or a line cut with a burin. A drawing may be lightly traced onto a hardened rosin ground by drawing through a chalk-coated paper. Alternatively, a fairly detailed plan or 'rough', indicating the position and quality of the different tones, can be used.

Rosin dust aquatint box, 'fan' type.

It is safer to apply a relatively small amount of stop-out varnish to an area, especially near the edges, rather than flooding it on the plate; at the same time the ground must be well covered, even if this means building up a really thick protective coating of varnish.

Stopping out is sometimes completed before the rosin ground is applied. This is because varnish, when generously brushed onto a rosin ground, is inclined to spread between the globules of rosin, making it difficult to control a drawn line or precise edge. To combat this, the consistency of the varnish can be slightly thickened (many varnishes will thicken anyway, if left uncovered for a few days), but it will be less manageable. A varnish which is already mixed with turpentine is less inclined to run on hard rosin than one mixed with methylated spirit, such as 'straw-hat' varnish. Rosin ground is actually removed with methylated spirit; so if 'straw-hat' varnish is also used, the work of cleaning the plate will obviously be made easier.

Brunswick black (which is already mixed with turpentine) is a strong, reliable acid resist, which will spread rather less than a thickened version of the normal quick-drying, stopping-out varnish.

Vigorous and positive marks can, however, be drawn freely and directly onto a ground with brush and varnish, but they may have to be carefully retouched and built up with thick varnish before biting. On the other hand, broken and textured effects are easily made by deliberate and incomplete stopping out with a dry brush, litho crayon or etching ground. Before biting, the back and edges are thoroughly coated with varnish. If the plate is taken from the acid, stopped out and rebitten, the back and edges should be checked and, if necessary, touched up with varnish.

ALTERNATIVE AQUATINT GROUNDS

There are also several other methods of making aquatint-type grounds. Generally, these grounds relate visually, rather than technically, to the more usual powdered rosin type, but they are, none the less, aquatint methods. These grounds are stopped out and bitten, more or less, as with a rosin aquatint ground.

Liquid ground is also known as 'spirit' ground and consists of rosin dissolved in alcohol. The mixture is poured over the surface of a plate, and the alcohol evaporates, leaving the granulated rosin on the surface, but with an extremely even, regular distribution. It is largely the amount of rosin used that determines the tonal quality of the ground. The usual recipe (as used in the nineteenth century) is 5 oz. of rosin dissolved in 1 pint of spirit of wine (or alcohol). Once the rosin has absolutely dissolved, and the residue has settled (twenty-four hours later) one-third of the liquid is mixed with two-thirds of the fresh spirit; otherwise the first mixture is too strong. If this proves to be too coarse, then

one part of the original mixture to three parts of the spirit should give a finer ground. Peterdi suggests dammar crystals, and Hayter asphaltum, as a possible alternative to rosin. Before biting the aquatint, previously bitten work can be prevented from further biting by filling in lines, etc. with copperplate printing-ink, applied at least twenty-four hours earlier than the liquid ground.

Sand-grain aquatint is a crude, but quick and effective means of achieving a porous, substitute aquatint ground. The plate is given a coating of ordinary hard ground, similar in consistency to that used for line-etching. A sheet of fine sandpaper is laid face down upon the plate and both are taken through the press, although under somewhat reduced pressure. The sandpaper remains on the plate but is moved very slightly, and again passed through the press. This is repeated several times, constantly and fractionally moving the sandpaper.

In principle, sand-grain aquatint is the opposite of the rosin-ground method, since it is the over-all mass of minute perforations in the hard wax that allows the acid to penetrate through to the metal. The tonal and textural character of the ground depends on the various sizes of sandpaper used, and on the number of movements and printings. To some extent the hard grains are inclined to blur the plate surface a little, and often the effect obtained will lack the more positive definition of a fine rosin aquatint. The sand-grain aquatint has one important advantage over the conventional rosin aquatint; it has a much tougher surface and can generally withstand more printing before wearing out.

In the *salt method*, ordinary salt is sprinkled onto a thin, warm, hard ground. The grains of salt sink through the almost fluid wax coating onto the plate surface. When the ground has cooled and hardened, the grains are dissolved in lukewarm water, leaving a porous, hard ground.

Sulphur tones. This is also an early method used for obtaining extremely fine, delicate tones or tints on copperplates. There are several versions, but the simplest is to leave a paste of olive oil mixed with flowers of sulphur on the surface of the plate for several hours. It should be possible to apply the paste to a precise area with a brush. Heating the paste-covered plate in hot water may hasten the corrosive action.

A useful substitute for a rosin-type aquatint ground can also be applied to a plate by a variety of *spraying methods*. Some years ago, this method would probably have been limited to the fixative-type spray, but many kinds of spraying equipment can now be considered; for instance, mechanical paint-spray attachments are available for domestic vacuum-cleaners.

Acid resists need no longer be limited to the traditional stopping-out varnish or asphaltum liquids. Various forms of enamels and lacquers are now sold in spray-cans. Liquid rosins and plastic-based paints can also be tried out; it is doubtful whether these can be applied by spraying.

LIFT GROUND OR SUGAR AQUATINT

With lift-ground etching it is possible to paint shapes directly onto a clean plate and process the plate in such a way that an exact intaglio impression of the shapes appear on the print (except for the inevitable mirror image). If tone, such as rosin aquatint, is then added to the shapes during the process, the drawn shape will print as a complete positive. The real significance of this method is that it enables a positive, free brush-drawing to be made actually on the plate, and to be carried through to an equally positive impression on the print. Lift-etching is most frequently used with rosin aquatint.

Although there are innumerable variations on the basic etching processes so far described, practically all involve drawing in positive and printing in negative and vice versa. Nowhere has it been possible both to draw and print in positive; for instance, a line drawn through a hard ground is a white line on a dark background and will print black; a black shape drawn with varnish is positive on a clean plate (or on a rosin ground), but is negative on print. When working out an idea on paper or plate, this negative-positive factor may have to be considered, but will not usually be a major technical obstacle. If, however, the idea necessitates making a positive print based, for example, on a natural, freely made pen- or brush-drawing, as with black indian ink on white paper, then a drawing substance other than stopping-out varnish is needed – one which will serve as an ink, and yet will be impermanent, non-drying and porous. In other words, lift ground is a method that permits the actual brushstroke to be bitten into the plate, hold ink and print black; a method where the actual drawing ink can, at some stage, be peeled or washed off the plate surface, leaving the exposed metal free to bite.

The simplest lift recipe consists of half sugar and half indian ink – hence the name 'sugar lift'. The drawn plate is thinly coated with acid resist, e.g. varnish or hard ground (and the back stopped out). As soon as the varnish is dry the plate is immersed in warm water. The varnish or ground will hold firm, except where it covers the sugar-lift drawing; gradually, the porous, water-soluble sugar and ink mixture will dissolve and lift, exposing the plate. The lifting can be encouraged by gently washing the area with cotton-wool.

A brushstroke is – at least for technical purposes – neither pure tone, nor pure line, but has the characteristics of both. An exposed brushstroke on the plate will bite, in part, like an open area; it will wipe more or less clear and print mostly as a negative. But when tone is added, it becomes an entirely positive brushstroke. Both aquatint and soft-ground textures can be applied. In its original (nineteenth-century) form it was, in effect, a means of imitating the fluid line of a pen-drawing, and was known as the 'pen method'.

The most spontaneous pen- or brush-drawing can be made directly with stop-out varnish on a clean metal surface, and the remainder of the plate etched down. The brush-marks will be clearly visible on an intaglio print, as they were drawn, except that they will print reverse, or mirror image, and in negative, that is, white on a black field. An obvious way to reverse this negative image is to treat the plate as a relief etching and roll onto the raised drawn surface with printing-ink. The printed effect would then be positive and clear, but flat and unvaried, with little of the essential quality of a brush-drawing. Another method is to paint carefully around shapes, as on aquatint ground, thus controlling the positive printed effect. Again, comparing sugar lift with aquatint, the resulting shapes, though positive, will tend to look contrived.

Sugar aquatint need not be limited solely to reproducing brush-drawings, but this kind of drawn mark would seem to exploit the method to its best advantage. Fine, deeply etched brush or pen work would obviously not require further tone.

The simplest sugar-lift mixture and one which seems to be as effective as any, is made of 50 per cent saturated sugar with 50 per cent indian ink added. Other mixtures include: 50 per cent tempera or poster paint and 50 per cent gum arabic; and a mixture, attributed to Lumsden, which consists of gamboge water-colour paint, with sugar added – a little black gouache can be included to make a darker pigment, and only the minimum of water is really necessary. Sugar is the main lifting agent, but gum arabic or gamboge are sometimes added to supplement the sugar and help the mixture to stick to the plate when applied by brush. S. W. Hayter (*New Ways of Gravure*) lists two rather more involved mixtures; these consist of ink and sugar, with traces of gum arabic and soap, or gamboge, gum and soap, with a trace of glycerine. The soap is included because it evidently prevents the mixtures from bubbling on the plate and also encourages the ground to lift.

The most common problem when drawing is to get the solution to take, especially on a highly polished surface. It is often impossible to make any kind of controlled mark; the solution refuses to stay put and runs into globules. A brief immersion in a weak acid bath will dull the surface, or it can be washed clean with a diluted sugar solution so as to give a slightly more adhesive working surface. Before any varnish is applied, the drawing must be adequately dried. This can be done more quickly if the plate is gently heated (excessive heat would simply blister the lift ground).

The drawing is then covered with a coat of acid resist, such as liquid hard ground, stopping-out or asphaltum varnish diluted in turpentine, transparent stopping-out varnish – if very thinly applied – or rosin dissolved in methylated spirit or alcohol. It is normal practice, and certainly safer, to use the sugar lift thickly and cover it with

the thinnest coat of ground or varnish. Liquid ground can be poured onto the plate; varnish should be brushed over the drawing, quickly and lightly, in order not to disturb and weaken the lift ground.

Again the plate is thoroughly dried. It is then placed in a dish or tray of warm water (the sooner the plate is immersed the better, otherwise the varnish can become too hard for the sugar lift to break through). Acetic acid or vinegar can be added to the water or even used instead. Immersing directly into acid is not recommended. Gradually, the porous lift substance should swell under the layer of varnish; both should then detach themselves from the metal and finally float off the plate, leaving the exposed drawing free for biting. If the ground fails to lift by itself, it can be loosened and rubbed gently with the finger or a stick wrapped in cotton-wool.

The aquatint process is carried out as described in the previous section. More often than not, sugar aquatint is used by itself, or, if it is combined with other techniques, it is the dominant one.

The sugar aquatint will probably be subjected to considerable wear, therefore the actual aquatint must have a particularly fine, close texture, and needs to be well heated and evenly and adequately etched. The aquatint ground is sometimes laid on the plate before the drawing is made, chiefly because the application of heat to the plate – essential when fusing the rosin dust – can weaken the varnish, resulting in foul bite, or can cause hard ground to spread, destroying fine work. And also, it means using the lift ground on a textured instead of a smooth surface.

Soft-ground textures may also be impressed into the soft wax laid over the exposed drawing, provided the varnish is hard and strong enough.

Etching: detail of *Yorkshire Landscape* by Richard Fozard, 1959. Multi-plate etching – intaglio, surface and stencil. $14\frac{1}{2}$ in. × 12 in.

5 Open bite, deep etch and relief etching

OPEN BITE

The terms 'open bite' and 'deep etch' are largely self-explanatory. Open bite is simply exposed surface that has been lightly etched, either to create pale, delicate tones, areas or shapes, rather like transparent washes, or deliberately to soften (and partially etch out) existing lines, edges or textures.

In the context of line-etching, wide, shallow lines or spaces at the junction of lines will tend not to hold much ink and should therefore wipe reasonably clean. This may give an unwanted crevé effect; or it may be done intentionally, in order to create a particular kind of open, clean line, or a number of overlapping lines, bitten in successive stages.

Ink will always collect where the levels of metal abruptly and precisely change, however slightly, and it will appear on the print as a darkish, graduated rim or contour. With an open line or area, this is not nearly as obvious or dramatic as a much more deeply etched plate.

The bitten surface is naturally somewhat rougher than the polished, unetched metal, even when it has been carefully 'feathered' in the acid. This roughness can be retained (more easily on steel), and will hold a film of ink for some time, but not indefinitely. It can even be made coarser and more lasting by encouraging bubbles to form in the ink, resulting in the familiar granulated texture. On the other hand, the corroded metal can also be burnished and polished to give a finish similar to the raised surface.

Traces of previous work, however finely etched, will still be visible, no matter how deep the open bite, but, unless deliberately treated (e.g. the raised-line effect, p. 101), they will be extremely vague, and are not unlike eroded, worn inscriptions in stone.

DEEP ETCH

Deep etch is, in a sense, a deep open bite, although, as a rule, the bitten areas are generally more definite and condensed. It is the abrupt wall of metal, enclosing the corroded area, that characterizes the really deep etch; and it is this wall or edge that holds the main body of ink, enriching both plate and print surface. The deeper the bite, the stronger and

(*Opposite*)

Etching: detail of a single zinc plate etching by Anthony Broomfield, 1968. Intaglio and surface relief (marbling), two colours. $26\frac{1}{2}$ in. × 17 in.

darker each embossed perimeter of collected ink will be on the print.

The term 'deep etch' is, of course, relative to the thickness of metal plate and even with 16-gauge zinc, only a fraction of an inch separates deep from shallow. It is pointless, for example, to etch a moderately fine line excessively deep; apart from the inconvenience of the ink-laden undercut, the actual printed line would be no darker or heavier. It would be quite enough, however, to make a noticeable difference to the character of an open-area plate and its printed impression.

A deep etch can be made with a single, lengthy immersion in acid. This will result in each bitten shape having one very definite boundary. The plate can also be deeply etched in successive stages, the metal etched progressively deeper, almost in shelves. This is easily done by increasing the coverage of stopping-out varnish at regular intervals and consequently reducing and, at the same time, deepening the bare metal. Metal exposed the longest to acid will, therefore, be the deepest and when the full thickness of plate is being used, the acid may penetrate almost through the plate. Either way, whether in single or graduated bites, the printed effect is unique to intaglio printing. The ink, when wiped from the flat layer or layers of the bitten cavity, will build up against the surrounding walls of metal; the print will show the variations, from the palest film of ink to the richest dark.

A deeply etched plate can be printed in relief, intaglio or both together. It is the intaglio method that makes the most of the actual depth, and even greater illusion of depth, and the range of tone and colour.

If the plate is unintentionally bitten through, the perforation, when printed, will be glaringly white and depending on the thickness of the metal, heavily embossed; this rather startling effect can be disastrous on certain work. The plate can, of course, be deliberately perforated as part of the design. But before printing, the corroded edge will require gentle filing. Heavy gauge zinc is, on the whole, the most appropriate metal for deep etch.

When preparing the plate for deep etch, drawing the positive shapes directly onto the bare metal surface with stopping-out varnish would seem, for most purposes, to be the best method. Scraping out an area through a wax ground rarely produced a clean, even surface. Any scratch will influence the biting, particularly when using hydrochloric acid, which often seems to seek out and concentrate on scratched, flawed or even bitten metal. This more uneven effect can also be deliberately employed. Drawing through the wax ground with turpentine is one possible way to avoid scratching the surface.

Other drawing substances permanent enough to resist acid during a long biting include the following: both hard and soft wax, used directly onto moderately hot metal (soft wax giving a smoother coverage), or liquefied with solvent

and applied by brush; soft lithographic chalk for line-drawing and stick ink (tusche), also liquefied with turpentine and brushed on, for heavier, more fluid lines. Strongly (rather than obviously) marked textured surfaces from all kinds of materials can be transferred onto the plate using a hard roller, thinly coated with stopping-out varnish, or even letterpress black printing-ink.

Buckland-Wright describes a method (referred to as Lambourne's) of offsetting a thickly inked print from a wood or similar texture onto a plate made more receptive by being roughened with a fine steel-wool. Because of the problems involved in deep etching a transferred drawing or intricate texture for relief printing, the 'keying' method was mainly used when biting thin zinc plates with pure hydrochloric acid, and then only for rather limited editions. Letterpress or black printing-ink will not normally stand up to acid for long; occasionally suitable work can be retouched with stopping-out varnish and a fine brush.

With care, and provided it is of a workable consistency, varnish can be rolled onto a reasonably complex surface for transferring onto clean metal. There are many variations on the application of varnish to a plate. A more obvious example is to run a dry roller over a textured fabric or even thick, broken or creased paper, smeared with varnish and laid over the plate. Another is to spray the varnish on, giving a textured aquatint effect. Any method of applying varnish, directly or indirectly, is justified, provided the image on the metal will resist the acid and give a clean, positive print.

To deep-etched simple shapes, a strong – but not violently strong – solution of acid is needed. 2 parts water to 1 part nitric acid is about the safe maximum strength for a varnished copperplate, and 4 parts water to 1 part nitric acid for zinc. Stronger acid, when heated up during the biting, could cause the varnish to lift or blister, especially if the varnish has not been completely dried. The main disadvantage with nitric is the familiar undercutting and the surface bubbles; to counteract this, and minimize the damage, a bite of several hours would require almost continuous surveillance.

A more broken, textured or linear drawing may require an even lengthier immersion in a Dutch mordant bath. Full-strength ferric chloride is a safe, slow solution, but is sometimes inclined to leave the corroded surface curiously marked (which is also visible on the print).

When stopping out the plate, prior to a lengthy immersion in strong acid, it is advisable to use several layers of varnish, each layer thoroughly dried before the next is applied. The plate must be absolutely clean before stopping out. Stopping-out varnish can be applied more accurately, and will dry and adhere more firmly on warm rather than cold or damp metal.

Brunswick black, though slow-drying, is usually a safe, strong acid resist. A tough (but not quick-drying) form of liquid hard ground is an alternative protection worth

experimenting with. A small amount (25 per cent) of bees-wax added to asphaltum varnish may increase its durability.

RELIEF ETCHING

When an image is drawn directly onto the plate with, for example, varnish, and the clean, unprotected background surface is etched down, the drawn image is left in raised relief. Technically, the etching process may be exactly the same as a deep etch, but visually the emphasis is on the more positive relief; the corroded metal has become the negative area.

With relief etching, the sunken portion of the plate can be left uninked, and the ink applied only to the raised surface, usually with a roller. On the print, the intaglio portions will show, more or less, as embossed white shapes; the positive surface relief will print as a flat, hard-edged black.

Not all relief plates require deep etching. With certain plates, it may be necessary to bite fairly shallow, to ensure that the roller deposits ink into parts of the intaglio as well as on the surface area. Normally, where a straightforward black and white relief print is intended, the biting need only be moderately deep.

Useful experiments can be made with old intaglio plates, by rolling black ink (or coloured ink, although a clean black and white proof will give the maximum contrast) evenly over the raised surface. A surface print, taken from a conventional intaglio plate, will then show the more familiar black drawing in reverse, as a white drawing on a black background.

Relief etching: detail, by Georges Levantis. 25 in. × 19¾ in.

There are many interesting printing variations on this negative-positive reversal theme; several of these are, technically, surprisingly simple, and visually extremely effective.

It is possible to make a free brush–drawing and transfer it exactly onto metal for relief etching, in such a way that the eventual printed image will be identical to the drawn image and not, as usual, in reverse. The real significance of this is perhaps most dramatically illustrated when transferring writing rather than drawing.

There appears to be several versions of how this is done, but the most successful seems to be the method or formula worked out by S. W. Hayter, and generally accepted as the equivalent of Blake's original relief-printing method.

A sheet of thin but strong paper is coated with a mixture of equal amounts of gum arabic and soap. The drawing (or writing) is made on the paper with a solution of asphaltum and rosin diluted with petrol. (Hayter used benzene.) The paper is then placed face down on a clean, well-heated plate and both are taken through the press, as if printing. It may be necessary to reduce printing pressure by removing one blanket: The back of the paper, while still on the plate, is thoroughly soaked with water; it is then peeled off, leaving the asphaltum drawing on the metal, but in reverse. Before etching the plate, the drawing can, if necessary, be retouched with stopping-out varnish.

The copperplate is bitten in strong nitric (2 parts water to 1 part nitric acid) for approximately nine hours. Dutch mordant can be used (especially on copper) for a more delicate drawing and where a relatively small amount of metal is to be bitten (see Chapter 7).

It is probable that much careful experiment will be needed, especially with the consistency of the asphaltum, before a perfect transfer is achieved.

READY-MADE AND WELDED SURFACES

Relief prints can be taken from many kinds of surface other than etched metal, the most obvious being the wood-block. There need be no confusion over the difference between a metal, wood or lino 'surface' print; the essential qualities of each, quite apart from the method of printing, are, in most cases, completely different. On the other hand, it is always possible to find (and easy enough to make) a print in which the effect obtained and the actual materials and techniques used are virtually impossible to detect. Indeed, a more anonymous surface effect may be deliberately sought in preference to others that are more recognizable.

Ready-made surfaces provide an interesting field of mark and texture for direct printing. The material needs to be no thicker than 16 gauge at any point, without any sharp protuberances or edges likely to cut into the blanket or tear

the paper, although to some extent this can be safeguarded against by reducing the printing pressure.

Other well-tried sources include the collage-type plate, not necessarily etched at all, but made of thin sheets of various metals bonded together, sometimes ornamented with wire or flat fragments of machinery and industrial waste. These plates are sometimes referred to as 'metal graphics'. Of particular interest in this field is the work of Rolf Nesch.

The following items are typical of the kind of additional equipment and tools that could now be considered essential, especially in a communal workshop or etching studio: power-drill, with attachments for polishing; various saws, including hacksaws, jigsaws and fretsaws, with metal-cutting blades; files, such as 'abrafiles', for cutting and filing shapes out of plates.

Material for repairing or building up entire plate surfaces – which can either be printed in relief or worked into intaglio – such as various forms of plastic metals, synthetic or liquid plastics, epoxy and acrylics (e.g. Cellocut, developed by Boris Margo) may also be necessary.

Plates can also be made by building up or joining shaped sections of sheet steel with fine welding. This approach, and that of the metal graphics is the reverse of the more usual intaglio method of hollowing out or incising a plate. Once again, there is a very definite limit to the maximum thickness of the final plate and, equally important, the variation in the depth. Only thick, strong, but reasonably soft paper will stand the strain of being both tightly stretched over and pushed down between the raised welded spots and seams. Etching, engraving and punching the metal can also be used as supplementary methods.

Welded-steel plates are inclined to curl up rather when subjected to even moderate printing pressure. Unless the greatest care is taken, and even when using reduced pressure and fewer blankets on the press than usual, the risk of forcing a fine welded mark through the paper and, even more important, through the blanket, is considerable. But some extremely successful prints have been made by this method and without causing any damage to press or blankets. There are several technical problems, and cautious experiment is essential.

The printed impression is quite unlike any other type of mark or effect, being generally more crudely embossed, mottled and undulating. Although much of the welded plate is actually in relief, it is the intaglio print (as with most deep etch) that brings out the essential quality. A slight all-over relief print (applying ink to the surface by roller) would, in any case, be technically very difficult, perhaps even impossible; visually it could be interesting, but would tend to underplay the particular welded character.

Although there can never be a 'correct' sequence of processes, especially with a complex, combined process plate, there are times when it is practical to work out before-

hand some kind of order. This is especially advisable, for instance, when processes such as soft-ground and burin engraving are to be incorporated in an etching. Both these techniques require a relatively unmarked, flat surface and are, to a lesser or greater extent, inappropriate on an open-bite surface. Aquatint can, in many cases, be applied later, although even this tends to be less successful on bitten metal.

Generally speaking, each individual plate and print should be considered separately and any processes likely to be involved, worked out accordingly. It is a matter of common sense and technical experience.

Relief etching: *Moth's Head*, detail of print taken from welded steel plate, by Gordon Senior, 1963. 22½ in. × 16 in.

6 Photo-etching

An increasingly important feature of the ceontemporary print common to most, though not all, of the autographic processes has been the widespread and liberal use of photographic images. During the past few years, the limited-edition photo-litho and the photo-screen print has been developed to an extremely high technical level, for instance in England and the USA, notably by Eduardo Paolozzi, the printer Christopher Prater of the Kelpra Press, and the Curwen Press and Editions Alecto.

Curiously, photogravure – the reproductive application of photography – has had little influence on creative etching. It is conceivable that the use of the photo-etched image (photography has long been considered by many to invalidate the original purpose of the exactly reproducible and illustrative print, not least etching and engraving) will now replace the emphasis on the decorative colour etching.

In spite, or perhaps because, of the fact that photography has been used with etching in various ways for commercial printing methods since the late nineteenth century, it has still to be fully exploited by the intaglio-printmaker. There are several possible reasons for this, among them the supposed (perhaps more than the actual) amount of time, facilities and technical complexities involved. Formerly, the traditional etcher's high regard for draughtsmanship and the straightforward and economic techniques of Rembrandt, Piranesi and Goya may have led to this neglect. More recently, it may be due to the enormous success of the photo-screen print with its liberal use of bold colour and profusion of ready-made familiar imagery. This is a form of printing that related extremely well to styles of painting typical of the sixties and also, to some extent, to graphic design.

On the other hand, the much older process of etching is still associated with a traditional emphasis on a sketchy form of line-drawing, or with a certain introspective, morbid approach (still prevalent in much central European etching). It is still thought of by many as essentially a small-scale, black and white medium, in spite of the developments in intaglio colour printing. It is still considered to be an involved and mysterious process, where every line or image has to be fought for. Some even feel that a worn and pitted surface or texture is alien to the clean edge and unmarked expanses of much familiar contemporary painting.

Such commercial processes as line block, half-tone and photogravure can all be applied in principle. But unless the printmaker is an accomplished photographer and printer,

(*Opposite*)
Intaglio etching employing photo-etching: *The Dream* by Dennis M. Rowan, 1970. 24 in. × 36 in.

Intaglio etching employing photo-
etching: *Judy* by Dennis M. Rowan,
1970. 24 in. × 36 in.

the resulting intaglio impression may not compete in terms
of mechanical perfection with that prepared by the specialist
commercial printers, although it could serve as a means of
achieving a personal image, drawing or texture.

At the same time, an image made professionally, on the
artist's instructions and integrated with the other processes
in the plate, could still be further manipulated. Or it may be
that the printmaker chooses to exploit the high degree of
finish associated with mass-reproduction techniques. In this
case, the ethics of originality must be considered in view of
the arguments raised at present (see p. 181).

Photogravure is the photographic method of printing
closest to the etching processes already discussed, in that it is
also based on the intaglio principle. It produces a very wide
and sympathetic range of tones, a greater and more subtle
tonal depth than any other photographic method. This is
even more remarkable when one considers that the photo-
gravure screen with its mesh of exquisite lines (150–175 per
inch) and minute squares, has 22,500 cells to the square inch,
and that the greatest depth of bite produced on the plate is
$\frac{1}{1000}$ in.

The copperplate is usually etched in ferric chloride using solutions of modified strengths – the strongest being used first and gradually weakening thereafter. The result is a cellular surface of microscopic, regimented squares formed according to the tones of the original photograph, in which the deepest tones are bitten to the deepest level, the medium and varying greys to intermediary stages, while the palest greys are only superficially etched.

Because of the delicacy of the bite, it follows that when the plate is inked and printed, the ink should be of a reasonably oily consistency (depositing merely a film in the very shallow areas) and a soft, medium-weight paper (e.g. 140 lb.) is needed, with increased pressure on the press.

Photogravure varies from the other photo-mechanical techniques precisely in its application of the principle that

Photo-etching: from series *The Conditional Probability Machine* by Eduardo Paolozzi.

light-sensitized gelatine hardens in proportion to the intensity of the light to which it is exposed. Therefore, when a transparent positive image is laid in contact with the sensitized gelatine over a light-table, the white areas will receive the most light, the dark areas the least and the greys a relative amount. Thus, when the gelatine coating is laid on the plate for etching, the thicker white areas offer a greater acid resist than the medium greys or thin dark areas, according to the tones of the original photograph.

A positive transparency must first be made (to the size required on the plate) from a continuous tone negative. The sheet of carbon tissue (gelatine-coated paper which has been made light-sensitive by immersion in a solution of $2\frac{1}{2}$ per cent potassium dichromate) is exposed to light through a photogravure-screen transparency, for approximately fifteen minutes. The screen is removed and replaced by the positive transparency, and the gelatine subjected to light for a varying period depending on the density of the greys. This can be from a few minutes to more than a quarter of an hour and will demand some experiment and comparative tests. The carbon is transferred to a bath of hand-hot water just for a minute or two, in order to soften the paper.

The gelatine-coated paper can be stuck down onto the copper with a squeegee, or by running the plate and carbon through a mangle with rubber rollers, or by using the press suitably prepared with a thick rubber sheet under the blankets. A piece of card may be necessary between the rubber and blankets and somewhat less pressure than one would use for printing.

The gelatine and paper must be dried with cold air blown by a fan or hand-drier before methylated spirit is poured all over the paper backing until it is completely soaked. If the plate is again immersed in hand-hot water, the paper will now yield until it can be carefully peeled off, leaving the gelatine fixed to the plate. The unexposed areas are lightly washed away with cotton-wool and, as soon as the gelatine is dry and those areas of the plate which need protecting from the acid are varnished, the plate can be etched.

Use a hydrometer to prepare the ferric chloride to a solution of 42° Baumé, and then immerse the plate and activate the solution thoroughly with a large, soft brush. Gradually adjust the acid to solutions of 41°, 40°, 39°, 38°, 37° and 36° Baumé. This can be done, as Anthony Gross suggests, by meticulously using several containers and placing the plate on a wooden box in a sink, or by adding a tiny and specific amount of water to the original solution. In either case, this critical operation should only take about twenty minutes before the gelatine can be washed off in water and the plate cleaned in a very weak solution of hydrochloric acid (about 2 per cent).

The crucial factor is that water is added to the mordant only to soften the gelatine and so facilitate the action of the acid on the paler tones, i.e. the thicker areas of gelatine. If at

any stage the process seems to accelerate drastically, return to a stronger solution.

If, however, after cleaning, the bite is too weak, the plate can be re-etched by rolling a very stiff printing-ink over it, and then reimmersing it in ferric chloride for not more than twenty seconds.

Heliogravure is a similar, but older, process that makes use of an aquatint ground rather than the photogravure screen. Clearly, this will result in a less mechanical image, but, like photogravure, it is primarily a tonal, rather than a linear technique. A fine (preferably bitumen) aquatint ground is laid and fused on the copperplate and the other processes continued as above, with the exception of the introduction of a photogravure-screen transparency.

Half-tone differs from the photographic processes already described in that it can be either a relief or intaglio process. It depends on the principle that the tones of an image can be split up into a succession of minute dots which, when printed *relief*, give an illusion of varying tones – the larger dots for the dark and the smaller ones for the lighter areas. Printed *intaglio*, the image would be negative and the tonal range of values determined by the reverse dot structure of the plate's design.

Screens vary from coarse (from 45 lines per inch for news-print), where the break-up of the image is obvious, to fine (up to 200 lines) where the dot structure is not so easily distinguishable, particularly if a coated paper is used (paper with a smooth, hard surface of kaolin or clay, totally un-suitable for intaglio printing). It is possible to obtain screens of different patterns, but the more usual diagonal mesh is the least conspicuous, and all are expensive. The half-tone screen is formed by two sheets of glass precisely engraved with a system of parallel lines. These are filled with a plastic sub-stance which causes them to become opaque; the intersect-ing network appearance is achieved when the glass sheets are laid together, with the infinite complex of plain glass 'windows' between.

The plate must first be well cleaned and free from grease. A light-sensitive emulsion of diachromated fish glue (obtain-able from the leading photographic suppliers) is laid evenly onto the copper. A positive or negative transparency is developed with the half-tone screen incorporated and a contact print made on the sensitized copperplate. Several tests may have to be made on spare metal to decide the time for exposure, but this should be from approximately five to ten minutes.

The unexposed emulsion will then dissolve in warm water, leaving the dots of glue which were hardened when sub-jected to light and which now serve as an acid resist. After varnishing the sides and back of the plate, it is immersed in a solution of ferric chloride.

Any imperfections which may occur during the operation will show up very noticeably; however, half-tone is a

process which can be interpreted and manipulated by the printmaker, particularly by the use of stopping-out varnish during biting. A straightforward single immersion would result in a rather grey, monotonous tone, so it is common practice to remove the plate when the darkest tones are etched sufficiently and apply a stopping-out varnish over those areas. This is repeated with the middle range of greys, while the palest areas are left for a further period, until the space between the dots is well bitten out and the dots themselves reduced in size.

By either method, the over-all time actually spent in the acid will amount to approximately twenty minutes, during which the developing tones must be carefully observed, and the mordant constantly rocked or stirred, to prevent the sediment from becoming established in the extremely fine, pitted surface of the plate.

A 2 per cent solution of hydrochloric acid washed thoroughly into the cleaned plate will leave it ready for printing. Some experiment may be necessary to find a paper which is ideally suited to the quality of the other etched work on the plate, as well as the half-tone; a light to medium weight (60–140 lb.) paper could be used for an initial trial. A thin ink will be needed, and perhaps also some experiment in methods of inking up the plate (perhaps both relief and intaglio). As a rule, where half-tone is applied to a plate containing other work, for example line-drawing, aquatint or soft-ground textures, the half-tone will need to be most carefully and sympathetically used, in a manner appropriate to the other work. On the other hand, it may be necessary to employ half-tone to create a blatantly mechanical effect.

Line blocks can be transferred, with care, to the plate by roller, off a paste ground or hard ground. The principle is the same as for transferring ground in rebiting a plate (see p. 93).

Clearly, unless he has access to the required equipment and is confident in his skill as a photographer, the printmaker, if he chooses to pursue this aspect of intaglio work, may need the co-operation of a knowledgeable photographer – perhaps a photographic or graphic design department in a college, or a local firm of commercial engravers or printers.

7 Acids

The three acids most commonly used for etching metal plates are nitric, Dutch mordant (hydrochloric acid) and ferric chloride (perchloride of iron) – the last-named, less commonly. Each of these will bite copper, zinc and steel. A number of other acids and formulae can also be used, just as there are other metals, but, for most purposes, these are the most practical and effective.

Acids corrode or bite into metal in various ways, depending on several factors, and it is essential to take into account the different characteristics of each acid. For instance, the stronger the solution or mordant – the greater the proportion of pure acid to water – the less controllable it is. Strong mordants may well bite more quickly, although this is not necessarily true with all acids and all metals, but this does increase the chances of foul bite, and coarsens, even destroys, fine drawing and textures. The strength of acid solutions, even when made each time to precisely the same formula, can vary surprisingly, according to atmospheric conditions and room temperatures. In warm weather, the acid will tend to be more active than on a cold day; thus in cold weather, it may be necessary to mix the solution with warm water. Alternatively, the bath or tray of solution can be warmed up a little on a hot-plate or heater.

No matter how much experience of biting one gains, acid is almost always unpredictable.

It cannot be emphasized enough that acid, if used carelessly or by the ill informed, can be extremely dangerous. The first rule to learn is that water should never be poured into a container, particularly a glass bottle, containing pure or very strong acid. When mixing a solution, acid is always added to water and never the reverse. A normal etching solution such as dilute nitric acid is not, in itself, difficult to mix or use; handling it safely is a matter of common sense.

If an accident does occur and pure acid is spilled onto any part of the body, the area must be instantly and thoroughly washed with water. The skin affected can be covered with baking soda; a supply should be kept for this purpose. Ammonia (not, of course, full-strength), being a strong alkali, is also a useful neutralizer. When mixing the solution, and most particularly when pouring pure acid into water, the utmost care must be taken to avoid splashing acid into the eyes. A glass of water containing a small amount of bicarbonate of soda is normally taken for coughing or stomach upsets caused by fumes.

Good ventilation in the workroom is essential; fumes from an open bath, particularly in confined spaces, can be harmful to the lungs. Fumes created by really strong acids (both nitric and hydrochloric are more dangerous, either in pure form or when giving off fumes, than a solution of ferric chloride), corroding fiercely into large areas of metal, are intolerable unless windows are opened wide or, better still, a fume-extractor is installed. As a last resort, plates may have to be etched outside in the open air.

The larger type of fume-extractor, with a wide hood, designed to fit over a full-sized bath, is naturally expensive to install, but smaller and cheaper wall or window extractors, placed close to the etching bench, may suffice. If the extractor is too powerful, it can actually suck moisture as well as fumes from the uncovered solutions.

For safety and convenience, acids, when not in use, should be kept in clearly labelled containers, indicating both the acid and its strength, with well-secured tops. Leaving a solution in an unlabelled container, whether it is an open dish or a bottle, is to be avoided. Solutions already used for copper are easily recognized by their colour; new solutions are more confusing. They can, however, be quickly tested with a strip of copper. If the metal simply darkens, the solution is probably Dutch; if it bubbles, it is nitric.

Whenever possible, acid should be stored well away from the printing-press or any machinery or tools.

DUTCH MORDANT

Dutch mordant is regarded as a 'modern' version of the acid used for line-etching in Rembrandt's time. Unlike nitric, which will coarsen and thicken a finely drawn line, 'Dutch' will bite straight down, accurately and evenly. It is, therefore, employed primarily to bite precise or closely drawn work and delicate tone and texture on COPPER.

There are several widely used recipes, all of which are variations on a 'standard' recipe (largely attributed to Seymour Haden), but the components remain basically the same. Dutch mordant is, in fact, a compound mixture, consisting of potassium chlorate, hydrochloric acid and water. The proportions vary slightly according to the nature of the drawn plate; some mixtures bite more quickly than others, while some are used more for absolute accuracy.

The solution is made by first dissolving the potassium chlorate in a little hot water – say 10 parts from the total volume of water – that is heated in a saucepan on a stove. The fluid is then poured in a bath containing the appropriate amount of water and hydrochloric acid. Opinion is somewhat divided over whether the acid should be added before or after the potassium chlorate. Either way seems to result in considerable and obnoxious fumes. The main thing is that the measured volume of water is poured into the bath first.

The 'standard' Dutch mordant bath (conceivably invented by Haden) consists, according to Lumsden, of

> 20 grammes potassium chlorate
> 880 grammes water
> 100 grammes hydrochloric acid (pure)

This is also the solution recommended by a number of present-day authorities, notably Peterdi and Hayter. The contemporary recipe is usually described in parts, rather than grammes:

> 2 parts potassium chlorate
> 88 parts water
> 10 parts hydrochloric acid

Although this is a weak, slow solution, it is extremely accurate. Normally, it is heated to about 80 °F (28 °C) to quicken the action.

Anthony Gross gives another version of Haden's recipe as

> 3 parts potassium chlorate
> 77 parts water
> 20 parts hydrochloric acid (muriatic acid or spirits of salt)

Lumsden himself used a solution known as 'Smillie's bath'. This he took from the English edition (1880) of Lalanne's treatise and it is as follows:

> $\frac{1}{5}$ oz. potassium chlorate
> 5 oz. water
> 1 oz. muriatic (hydrochloric) acid

The amounts are made up in proportion as required. This too is a slow bath when cold and is usually heated to 80 °F (26 °C).

Buckland-Wright recommends a somewhat stronger mixture:

> 4 parts potassium chlorate
> 76 parts water
> 20 parts hydrochloric acid

This is a faster, but still very accurate solution.

The choice of which version to employ – and in most cases the difference is minimal – depends on the nature of the drawn plate. For instance, the most delicate work may be safely bitten with the first solution (Haden's) and the coarser or more vigorous work bitten more quickly in the last solution (Buckland-Wright's).

Dutch mordant is not regarded as being particularly dangerous, but pure hydrochloric, like nitric, should always be poured and mixed with the greatest care. It also emits chlorine gas which clears fairly soon after being mixed, but can be just as harmful as nitric fumes in a poorly ventilated, confined space. It is advisable only to make Dutch mordant

in a bath covered by a fume-extractor fan or at least close to an open window or, as a last resort, out of doors.

Although Dutch mordant is excellent for fine, close drawing, cross-hatching, soft-ground textures and fine aquatints, it is less appropriate for deep, coarse, open biting. It bites cleanly and accurately and since it has a negligible sideways action and undercuts only after penetrating down, it does not make the drawn line heavier. As a result, however, of the slight widening under the surface, a deep line is inclined to hold a surprisingly large body of ink, which can cause printing problems.

Large, open, closely worked or heavily textured areas tend to bite faster than single or isolated lines. This is because the metal, when etched, becomes increasingly warm and thus encourages the action of the acid. Dense areas should not, therefore, be left to bite unattended; a fairly constant check is necessary. This heating up of exposed metal applies to both Dutch mordant and nitric acid.

With Dutch mordant there are no gas bubbles and only a small amount of sediment; although there is enough to occasionally darken the lines, making them difficult to follow on a dark, smoked ground. This darkening is soon removed by gently swilling the solution over the plate.

After moderate biting into copper, Dutch mordant becomes a vivid green colour and is then easily distinguished from the bright blue of nitric used on copper.

A little pure hydrochloric, without potassium chlorate, can be added to the solution from time to time, to keep it active (or initially, to clean away a film of wax); but when, after continual use, the solution becomes really dark and dirty or too 'raw', it should be completely changed. Exhausted Dutch mordant becomes increasingly cloudy on the bottom of the bath and under the plate.

There is always a slight risk of foul bite with Dutch mordant, due partly to the lack of 'warning' bubbles. Faults in the ground are quickly penetrated and easily overlooked during the biting. It also has a slight tendency to bite deeply down into exposed metal that has been scored into with a sharp point, and it is less inclined than nitric to bite evenly through a thin trace of wax or grease. A small amount of old, used Dutch mordant can be mixed in with the new solution: this should control the sudden, vicious attack, which is so often the cause of foul bite.

On the whole, most experienced etchers make little use of Dutch mordant for ZINC or STEEL. A few leading authorities recommend copper solutions (2 parts potassium chlorate, 88 parts water and 10 parts hydrochloric acid) for zinc and a stronger solution (say 4:76:20) for steel.

A strong, coarse bite on zinc can be made with a solution of hydrochloric acid and water, without potassium chlorate, at about 6 or 4 parts water to 1 part acid. The absence of potassium chlorate will mean that considerable gas bubbles are released.

NITRIC ACID

The usual mixture for etching COPPER is about 2 parts water and 1 part acid (70 per cent of commercial quality). The maximum controllable working strength of the mixture is about half water and half acid. At the other extreme, it can be diluted to three parts water and one part acid; anything weaker than this would be ineffective on copper.

Nitric corrodes down into the bare metal with a boiling action, but simultaneously it also corrodes sideways into the walls of the etched cavity, undercutting the metal and its surface protection. Edges of wide lines and exposed areas require constant touching up with varnish if they are to be prevented from crumbling too much during lengthy biting in a strong solution.

The extent of the undercutting depends on several factors, such as the strength of acid used, the length of time the plate is immersed and the amount of metal exposed. Lines become somewhat coarse and ragged, yet in relation to their width tend to remain rather shallow.

Nitric is ideal for the larger areas of open biting, but it would be pointless to use it to bite a predominantly fine, precise, linear drawing on copper, even with a well-diluted solution. To some extent, all compact, detailed line work and fine textures suffer from the coarsening action of the nitric. This is particularly noticeable where lines cross or converge; the sharp corners are soon rounded off, leaving a small grey hollow known as a 'crevé', and the over-all quality of the drawing is impaired. It is safer, before using nitric, to separate the broad, heavier lines somewhat, otherwise, if too closely drawn, they tend to merge in the acid. For open bite, where an exact edge is required, use Dutch mordant.

To ensure that a fresh solution starts to bite with a consistent, regular action, a little copper can be added until the solution begins to take on a slightly bluish colouring. A fragment or a few filings of copper or even a small amount of old, 'exhausted' acid, is quite sufficient. After prolonged, heavy biting on copper, nitric will gradually turn a deep blue colour.

Copper, in a bath of nitric solution, gives off nitric oxide gas, which appears on the bitten portions of the plate in the form of gas bubbles. When bubbles are left undisturbed on the plate, they will cluster along an entire drawn line and on an open or densely worked area, and will constellate in patterns over the drawing. These should be lightly brushed from the plate at frequent intervals, whenever they are fully formed. The traditional, and probably still the best, method is to remove the bubbles with a feather – this prevents damage to the ground – but a swab of cotton-wool, or an old brush will serve almost as well. Bubbles can also be removed by tilting the bath (containing only the minimum

Removing bubbles in acid by feathering.

Removing bubbles in acid with a cotton-wool swab.

acid needed to cover the metal) to expose the plate to the air, thus releasing the gas.

The nitric solutions used for ZINC are normally much weaker than those used for copper. The variation is also much wider, between 20 parts water to 1 part acid – an extremely weak, but still an effective solution – to 3 parts acid and 1 part water, which would be the absolute maximum strength for a barely controllable solution.

The usual solution for most work varies between 12 parts water to 1 part acid and 6 parts water to 1 part acid. The 20:1 proportion would be suitable for most aquatints and the 6:1 for a regular, controlled deep etch. A solution stronger than this would only apply to deliberately fierce, ragged biting.

Using a really strong solution, especially for line-etching, is always risky; in any case, a strong solution is inclined to exhaust itself quickly, after its initial attack. With a reasonable amount of water added, acid will bite steadily for much longer. A weaker mixture, although slower, will always bite smoother and cleaner than a strong one.

Hydrogen gas bubbles form on zinc plates and, unless removed, can have a more drastic effect on zinc than the nitric oxide bubbles have on copper. They should be removed in exactly the same way. The presence of bubbles on undrawn areas is a clear indication of foul biting; the absence of bubbles on a drawn section (and where the lines are still shiny) is usually due to the metal not being cleanly exposed. The plate should, therefore, be taken from the acid, thoroughly but gently rinsed (as always), and the lines opened with a point.

Drawn lines that refuse to bite in normal solutions – often a result of even the merest trace of wax covering the metal – can sometimes be forced to open up by pouring a little pure acid directly over the troublesome area: the sudden attack from pure acid may be enough to break through the wax film. Fresh acid will gradually disperse into the rest of the solution, but before it does, there is considerable risk to already bitten drawing in the vicinity, and the ground itself may also foul bite. Whether or not the pure acid penetrates the film of wax, the bath should, after a minute or two, be gently rocked a few times to disperse and dilute the acid. This method, though somewhat extreme, can be used in a more positive sense: for instance, to create a coarse, ragged bite deliberately. The activity of both nitric and Dutch mordant increases where there is a greater expanse of exposed metal.

Although zinc is perfectly suitable, and may even be preferred (quite apart from its comparative cheapness) for most etching purposes, its softer and slightly more uneven structure invites a freer, more vigorous treatment than copper. Nitric acid tends to emphasize this even more. A line drawn and then etched into zinc with nitric, however mild the solution may be, will be more irregular and heavier than a correspondingly drawn line bitten into copper. For

Adding pure nitric acid.

fine, detailed work (which, in any case, is normally bitten in Dutch mordant), and for larger editions of prints, copper is undoubtedly more suitable, although the greater durability of copper is usually exaggerated. With most editions, say up to seventy-five, the durability factor is seldom crucial – that is, if reasonable allowance is made for the relative softness of the metal and the minimum use of shallow open bite and texture.

Acid that has been used to bite copper must never be mixed in any quantity (nitric acid when used on zinc barely changes colour) with acid used to bite zinc and vice versa. To do so would certainly hinder clean, regular biting and possibly cause the ground to foul bite or even lift.

A solution of between 7 and 5 parts water to 1 part nitric acid is suitable for both IRON and STEEL. Both metals give off strong, poisonous fumes when etched and should be used only with a fume-extractor or out of doors.

FERRIC CHLORIDE (perchloride of iron)

Ferric chloride is one of the most controllable and predictable of mordants. It bites fine line-drawing, texture and aquatint, evenly and accurately, almost as well as Dutch mordant, but more accurately than nitric and especially nitric on zinc.

In spite of its recognized biting qualities and the fact that there are no fumes, it is not employed to the same extent as nitric or Dutch mordant. This is because the corroding action of the solution on metal causes a sediment of iron oxide to form inside the bitten work; this accumulates and makes the drawing difficult to observe. Unless the sediment is continually removed, it will block further biting. This can be largely prevented by etching the plate face down in the bath, thus allowing the sediment or deposit to fall away as the mordant eats into the metal. The plate will bite more freely if it is raised from the flat base of the bath by resting it on bits of wood, cork or even wax.

As it is obviously not possible to keep a constant visual check on the plate, it must be taken out at regular intervals (about every twenty minutes), washed and examined. The mordant is, however, slow to bite and there is not much risk of sudden accelerated biting or foul bite. Lines are darkened in the acid, but no gas bubbles are formed. A mild solution of hydrochloric acid or acetic acid can be used to clean the etched work. Zinc plates may need scrubbing to remove all the deposit.

Ferric chloride can be obtained from chemical suppliers, either as a saturated solution, normally at 45° (Baumé), or as dry salts. It can be used at this strength or diluted with an equal proportion of water; 25° to 30° is considered best for most work. The same mixture applies to copper, zinc, iron and steel.

Anthony Gross suggests a useful way of removing the initial 'sting' in the new acid. This involves mixing a small amount of ferric chloride with equal amounts of ammonia and water; these are then thoroughly stirred together for perhaps fifteen minutes. The resultant liquid is discarded and the remaining sediment poured into the new mordant.

ACETIC ACID

Acetic acid is mostly employed as a kind of mild cleansing acid, mainly for removing tarnish (see p. 38). It needs to be chemically pure and is supplied at about 30° strength.

A complex line-drawing on a wax ground that may well have taken hours of work is usually affected to some degree by grease from the hand. To ensure clean, even biting, the drawn surface is first gently washed with acetic acid or vinegar. (If the plate is washed or even immersed for a few minutes in a clean bath containing acetic, the acid can be collected and used again.) This should enable all the lines, regardless of whether they were drawn first or last, to bite simultaneously. No other acid, even if generously diluted, is as effective for this purpose.

As a corroding acid, acetic is too weak to make anything but the faintest impression on copper or even zinc, but it will destroy polythene trays.

8 Methods of biting

A plate is usually etched by immersing the entire drawn plate in a tray or dish containing a solution of acid. Plates can also be etched by direct application of acid, by swabbing or feathering acid into localized areas – perhaps partly controlled by saliva or even more precisely by gum; or (especially in the case of large plates) by building a wall of bordering wax (beeswax) or Plasticine round the plate edge and pouring the solution onto the plate surface. With the latter method, the plate edge should be embedded deeply into the warm, soft wax to prevent seepage of acid.

Any suitably shaped tray that is unaffected by strong acid solutions will serve, but most ready-made acid trays are made of plastic, hard rubber, porcelain, Pyrex glass or enamel.

Probably the most commonly used trays are the photographic kind, of plastic or hard rubber. These are lighter and more convenient to handle than the older types made of porcelain and enamel (in any case, acid will quickly corrode into a chipped enamel tray). Plastic photographic trays are available in various standard sizes, the maximum being apparently 4 ft. by 3 ft. by 4 in. Large plastic trays are expensive, although in the long run, they usually prove economical. They will not, however, endure very strong acid indefinitely.

No trays, especially the plastic and rubber kinds, should hold acid solutions for lengthy periods; even overnight is unnecessarily long. It is pointless to leave out an open tray of acid if it is no longer needed; fumes persist and the water may evaporate and thus alter the mixture, but most important of all, the tray will tend to deteriorate. If, after each period of biting, the solution is still serviceable, it can be poured into a storage bottle (and clearly and correctly labelled).

A cheap, serviceable tray can be constructed from wood, treated with several protective coatings of stopping-out varnish or thickly applied layers of beeswax and turpentine. A fairly deep frame, made out of four strips of hardwood is nailed and glued onto a hardwood or masonite base. The corners and seams can be plugged and sealed by wax, or they can be covered by strips of linen, fixed between layers of varnish. Unless an unusually large plate is to be etched, the dimensions will depend largely on the standard sizes of printing-presses, metal plates and papers (and also on the number of plates that may have to be etched at one time, as in the case of a 'group' workshop) but 4 ft. by 3 ft. would

normally be considered the maximum practical size for most work.

An even more permanent tray can be made from rosin and fibreglass. A small draining-hole can be made in the bottom of the tray, whether wood or fibreglass, and fitted with a cork or glass stopper.

BITING THE PLATE

The way in which a plate is bitten depends largely on the kind of work it contains. Possible methods of drawing up a plate for biting are briefly described in the section on working into the hard ground.

Estimating the depth of a bitten line by timing alone is an unreliable method. Timing is merely a rough guide; even with considerable experience, regular inspection is essential.

A plate should never be left in the acid, especially in nitric, for more than a few minutes, without being checked and, if need be, feathered. This is absolutely necessary to ensure that foul bite does not occur, and that the drawing is biting correctly.

With so many factors affecting the biting, such as the temperature of the room and the solution, the amount of metal exposed, the character of the line or mark, and even the quality or structure of the metal, a test plate would, for most purposes, be a waste of time and material. But one can generally assume that, when etching a line into a copper or zinc plate in an acid of standard strength, a few minutes will probably result in no more than the palest of greys (steel would be darker), whereas a deep, regular trench may well take several hours of controlled etching. Between these extremes, it is almost impossible to predict exactly the effect of the acid on a drawn plate.

A finely drawn line, bitten in a new solution of Dutch mordant, should be adequately bitten in about ten to twenty minutes. It will be thin, but positive; further biting will deepen the line, but need not noticeably strengthen it.

If the plate is to be bitten in successive stages, from pale to dark, the first bite – the palest – will determine the depth and weight of all subsequent marks. It is essential, therefore, if the maximum variation is required (from the most delicate grey to the heaviest black), that the initial pale work should not be overbitten. The infinite variation in width and depth of line, and therefore in weight and colour, is unique among all printmaking methods.

A strong, thick, but not open line may take over two hours in Dutch mordant, depending on the width. Up to a certain point, the wider a line, the deeper it needs to be.

Fine-drawn lines and textures are also apt to bite more actively when adjacent to larger areas of exposed 'warm' metal.

Wide lines that are too open can be made to retain an amount of ink by deliberately scoring into them with a dry-

point tool, or they can be scratched into through a hard ground, or textured by litho crayon and rebitten.

By far the most reliable and accurate way to test the depth of a line is to remove the plate from the acid, rinse it and dry it, and then to insert the point of a needle into the bitten groove. If the point holds firmly when the needle is pressed gently sideways against the edge of the line, then, depending on its width, it has been bitten well enough to hold some ink and print. If there is any doubt, it is better to continue biting; within reason, it is better to overbite than to underbite.

Lines can be opened, and new work added, while the plate is actually in the acid. It is, however, necessary to keep an old or improvised needle especially for this purpose; a good steel point would be ruined by contact with acid.

Once the ground has been removed, inadequately etched lines are difficult to re-etch, although they can, to some extent, be re-opened by drawing into them through a new hard ground. Alternatively, the lines can be filled with water-colour or poster-paint, and a wax ground laid over this; when the plate is again immersed in acid, the paint dissolves, leaving the lines open to bite.

It is difficult, but quite possible, to transfer a wax ground from another plate of a similar size, provided the wax is still quite hot and is thinly applied by roller. This ground should then protect the plate, and at the same time leave the lines sufficiently open for further biting.

It may be easier to rebite lines by applying a cold paste ground, rather than a hot, melted, hard ground to the unbitten surface.

A paste ground is made by adding an amount of oil of lavender to the ordinary hard ground; the amount can vary between 1 and 2 parts oil to 1 part wax ground. The oil is poured into a pan containing warm, but not hot, melted hard ground. Paste ground is always used cold and should retain its consistency if stored in a screw-topped jar.

To apply the ground, first use a roller to spread a little paste over an inking-slab (a clean plate or sheet of glass) and, using the same roller, carefully roll it onto the surface of the bitten plate. Only cold plates should be used; heat would soon cause the oil to evaporate.

Leave the grounded plate for a few hours before biting, to ensure that the paste is adequately dry.

BITING THE AQUATINT

The fragile and relatively open surface of a hardened rosin ground requires an even, gentle, downward bite. The most suitable acids for aquatint, especially on copper, are Dutch mordant and ferric chloride. The deepest bites, and therefore the blackest of tones, can be safely and accurately bitten with Dutch mordant on copper. Nitric can be used on zinc, but the deeper bites, for darker tones, need to be bitten fairly slowly in weak acid; a strong solution will gradually eat

sideways into the rosin, destroying the textured grain. Coarse, shallow bitten areas tend to print as dirty, insipid greys. Normally, a nitric bath for aquatint should be approximately 1 part acid to 12 – or even more – parts water. It is advisable, at least until some experience of timing the biting has been gained, to use weakened solutions of Dutch mordant as well as nitric.

Compared with line-etching, an area of aquatint tends to have quite a large proportion of metal exposed; a dark tone will take much less time to bite than a moderately strong line. An obvious difference between successively bitten tones is achieved in a matter of minutes; it is, therefore, quite easy to overbite an area and end up with a much darker tone than was intended. The plate is taken out of the acid, rinsed and dried, and the palest areas are stopped out to prevent further biting. This is repeated each time a tonal area is considered to be dark enough. If the plate is left to bite, it will, before very long, reach a certain depth, corresponding to the darkest printed tone; beyond this point the aquatint ground will start to break down and the tone will actually get lighter. It is impossible to calculate beforehand exactly when this point will be reached.

During the early stages of biting, and after some variation in the paler tones has been obtained by stopping out, the plate can be taken out of the bath and a small section of the surface cleaned for examination. The depth of the bite can be tested with a needle-point in much the same way that a line is tested. Chipping off a rosin grain or two will give some idea of the contrast between bitten and unbitten metal. The tonal variations, even without removing the rosin, should be fairly clear. As the acid bites down into the minute network of open surface, it should be just possible to observe the depth of the darkening, corroded metal; that is, if the plate is closely examined from opposite the light sources. By using transparent stopping-out varnish, one can estimate the tonal variations more accurately by comparing the various bitten and unbitten areas of plate. Later on, it becomes increasingly difficult to estimate by visually checking the plate, whether a bitten area will appear on print as a dark grey or an intense black. The bubbles caused by nitric acid are also a problem when examining the plate in the bath.

A test plate is almost useless since, as always, the conditions affecting the acids vary constantly. Even testing the depth of the bite with a needle-point is not an absolutely reliable measure. Controlling the biting of an aquatint by estimating the time needed to achieve a certain density of tone, perhaps more than any other aspect of etching, depends so much on experience.

Ideally, where several distinct gradations in tone are required, a completely fresh and therefore reasonably predictable solution should be mixed. Thus, by etching a rosin ground on copperplate in a new solution of Dutch mordant (often used at 80 °F or 27 °C), it should be possible to estimate

with some degree of accuracy the various tones by 'timing'.

There can be no standard time-scale applicable to all aquatint, even fine-grained aquatint on copper. However, a medium-grain aquatint should bite to a pale, but positive, grey within a couple of minutes. A wide range of progressively darker greys can then be made by increasingly lengthy bites, until a dense black is obtained. This will mean taking the plate from the acid, washing and drying it, and stopping out, perhaps six, seven or eight times – more frequently in the early stages. The over-all time needed to bite a full range of tones may be anything from one to two hours.

A fine-grain rosin aquatint will, as a rule, bite to a perfect black in approximately one-third of the time it takes to bite a medium-grain black. A fine bitumen powder ground will take even less time to bite a black. In either case, whether fine or medium grain, the paler gradations are always much more quickly differentiated; the darker greys take proportionally longer to bite.

Ferric chloride (normally a slow-biting acid) is inclined to form a deposit where it bites into the metal. Because of this, as described above, plates are normally bitten face down. If the plate is not sufficiently bitten and the deposit prevents further clean biting, the plate can be thoroughly washed with a well-diluted solution of hydrochloric acid, and again immersed in the ferric chloride, or it can be moved to a Dutch mordant bath. Separate solutions of ferric chloride should be used for each metal.

CREEPING BITE

A gradated tone, without the usual rather obvious edge, can also be etched into an aquatint ground. There are several ways of doing this, the commonest of which is a method known as 'creeping bite'; or one can draw directly onto the rosin ground with a moderately strong acid, perhaps softening the edges by diluting the bite. A creeping bite involves tilting the acid bath containing the plate, so that the plate is at first only partially immersed. The deeper, darker area is bitten, and then the angle of the bath is gradually decreased. The acid is also constantly disturbed to prevent an edge from forming. In this way, the plate is slowly covered by the acid. The palest tones need the briefest etch. Damp blotting-paper placed partly on the plate and partly in the acid will, by absorbing acid, give a gradated bite to the plate surface.

With the creeping method, the areas of biting are rather limited. A complex plate where several areas of creeping bite are needed would have to be reground and stopped out each time.

A much freer method (spit bite) is to apply strong acid directly, dropping or painting the acid onto the ground. This enables more localized and controlled biting.

Edges, where tonal areas meet, can also be softened and gradated by scraping, burnishing and rubbing with charcoal. Most aquatint requires only the minimum of scraping; generally the burnisher alone is perfectly adequate for this purpose.

REBITING

It is seldom possible to rebite an aquatint successfully, particularly on a rosin ground that has been inadequately bitten and prematurely cleaned. If the first ground is extremely fine, only a coarse second ground can be laid over it, but even so, a certain amount of crevé and rather muddy grey background will be inevitable. If the first ground is moderately coarse, a second, but much finer ground can be applied over it, and this is generally more successful. In both cases, however, the printed effect will be somewhat different from the original intention.

Smaller areas of overbitten or underbitten aquatint can be roughly repaired by rubbing over the textured metal with lithographic crayon and rebiting. This should give a coarse-grained tone.

It is sometimes possible to salvage the original ground if it has already been bitten to a reasonable depth. The best way to do this is to protect the points of metal by reheating the plate and carefully applying a thin, hard wax ground (preferably from another rolled-up plate), with a roller or dabber. The slightly sunken, bitten metal is then left exposed to further biting.

9 Corrections and alterations

When the first stages of biting are complete, the acid resists (hard or soft grounds, rosin or varnish – on both front and back of plate) should be completely removed with the appropriate solvents. Normally, a trial proof is then taken (see Chapter 14). It may be necessary at this stage (and also at later stages, for most plates will subsequently require further biting), to make certain alterations or erase any foul biting before a new ground is applied and the plate is drawn and bitten again.

It is quite possible to remove scratches and even moderately deep etching and foul bite from the surface of a plate by polishing (as described previously in Chapter 2, p. 37). However, when a solitary line, perhaps close to other acceptable work, or a specific section of drawing or texture has to be completely removed, then a much more exact and concentrated method than snakestone and charcoal polishing is needed.

The most effective way of removing an intaglio mark from a plate is to cut or carve it out of the metal with a steel tool or scraper. In order to avoid leaving an abrupt, bitten edge, an area slightly larger than the actual indentation has to be scraped out. At times this will also mean scraping into good work; this is inevitable, but generally it should be possible to repair the lost work. The scored and roughened surface of the hollow left by the scraper is then smoothed down with a second steel tool, the burnisher.

If the resultant hollow is deep enough, or large enough, to affect the print, or if a perfect surface at that point is necessary for further drawing, then the concave surface has to be brought up to a level consistent with the rest of the plate. The method normally employed for this operation is called 'repoussage' (see p. 99).

Depending on the scale or complexity of the work involved, the surface can be finally polished, either by the rather lengthy snakestone, charcoal and oil-rubber method, or simply by rubbing with metal polish.

The steel *scraper* is triangular in section and tapers to a point. The sides, forming the three cutting-edges, are hollow ground, except at the actual point. Each of the sides or blades of the scraper must be sharpened and polished, and the edges kept smooth and clean.

The blades are sharpened first on the fine side of an indian oilstone or an aloxite, then on an arkansas stone; they can be

Scraper.

additionally polished with emery-paper. It is, therefore, essential that the blades of the scraper are absolutely flat, and the edges razor-sharp, in order to restrict damage to the surrounding intact area of the surface.

It is necessary to scrape an area rather larger than the actual mark, because the new surface will then be quite smooth and even, without any abrupt change in level to collect and hold ink during printing.

The metal is methodically planed off from every direction until the intaglio mark disappears. To do this, the scraper is tilted at a slight cutting angle and is pulled inwards, across the mark, almost with a shearing action. The tool should be used with gradually increasing pressure; to suddenly drag the blade deeply through the metal would cause ridges to form. A blunt- or rough-edged scraper will merely scratch and score into the metal, instead of cutting it cleanly out.

The scraper is also used to cut away the raised metal spikes projecting from the plate, caused by the engraver's burin (normally a second scraper, blunt, but certainly not rough, can be reserved for this work) and to remove, or soften, excessive burr on a drypointed plate (see Chapter 12, p. 129).

There are a number of flat scrapers designed for even more specialized work, such as scraping into and lightening mezzotint ground (see Chapter 13, p. 139).

Scrapers are generally supplied already fixed into a wooden, chisel-type handle, although it is possible to buy a combined, all-steel, scraper and burnisher.

Steel *burnishers* are made either as separate tools, in a variety of shapes – double or single ended, flat, spoon-shaped or conical – or combined with the scraper. They need to be of highly polished steel (the one notable exception being agate, used primarily for burnishing gold-leaf), and are usually round in section, except at the end, which flattens out slightly, curves upwards and tapers to a point.

Scraper-burnisher.

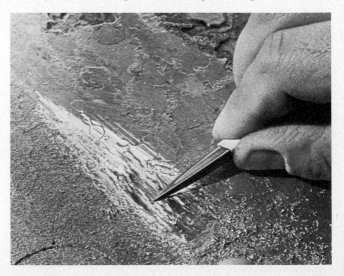

Scraping.

Burnishers are chiefly used for repolishing the surface of a plate after scraping, and for lightening tonal areas such as soft ground, aquatint or mezzotint. To some extent, fine etched, engraved and drypointed lines can be completely removed simply by burnishing.

When repolishing roughened metal, the burnisher is much more effective if used carefully and deliberately, rather than with an energetic, but erratic action (see also Chapter 11, p. 126).

Before burnishing, the metal should first be thinly covered with machine-oil; this considerably eases the often laborious task of smoothing out the roughened surface.

REPOUSSAGE

A shallow indentation resulting from scraping and burnishing may, within reason, be left in the plate and can even be re-etched. On the other hand, a deeply scraped indentation, no matter how smoothly the metal has been cut and the surface polished, will inevitably show up on the print, generally as a dirty grey or, if well wiped, as a noticeably swollen, lighter tone. The hollow can be carefully wiped before each print is made, but if further work is to be carried out, the sunken area must be brought up to the same level as the rest of the plate.

The traditional method employed for this is known as 'repoussage'. This involves hammering up the back of the plate, or forcing the hollow up by employing the pressure of the printing-press.

First, the exact position of the scraped depression is marked on the back of the plate with a pair of callipers. The position can also be adequately fixed by placing a new proof on the back of the plate and marking the relevant area through the paper with a point (if a dry proof is used, allow for slight shrinkage).

The quickest and easiest, but not always the most satisfactory, way to bring the depressed surface back to its original level, is to cut a few pieces of paper – usually blotting – to the shape required, gum these onto the marked back of the plate and run it through the press.

Before attempting to hammer a metal plate, it would be as well to practise a little on an old, discarded plate. It is not at all easy to beat the thinnest, hollowed metal into a flat smooth surface consistent with the remainder of the plate.

The plate is rested face down on a solid, flat, steel surface; the face of the plate should be well protected to avoid scratching. The marked area is then hammered firmly and positively, but not violently, with the smaller, rounded end of the repoussé or 'chasing' hammer. If the surface is overbeaten and pushed too far, it forces up a swelling or 'blister' on the front of the plate; this can easily be evened out by gently tapping with the flat part of the hammer-head. The operation

Repoussage hammer.

may need to be repeated a few times, the levels constantly being adjusted.

To complete the work and prepare the plate for proofing, the cavity in the back of the plate can be filled in, more or less permanently, with cardboard or similar substance. If this is not done, heavy printing pressure will soon depress the metal again. Finally, and especially before applying a new hard ground and re-etching the plate, the new surface of the area is polished.

SCRAPING AS A POSITIVE TECHNIQUE

The scraper can be used in a much more positive way than merely as an eraser. A wide range of effects quite apart from gradations in tone, can be achieved as in mezzotint, by deliberately incomplete scraping; that is by softening, subduing or blurring, but not actually obliterating an etched mark.

No less than the needle or the burin, the scraper should also be thought of as a creative drawing or mark-making tool. It can be employed in innumerable ways, e.g. as gouge, chisel, knife, plane and point.

A plate can be scraped into, not just to erase mistakes, or even to lighten tones, but to create a carved and sculpted surface. This can be done in small sections, combined with other processes, or over the entire plate. Heavy gauge zinc is a particularly suitable metal for this.

Deeply scraped surfaces, like all intaglio work, can be inked and printed in a number of ways. They can be inked by the normal intaglio method; they can be printed, uninked, into paper, or the soft-edged, raised relief can be inked over with a hard roller.

There is obviously a limit to the variations in the depth; even so, to hollow out, by scraping, an area of maximum depth, could well take a couple of hours of hard work. It is much more practical, when making such a plate, to remove most of the metal by etching, and then complete the work by scraping. The plate is first drawn out and deeply etched; then the hard surface edges round the bitten metal are rounded off by scraping, leaving no sudden 'cliff' or undulation for the ink to lie against or collect in.

The metal can also be cut or chiselled out with tools such as gouges or scorpers (see Chapter 11, p. 118), or even mechanically ground away with a power-drill and appropriate attachment.

The surface of a plate can, of course, be worked for its own sake, for the particular qualities of bitten, gouged, scraped and polished metal. Carried to the extreme, this preoccupation with the metal would mean that the plate becomes an end or object in itself, quite regardless of any print. This is a perfectly legitimate use of etching and scraping; the techniques of etching need not relate solely to printmaking and

the graphic arts. There is obviously nothing new in this approach; such possibilities are bound to occur to anyone involved in making plates to print from. Intaglio plates, particularly etched and engraved copperplates, have long been considered as complete and acceptable objects, and are frequently displayed as such.

The time and effort required to make an entire surface by scraping (even with preliminary etching) will rarely justify large-scale work, whereas creating a surface by pure etching is a much quicker process and is, therefore, far less limiting in scale.

ETCHING OUT

Existing work can be subtly or drastically altered and, to a certain extent, removed by etching out. This is done by protecting the remainder of the plate with varnish, then exposing an area containing the already bitten drawing to acid – normally a strong solution. The whole area is, in fact, lowered; sharply defined edges are softened and the original contrast in depth appears greatly diminished.

A grey, granulated effect is caused by the bubbling action of strong acid. This textured effect can be prevented by wiping, or it can be left and used, although it seldom prints well for long. It can, alternatively, be smoothed down with the burnisher.

It is rarely possible to remove absolutely all trace of bitten work by etching it out, without subsequent scraping and burnishing. Etching out, as with scraping, is both a means of partially erasing, and a way of deliberately creating certain effects.

An interesting and, at times useful, variation on the etching-out method is to re-etch a drawn plate in order to create raised lines. Intaglio lines are filled with printing-ink, wax or varnish (printing-ink is usually the most successful). The surface of the plate is then wiped clean and stopping-out varnish is applied to the sides and back of the plate.

The open area containing the lines is then etched until it is actually deeper than the original lines. When the area is cleaned, the lines should lie fractionally above the level of the bitten metal. By this method, it is seldom, if ever, possible to create raised lines with the definition of an intaglio line. A reasonably good example would show up on print as an area of pale almost negative lines against a darker background; the darkest parts being on either side of the lines, and round the edge of the open area.

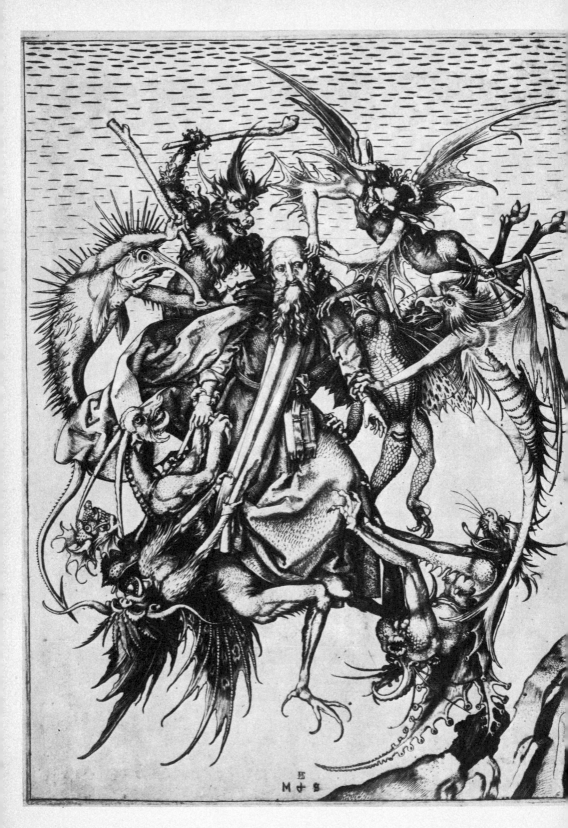

10 The history and development of burin engraving

The history and technical development of engraving, as a method of making prints, has been less eventful and, of late, less dramatic than that of etching. Among many students and artists, misconceptions and prejudices still exist regarding the precise nature of the technique. Compared with most other printmaking methods, particularly the photo-screen print and lithograph, engraving has not been so susceptible to the introduction of new materials and methods, nor so vulnerable to new concepts and movements in art.

In spite of the current, unprecedented growth of interest in printmaking, engraving remains one of the least practised of intaglio techniques. The fact that it has been practised and developed in recent years, is largely due to artists such as Joseph Hecht and Stanley William Hayter. No contemporary artist has explored, discovered and communicated the creative and technical possibilities of burin engraving more than Hayter. Since the twenties, his original, experimental work in the intaglio processes has been, and probably still is, the greatest single influence on the theory and practice of line-engraving.

Archaeologists have used the term 'burin engraving' to describe the precise and deliberately inscribed surface markings made by Palaeolithic man. Even primitive man had developed a variety of skills and techniques that included cutting and burning marks into rock, horn and bone. Before metals were available, the range of serviceable materials, both for burins and surfaces, was obviously limited; but, by careful, patient handling with remarkably effective tools, controlled marks of often incredible permanence and surprising beauty were achieved. At least twenty kinds of Palaeolithic burin have been recorded, each type made for specialized work from blades of flint.

Many of the objects containing man-made surface markings would have had considerable personal value; often, the more valuable the object and, as in later periods, the more precious the metal, the more man desired to enrich and embellish it. In a sense, the presence of engraving verified, almost celebrated, the worth of an object. The majority of the objects, whether functional or decorative, were intended to be constantly handled and carried, and had to be quite small; consequently, suitable surface areas for cutting into would normally have been very small indeed. The inevitable limitations of materials (and therefore scale) applied equally

(*Opposite*)
Engraving: *St Anthony tormented by Devils* by Martin Schöngauer. 12½ in. × 9⅛ in. *British Museum, London.*

to the subsequent use of metal and especially to precious metals. There was also a significant tendency to separate and concentrate inscription and decoration onto luxury rather than utility objects.

Every civilization and culture appears to have employed the technique of burin engraving for an infinite variety of purposes; in essence it has remained the same. The mainstream of development, eventually leading directly to the print, was in the ornamentation of precious metals, and continued to be so until at least the fifteenth century. Before and to some extent after this, engraving has been increasingly considered a rather specialized skill, associated with the goldsmith's, and later the armourer's, craft of enriching and decorating a surface.

Much less professionally established (but equally acceptable) forms of engraving have always existed outside and independent of the main tradition. They were mostly simple and direct in technique, and often naturalistic, rather than decorative, in subject-matter. Much of this insular and perhaps elementary engraving depended on the availability of suitable local materials, such as fresh bone and ivory surfaces just as durable as metal. The illustration shows a piece of engraved whalebone or scrimshaw, a nineteenth-century example of this independent approach.

Apart from an obvious, though significant, difference in scale, the act of engraving into copper is, at times, virtually a sculptor's technique, especially in more two-dimensional relief work. For instance, in the stone carvings by Agostino di Duccio, in the Temple of Malatesta at Rimini, the linear movement and rhythm of the sculpted grooves and channels

have much in common with the incised and driven lines of a metal engraving.

It is generally accepted that the first prints on paper were taken from engraved metal during the first half of the fifteenth century. The earliest dated print was made in 1446. It has been suggested that a number of these early prints or rubbings could, conceivably, have been intended for use as a kind of catalogue of design and ornament. The questions precisely when, where, by whom and even why the very first printed impressions were made may be of historical interest, but are not particularly relevant when tracing the general development of the print as graphic art.

The engraved print, as a form of visual expression, originated and was established in the fifteenth century as a result of several factors, some complex and indirect and some obvious and predictable. The main reasons can be broadly attributed to the following: the increasing influence of the Renaissance throughout Europe; the impact and widening effect of printing; the need to further and strengthen the teaching of Christianity (for this the production and distribution of the print, as illustration, was invaluable); the rapidly improving quality and availability of paper; the understandable desire of individual artists to reach a larger public.

Initially, the main centres of activity were in Germany and Italy. Many of the original print-engravers of the fifteenth and sixteenth centuries, even then virtually anonymous or little known, used a technique that relied almost exclusively on line, with occasional dotting and only very limited texture and tone.

The first artist, as opposed to craftsman-engraver, known by name was Martin Schöngauer. In Schöngauer's work are many of the essentially Gothic features of northern European art; imagination, realism, a strong expressive use of line and a composition firmly and vigorously constructed. Compared with the earlier engravers, his technique was complex. Even at this stage, within only a few years of the first acknowledged prints, Schöngauer had developed the art of engraving to a level regarded by many as the most perfect form of the art.

Engraving, if only in a technical sense, was soon to be developed much further by both Dürer and Lucas van Leyden. The genius of Dürer was fully recognized even in his day, and as a burin engraver, his brilliance of technique was unquestionable. He belongs essentially to the Gothic tradition, and although apparently much preoccupied with Renaissance ideals, he had an intense and typically northern concern for meticulous, detailed statement and dramatic conception. In his burin engravings he was able to express this close and exact observation of nature to an extraordinary degree, although it would seem that, in the opinion of some recent and contemporary engravers, this extreme and often overwhelming display of technical virtuosity has come to seem excessive and extravagant.

Relief sculpture: *Aquarius* by Agostino di Duccio, in the *Tempio Malatestiana, Rimini*.

(*Above*) Engraving: *Adam and Eve* by Albrecht Dürer. 9⅞ in. × 7 9/16 in. *British Museum, London.*

(*Opposite*) Engraving: detail of *St Eustace and the Stag* by Albrecht Dürer. 14 1/16 in. × 10¼ in. *British Museum, London.*

(*Above*) Engraving: *The Flagellation,*
School of Andrea Mantegna. $15\frac{13}{16}$ in.
$\times 12\frac{7}{12}$ in. Detail. *Victoria and Albert
Museum.*

This standard and somewhat purist assessment of Dürer's
metal engravings, whether justified or not, seems less rele-
vant when considering them as complete and individual
works of art. There is little doubt, however, that Dürer's
influence was partly instrumental in revealing and promoting
what must have been the inevitable reproductive potential
of engraving.

In Italy, the engraved print developed rather differently
from the German print, although, during the early part of
the Renaissance especially, they had more in common. The
Italian engravers of the fifteenth century followed a long
tradition of ornamentation.

One significant aspect of this tradition was a form of
engraving known as 'niello work'. This involved engraving
lines into metal – usually silver, copper, but also bronze and
gold – then blacking in the lines, so as to achieve a contrasting
effect. Niello was normally part of the goldsmith's orna-
mental work, yet much of the subject-matter was pictorial.

It seems probable that these later niello craftsmen would also have engraved plates for printing.

The finest of the early Italian (or southern) prints contain certain characteristic features. The Italians were evidently more conscious of, and concerned with, the inherent qualities of the line as contour or profile. Feeling for surface ornamentation, expressed predominantly through the use of line and a highly developed, almost abstract use of the white paper, gave their work an identity entirely different from that of the Gothic print. The Renaissance, not unexpectedly, had a more immediate and profound effect on Italian engravers.

Two main and recognizable styles of early Italian or to be more precise, Florentine engraving, were known as the 'fine' and the 'broad' manners. The masters of this Florentine period were Antonio Pollaiuolo and Andrea Mantegna. Mantegna's technique belongs to, and perhaps typifies, the whole broad manner, a method of engraving, almost modelling, with open, spaced, mostly parallel lines, making full and positive use of the white of the paper. The ultimate, printed example of this sculptural style is the famous *Battle of the Naked Men*, by Pollaiuolo.

The fine manner school made less use of spacing and light, had less consideration of area, but employed to a greater degree fine, short, close, but rather weaker strokes and cross-hatching.

Even in the fifteenth century, there was an increasing tendency for artists, especially artists of renown, to rely on

Engraving: *Battle of the Naked Men* by Antonio Pollaiuolo. 15¾ in. × 23⅜ in. Detail. *Victoria and Albert Museum.*

Engraving: 'St Michael and his
Angels fighting the Dragon', from
the *Apocalypse* series by Jean Duvet.
$11\frac{5}{8}$ in. × $8\frac{1}{4}$ in. Detail. *Victoria and
Albert Museum.*

skilled assistants to execute part, if not the whole, of the
actual work of engraving. This division of labour was then
an important factor contributing to the future development
of the print. The artist conceived and drew the design, but
could hand over the laborious task of reproducing it to the
'professional' engraver. Probably the first, and by far the
most able, of these early professionals was Marcantonio
Raimondi, whose impressive facility, and individual and
sympathetic interpretations of other artists' paintings had a
powerful and lasting influence on the technique of subsequent
engravers.

By the sixteenth century, few creative artists continued to
engrave their own plates; one rather curious exception was
the Frenchman Jean Duvet, a contemporary of Dürer and, in
fact, a practising engraver. Although hardly a technical in-
novator, he was remarkable for his originality of vision. His
work, often similar to Dürer's in subject, is totally unlike it in
style. After Duvet, there were few, if any, individual artist-
engravers of equal originality until William Blake.

By the seventeenth century, engraving had become the

Engraving: detail from *Portrait of Jean Chapelain* by Robert Nanteuil. $10\frac{1}{4}$ in. × $7\frac{7}{16}$ in. *Victoria and Albert Museum.*

accepted method for reproducing illustrations and works of art. The growing mass and variety of reproductive work continued. Other technically interesting aspects of engraving appeared, and many of these are well worth serious examination, such as book illustrations, title-pages, portraits, maps, architectural views and garden plans. The best reproductive engraving was, in terms of technique, possibly the ultimate in exact, disciplined, graphic skill; but the greater part of it was entirely repetitive. What survived of this once vast field of work was largely replaced in the nineteenth century by the engraved woodblock and later by various photo-mechanical processes.

To the creative artist, engraving had long been too easily associated with the technically restricting, demanding and time-consuming labour of reproducing material for print, or with the older, fading tradition of ornament and embellishment.

Line-etching was originally introduced as a reproduction print method, primarily to economize on the time and labour required for burin engraving – while still achieving a

Engraving from the *Book of Job* by William Blake. 7⅝ in. × 5⅞ in.
Victoria and Albert Museum.

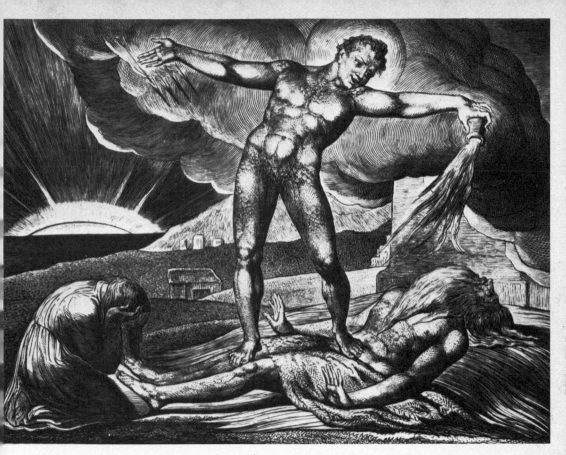

Engraving from the *Book of Job* by
William Blake. Detail. 7⅝ in. × 5⅞ in.
Victoria and Albert Museum.

similar effect. It was widely and successfully used for this
purpose. However, after and almost because of Rembrandt,
artists who were unable or unwilling to give their time to
engraving, were now able to turn more readily to the
comparatively free medium of etching.

The outstanding exception, since Duvet, to the general
trend in engraving was William Blake. For much of his life
Blake worked as a professional engraver. There is nothing
remarkably new in his actual burin technique; it was
perfectly adequate for his commercial work. There was
certainly no necessity for him, nor did he have time, to
adorn his plates or to display dexterity. Yet his personal and
highly original work on metal is indisputably that of a genius,
a genius who happened to be a trained and practising
engraver. Blake's influence on engraving generally was not
in any way direct. His technique was, perhaps, still too con-
ventional, and as an artist he was too personal, too much an
exception, to affect the dominant, reproductive direction of
engraving.

A number of individual artists since Blake have used
engraving in a genuinely creative sense, frequently en-
deavouring to work in the pre-Dürer manner of the early
Italians and Germans. Apart from a few interesting excep-
tions, their work inevitably suffered from an overemphasis
on the style and craft and became too self-conscious. By the
late nineteenth century and the early part of the present

century, burin engraving had a decidedly anachronistic image.

In retrospect, it now seems so natural, so inevitable, that in the experimental and innovatory twenties, even copper engraving could be made to appear creatively acceptable again. After all, completely new technical and aesthetic potential in other intaglio methods was rapidly being explored. There is little doubt that engraving would have been revived; it was, in fact, revitalized. It was not artificially related to the modern movement, it was part of it, because engravers such as Hayter were themselves part of it, and, even more, because individual and original artists such as Hecht, by the quality of their own work, continue to reveal possibilities afresh.

Of particular interest among the few modern engravers are Jean Laboureur, Roger Vieillard, Etienne Cournault and Henri-Georges Adam.

11 The technique of burin engraving

To engrave means, literally, to cut, inscribe or even carve into the surface of a substance that is normally hard and durable enough to render the cut as permanent as possible. It follows that, in order to give a line comparative permanence, the actual surface worked will be relatively resistant and unyielding. Engraving involves a form of cutting which is, in reality, a pushing, rather than a pulling or dragging action. It is clearly unlike drawing, at least in the physical sense of, for example, a line drawn freely on and across a static surface of virtually no resistance. An engraved line is also unlike a line drawn easily through wax and corroded into metal by acid, as in etching.

An engraved image for printing, therefore, requires no acid, wax or varnish; instead it is cut into a flat sheet of metal, normally and preferably of copper, with a small hand tool or burin. The plate is then inked and printed in a similar way to an etching.

Line-engraving on metal is the most decisive and the most direct of all the intaglio processes; it is also the most intractable and demands the greatest control and discipline. A degree of skill has to be acquired in order to work the plate, and this takes serious effort and patience. In original engraving it is not necessary to attempt to master the often incredible variety of skills and specific techniques that had to be learned by reproductive and process engravers. As with etching, it would now be quite pointless to imitate slavishly, by engraving, a work conceived and executed in an entirely different medium. The essential character of a print taken from an engraved plate is normally quite unlike that of a print produced by any other intaglio process. Etching, admittedly, can be made, or rather forced, to imitate engraving, more or less convincingly; this was its original purpose. But if either technique is used with feeling and imagination as a means of personal expression, imitation would now be unthinkable and virtually impossible.

No written definition of the essentially visual qualities of engraving can be entirely satisfactory. Recognition and appreciation of these qualities can only come from consideration and an understanding of the technique itself.

In learning a new technique, it is a purely personal decision whether one need start with an idea or prepared drawing, however vague or definite, and then try to interpret it, constantly channelling experiment towards the

idea; or whether to start as open-mindedly as possible, without a preconceived idea and in a sense, play around, responsively and observantly. The beginner attempting to engrave a replica of his own original drawing, however technically competent he may become, is hardly making an original engraving. The actual moment the burin cuts through the surface, enters into the metal and gouges out the line is in itself a creative act.

Engraving requires not only pressure from fingers and movements of hand and arm, but the involvement of virtually the whole body. This is not because engraving demands physical strength; but, in order to fully control the burin's cut, and direct the consequent line, it is also necessary to hold and often to move the plate against the burin. The mobility of the plate is crucial to both the cutting of curved lines and the recurring need to approach the image from many directions. To achieve a completely controlled force and ensure maximum sensitivity of the burin's stroke, a comfortable working position is essential.

Apart from the burin and the metal plate, few materials and tools are needed to engrave; but of all the tools any artist or craftsman uses, few can be so individually important as the engraver's burin.

THE BURIN

(*Top*) Square-section burin; (*above*) multiple graver.

This burin (or graver) consists of a few inches of straight steel rod or blade and is usually square in section. It is set at one end into a partially rounded wooden handle; the other end – the actual cutting-point – is sharpened flat, but to an angle of approximately 45°. For short, bold cutting and dotting an additional burin ground to an angle of 60° can be used. The handle is generally of a standard size, designed to fit comfortably in the palm. The total length of the tool must be in proportion to the engraver's hand and normally should not project more than half an inch or so from the fingers when correctly held. Before entering the handle, the shaft is usually bent slightly upwards at an angle of between 15° and 30°; this facilitates close manipulation and cutting contact with the surface of the plate.

Each of the blade's four sides must be kept perfectly flat, but most especially the two lower sides or planes which form the belly. The crucial cutting-point is precisely where the two lower planes meet the square-shaped end facet. Unless this point is kept constantly sharp, it will need to be forced through the metal and will not give a true cut. The facet must, therefore, be ground and sharpened absolutely flat.

The width of the most commonly used square-sectioned burins varies between $\frac{1}{10}$ in. and $\frac{1}{8}$ in. They are supplied in a number of sizes, usually, but not always, complete with a handle and with the point cut to the conventional angle. They invariably need individual adjustment. Occasionally they

are sold with the steel portion left straight in the handle. The blade should then be removed, and the rougher, tapering end heated until red-hot over a gas-ring and carefully bent to the appropriate angle using two pairs of pliers. It is important that only the minimum amount of metal should be heated. It should never be overheated, otherwise the temper of the steel will be lost.

A lozenge-shaped, as opposed to the square-shaped, graver can also be used, especially for deep, fine lines, although, like a burin cut to 30°, it is normally used for wood engraving. The main advantages of the square shape are that it throws up less burr and is more easily turned, thus increasing the sensitivity and expressiveness of line by the very slightest variation in pressure and direction.

It is also well worth trying to obtain old burins, as these were apparently made of steel superior to many of the modern tools.

There is also a multiple- or lining-tool version of the burin, made on the same principle, but with a varying number of tiny cutting-blades or points. This should be available in a number of sizes or grades, the size indicating the number of lines to an inch (for instance, a tool may vary between 25 and 200 lines to an inch). The purpose of this tool is simply to enable the engraver to incise a number of close, parallel lines with each separate cut. Originally an almost mechanical device, the multiple tool can at times be very useful but, being essentially both limited and extremely effective, it should not be employed, in the context of line-engraving, thoughtlessly and needlessly.

Both the scraper and the burnisher are essential to the engraver. They can be bought either as a combined, steel scraper-burnisher – as described previously in the section on etching – or as separate tools. It is a purely personal choice, but on the whole, the single-purpose tool with the wooden handle tends to be more comfortable to use. The function of these tools in engraving is in many ways identical to that in etching. The scraper really comes into its own when removing the burr and spikes of copper left by the burin. The spikes, especially the heavier ones, are extremely sharp and can easily cut the hand. They and any other burr or fragments should be removed as each line is completed with a sharp, well-polished scraper rather than allowing them to accumulate on the plate. It is advisable to shear off the spikes in the same direction as the engraved line. The scraper used for this purpose should not be razor-sharp, otherwise the surrounding area of copper may also be shaved off.

The burnisher is used for smoothing out scratches, alterations and unwanted fine lines. It is much more effective when used methodically, that is, by pressing it along short, straight, overlapping lines, rather than with an energetic, but erratic motion. A drop of light machine-oil on the area to be burnished helps to minimize friction; the tool itself should be frequently oiled to prevent possible damage from rust.

Burin with lozenge-shaped section.

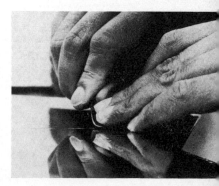

(*Above*) Removing the burr with a scraper; (*below*) burnishing.

(*Top*) Round scorper or engraver;
(*above*) flat scorper or engraver.

Several other variations on the burin exist; two at least can be useful, but neither is normally essential. These are half-round and square-sectioned gouges rather than gravers. The round gouge or scorper is designed primarily to cut broad, textured lines, and to hollow out areas for eventual embossing. These textured lines are achieved by holding the gouge at a fairly steep angle – best arrived at by trial and error – and moving it forward into the plate with a twisting, side-to-side action of the wrist. To hollow out an area for embossing, first define the area with a single, fine line, then, holding the round gouge at a slight angle, cut into the surface of the metal by rocking the tool. The remaining ridge of metal left by the ploughing effect of this action are then cleaned out with the flat gouge. This is not nearly as straightforward as it sounds and obviously requires a certain amount of practice, preferably on an old plate.

Once a burin has been properly prepared, it is the end facet only that requires regular sharpening. Initially, and then very occasionally, the belly and cutting-edge need to be resharpened. The two undersurfaces must be made perfectly true. This is done by placing the side of the graver diagonally and flat on an aloxite or oilstone (preferably a stone large enough to contain the full length of the blade); then, holding the blade down and pressing on it heavily with the fingers of one hand, draw it firmly and smoothly up and down with the other hand. Both surfaces are treated in this way and the operation is repeated, finally using an oiled arkansas stone to polish the blade. No reflected light should be visible along the cutting-edge.

The end facet is first ground flat by holding the burin at an angle of 45°, as close to the point as possible, and rotating it over the surface of the oilstone. The wrist should be kept rigid and at a constant angle, but it is not necessary to exert great pressure; this could only increase the risk of grinding an uneven or convex facet. Further honing of the end cutting facet on the arkansas stone is also recommended as the work proceeds.

When the cutting-point is moved gently across the finger-nail it will, if perfectly sharp, dig in by its own weight, without any pressure.

Not all burins are tempered when sold. When ordering a new burin, it is advisable to check whether, in fact, it has been tempered. Normally, the manufacturer will temper a tool on request.

The steel graver is hardened by heating until it becomes a dull red colour, then quenching it in water containing a little salt (linseed-oil is sometimes used instead of water). At this stage, steel is hard but rather brittle; tempering is necessary in order to overcome this. The graver is prepared by polishing it with the finest emery-paper. Avoid leaving fingerprints or grease on the clean tool. It is then slowly and carefully reheated, by applying the heat to the end opposite the cutting-point. The increasing temperature is indicated

by a corresponding range of colours forming along the entire length, starting with a pale yellow or straw colour, followed by a dark blue and a second straw colour. The ideal temperature seems to be about this point, the second straw colour. The graver is again quenched in water or linseed-oil; it is still hard, but much less brittle.

THE PLATE

Copper is the most suitable metal for line-engraving. It needs to be either 16 or 18 gauge. A thicker gauge than this is entirely unnecessary and, as with a particularly thin plate, causes printing problems; a thick plate edge, although adequately filed, can severely strain and tear even the heavier hand-made printing-papers. The copper normally used is cold-rolled copper, the metal being crystallized and softer in the direction of the roll. Lines engraved in this direction, as well as leaving more burr, are also a little more difficult to control. This applies especially to curved lines, for the metal can suddenly and unexpectedly become less resistant. The hand-hammered plates used in the past were of an even, consistent structure; consequently they were harder and more predictable. They can still be bought, but are, in any case, considerably more expensive. Old and unworked copper plates also tend, with time, to rearrange and even out their structure.

Glare from the high polish of a new plate is distracting and irritating to the eyes. To prevent this, the polished surface can be rubbed over with ordinary non-gritty scouring-powder; alternatively the plate can be immersed briefly into a mild solution of nitric acid or even rolled with Plasticine. This dulled surface is also easier to draw, trace or transfer upon. Other metals that can be engraved and printed from include zinc, steel, brass and aluminium. Soft steel and iron are mostly associated with reproductive engraving, primarily because of their greater durability. All these metals are, in various ways, much less pleasant and manageable than copper.

Zinc – and equally micro-metal, see p. 33 – has gradually become more acceptable to the artist-engraver. No longer is it the pure zinc regarded as so unsuitable in the past; modern zinc plate is really a zinc alloy and is naturally much harder. Compared with copper, zinc is still relatively soft and possesses a more uneven structure than new copper. Many contemporary engravers, including Hayter, are quite positive in their rejection of the metal; Peterdi, on the other hand, has evidently made considerable use of zinc and even prefers it for bold, free work.

The different characteristics of copper and zinc are very noticeable when cutting. With zinc, the burin's point needs a firm, downwards pressure. This should never be necessary with copper. Although zinc is a soft metal, it is also coarse enough to affect the point, so more frequent sharpening will

be needed. A zinc plate also tends to wear out much faster than copper when printing, but is still sufficient for a moderate edition. For large editions, it is possible to have zinc plates faced with steel. This cannot be done directly until the plate is initially faced with copper – a process that could result in some deterioration of the quality of line.

Various forms of perspex or plexiglass are also quite commonly used to engrave upon. Although these surfaces cannot be compared with copper for quality and range of line, they do provide cheaper alternatives, and may even be equally appropriate for certain kinds of work. Plexiglass cuts in much the same way as metal, but the incised line has a slight burr and is, therefore, somewhat rougher than a line incised into copper. It also has the obvious advantage of being transparent; thus, the original drawing can be read through the 'plate'.

WORKING POSITION

There is no single, correct way to hold the burin. Each individual engraver evolves his own personal method, but there are, in general, characteristics common to most; any apparent differences are usually variations of one method. It would obviously be quite impossible to engrave a line with a burin held as if to stab, shove or scratch into the metal. The hold most frequently advised and described is really the classical hold for line-engraving. The handle of the burin should rest against the palm and is secured there by the little finger. The blade is held and steadied between the thumb and the two middle fingers (these must also be curled up, against, but never under, the blade), the forefinger rests alongside or even slightly over the blade. A burin held in this way can be placed as level and as close to the plate as possible. When cutting, the tip of the thumb and either the fore- or the middle-finger should slide over the plate behind the point. The finest and most sensitive of lines can then be engraved with the hand resting on the plate.

The hold should, at all times, be comfortable and reasonably relaxed; it is not necessary to grip the tool tightly. A gentle but firm pressure is needed to move and direct the point through the surface of the metal; this comes from the palm of the hand, but has also the controlled force of the arm and shoulder.

In order to concentrate completely on the actual cutting, good working conditions are essential. Adequate lighting is, of course, of prime importance in avoiding eye strain. For engraving, normal daylight is always preferable to any artificial light, and a really dazzling light source is utterly inappropriate. A paper screen can easily be made, and when placed between light and plate serves as a filter. Provided the light is even and not extreme, and does not cause the plate to reflect the glare excessively (even a lightly etched or dulled plate reflects a certain amount), a screen is not necessary.

The correct engraving position is best found by personal and practical experience. To ensure maximum working comfort, especially if cutting for lengthy periods, the table or bench upon which the plate lies must be of a height suitable for sitting at, so as to allow the engraver to lean over the plate and rest, and consciously keep, the elbow of the cutting arm on it, without straining the back or shoulders. The usual sitting position is facing and diagonal to the table edge. Both hands are in use, one cutting, the other holding and rotating the plate. In this way, with the body leaning slightly forward, the eyes are constantly over the cutting area, but at no time need they become strained by unrelieved concentration. The magnifying glass used by process engravers is rarely necessary in original work. Rather than dutifully striving to govern the accuracy of every detail of the cutting by eye, it is preferable to try and achieve complete control by touch and feel. The sense of involvement with the copper soon becomes very real. As the work proceeds and experience is gained, confidence increases and cutting becomes more natural; this is important, because a relaxed and anything but tense and apprehensive approach is needed.

Some form of flat, smooth support under the plate ensures easy manipulation. Sandbags are supplied for this purpose, but an alternative can easily be improvised, and may have to be for a very large plate.

CUTTING

To engrave a straight and even line, engage the burin's point in the copper at a fairly low angle, and decrease this angle further while moving slowly and deliberately forward – but not downward. Too extreme an angle from the plate will inevitably cause the point to dig in, preventing fluent, progressive movement. Too shallow a cutting angle, perhaps due to a fractional and unintentional lifting of the point, lessens the metal's resistance; this can result in sudden, exasperating slips. Heavier lines are made even more slowly and are intensified, preferably by repeated cuts either within the same cut or closely alongside it, and not simply by exaggerated pressure. Brutal, unreasonable force can mean disastrous slips, and worse, a broken point. Once it has entered the metal the tool should be held straight, and the incision into and through the surface must be made slowly and unwaveringly. To vacillate during the actual cut will cause the line to appear uneven and indecisive without being in any way sensitive.

To end the line, reduce the pressure behind the tool; at the same time continue with the stroke, but lifting the point clear of the metal. This can be done very gradually or quite quickly, depending on whether a short pointed end or a long diminishing one is required. Alternatively, to create a more abrupt, squared end, merely stop and withdraw the blade,

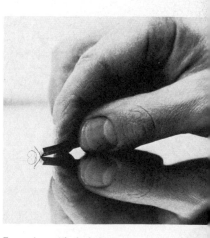

Engraving with the burin.

shearing off the remaining spike or spiral of copper with a scraper. When engraving a line that is to meet, enter, but not intersect an existing line – as if forming a T-junction – reduce the angle of the burin fractionally the instant before the lines merge. The point should then move easily into the existing furrow, but without sufficient force to travel further.

Engraving a curved line requires more active participation from the non-cutting hand; this hand has to guide and revolve the plate, so that the area to be cut is actually moving in the opposite direction to the cut. The burin also moves, but only very slightly; almost imperceptibly its point presses forward, as if intersecting the oncoming expanse of copper. For a curved line, the burin's normal cutting angle is increased by a few degrees, otherwise the line has a tendency to straighten and wander. When cutting a complete circle or spiral, the smaller its diameter, the more fully must the plate be turned, and the more severe the angle of the tool. A stiff, wiry and monotonous line is usually a sign of practical inexperience, and a preoccupation with the physical control and direction of the burin. While this is, at first, understandable, it may be useful to deliberately exaggerate the variation in the line and consciously explore its expressiveness.

TONE, TEXTURE AND SCALE

It should be possible to create tone, texture and, in a sense, colour, by using only the burin. Considerable variation can be achieved by line or dot, or by a combination of both. An area of uniform, heavy black can be built up by close spacing of strong, regular, parallel lines. This can be further intensified by additional lines cutting across the first, but at a slightly altered angle. Engraved lines crossing at a severe angle, or even at a right angle (cross-hatching), although capable of giving a perfectly uniform area of tone, are apt to appear mechanical. An infinitely subtle range of greys can be made by careful spacing of fine and broken lines, and to a lesser extent, by dotting.

A dotting effect can be made by simply engraving a group of short, abrupt cuts, or by cutting forward and then flicking upwards, leaving a two-point mark. More positive dots are obtained by either driving the burin's point quite deeply into the plate and disengaging it; or by driving deeply, but at the same time forcing up a spike of copper, which, when sheared off, leaves behind a precise, triangular puncture mark. Round dots and minute circles are cut by rotating the plate with the burin's point engaged in the metal at varying angles. A second burin, ground to an angle of approximately 60°, is recommended for this purpose, primarily to safeguard the more vulnerable point of the line burin.

Relating tone (and texture) to the engraved line, and both

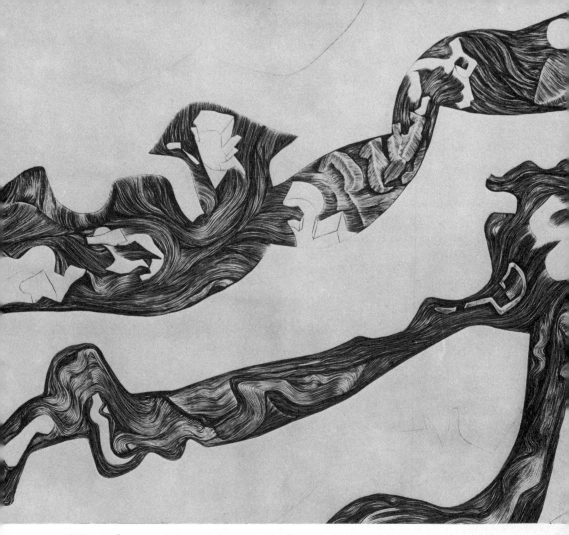

Engraving: detail from *Winter Earth* by Walter Chamberlain. 28 in. × 22 in.

tone and line to the size of plate (and ultimately the print), is a major problem for the inexperienced engraver. This relationship is, perhaps, what engraving is really about; for it involves in particular, understanding and awareness of the intensity and character of the engraved line, and extremely careful consideration of scale.

It requires a surprising number of dots to achieve even a moderately grey tone, yet indiscriminate use of the dot can give a fussy, contrived effect, almost as mechanical as cross-hatching. Also, an engraved line, apparently heavy and forceful on the plate, can be disappointingly lightweight on the print, while an extremely fine, delicate line can print with an unexpectedly positive definition.

Exceptionally heavy lines made by repeated, successive cuts, will, even after wiping, hold a troublesome quantity of ink. During printing, this surplus ink is easily forced out of the actual line and onto the surrounding print area. Several possible ways of preventing this blotching effect are discussed in the section on intaglio printing.

It is advisable to take prints after each new section is cut; an adequate proof or 'state' is essential if one is to assess and

control the development of the work. During the cutting, a little black pigment or copperplate ink can be rubbed into the lines so as to roughly simulate a printed effect. A sheet of tracing-paper laid over the plate reduces the glare and clarifies the lines, making the work generally more readable. This is especially useful if a printing-press is not always available. Copperplate ink must never be left in the lines to dry hard; it is better to clean the plate after each day's work. Dried ink which cannot be removed by turpentine may need scraping or even boiling out with caustic soda.

PRELIMINARY DRAWING

To attempt an engraved translation on copper of a drawing raises a number of issues. It is simple enough to draw freely and directly on a plate or, alternatively, to transfer a drawing exactly onto the copper surface, prior to engraving. The really crucial issue involves the relationship of drawing and engraving. For example: what is the real purpose of a preliminary drawing on the plate; and to what extent should the engraving be made to conform to this drawing? It may be that for certain kinds of work, representational or geometric for instance, guide-lines on which to base the work are vital. But for engraved work that does not demand such conditions of accuracy or exact measurement, a drawing or even reference points on the plate need only be minimal. In any case, the manipulation of a pen or pencil line hardly ever bears much relation to an engraved line.

It is not easy, when cutting for the first time, to control the swing and direction of a curved line, and confine it to within not only the plate edge, but within an arbitrary, drawn boundary line. Obviously, what finally counts most of all is personal experience. The degree of accuracy and complexity of drawing for engraving, depends on one's requirements and on one's sensitivity to the medium.

The print is always a reverse image of the plate, and this must be considered when drawing and tracing. If the original conception is to be carried through exactly onto the print, then the engraving must be made in reverse.

An outline plan of the proposed engraving can be drawn onto a dulled or polished plate, with either a china marking-pencil or a wax crayon. If this outline is drawn on a bright, polished surface, the plate can then be lightly etched for a very few seconds; its surface becomes dulled (making it easier to work on), but the bright, drawn line remains. No trace of this line will be visible on the print.

Other materials equally suitable for this method include Flowmaster felt-tipped pens, indian ink, litho ink and litho chalk, stop-out or asphaltum varnish.

For a more precise or accurate outline, a white-coated transfer-paper, or white waxed or even ordinary carbon paper, can be drawn or traced through and the plate etched

(see pp. 44–5). If desired, the image can be reversed at this stage. Alternatively, a carbon-traced line can be drawn onto an already etched surface; the waxed line itself should be reasonably durable. A lead pencil line is much less advisable, since it tends to smear and rub off more easily during the engraving.

Another commonly used method is to scratch in the design lightly with a metal point. The lines can also be blacked in with a small amount of printing-ink (this ink should not be allowed to remain and to dry hard). Except where this is followed by extremely accurate engraving, the scratched lines remain, rather like a drypoint effect, until removed by scraping and burnishing. This well-tried method still seems difficult to justify.

STIPPLE ENGRAVING

Stipple engraving is a method of engraving a plate entirely with minute dots. Gradated, soft, tonal effects are gradually built up by various systems; for instance, the general outline can be indicated by etching dots made with a needle-point or with a single-wheel roulette. The main tones are then worked in with an assortment of roulettes, for instance the drum roulette, multiple-point and drypoint needles. Usually, the engraving was completed with a stippling tool – a burin with a specially shaped, downward-curved blade or shank, to facilitate easier dotting or stippling. (These tools are still obtainable from some dealers.)

Stipple engraving originated in France in the eighteenth century, but was more fully exploited by the English. It was predominantly (though not entirely) a reproduction method. The artist most associated with the stippling method was the Italian F. Bartolozzi, whose work (and that of his school) was immensely popular in England during the eighteenth and nineteenth centuries.

(*Above*) Stipple engraving: *Charles Burney, Esq.* by Francesco Bartolozzi, after Sir Joshua Reynolds. $7\frac{5}{16}$ in. × 5 in.; (*below*) detail. *Victoria and Albert Museum.*

THE CRAYON METHOD

Stippling tool.

The crayon (or chalk) method is another eighteenth-century French invention. It is more properly an etching rather than engraving method, as it involves working into a hard ground.

Generally, the tools used are the same as those used for the closely allied stipple method, although a 'chalk roll' roulette is more extensively used. The printed effect of the crayon method is often very similar to that of a drawing, etched in the traditional manner through a soft ground (see p. 53). The crayon method is, however, more truly a means of exactly reproducing an original crayon-type drawing; and as a rule, when closely examined, is shown to be a more faithful copy. Both stipple and crayon methods were often combined.

CORRECTIONS AND ALTERATIONS

Fine, shallow lines can be fairly easily removed by methodical burnishing; that is, by firmly and repeatedly pressing the tool along and into each line (a little machine-oil greatly assists the work) until the copper completely closes up. Strong, deep lines will need scraping out before burnishing, but, apart from unavoidable hard work, they are not difficult to eliminate (a razor-sharp scraper is essential). Regardless of whether the section to be cleaned out is compact or straggling, or merely a straight, solitary line, the scraping should be absolutely thorough and, within reason, encompass as generous an area as possible. This is to avoid forming narrow trenches and hollows that could, during the printing, retain ink.

Deeply scraped sections (burnished or not) are, to say the least, awkward to rework. It is advisable to push the scraped depression back up to the original surface. The usual methods employed to do this are by hammering the back of the plate (repoussage), or by levelling off the plate in the press. Hammering a polished copperplate to reclaim a surface suitable for further work is a difficult operation; it is easier, and the results are generally more satisfactory, to utilize the pressure of the printing-press. In both cases it is first necessary to mark the position of the depression on the back of the plate by callipers. A scraped surface, however evenly finished, will still require final polishing (and especially preparatory to further burin work) before printing. The use of callipers, and polishing the plate by snakestone and charcoal, are described on pp. 99 and 36, respectively.

12 Drypoint

'Drypoint' is the term commonly used to describe the technique of scratching or scoring with a sharp point directly into the bare, polished surface of a metal plate (traditionally copper). No acid is used; a drypoint line is not made by corroding into the plate, as in etching. No cutting is involved and no thread of metal is carved out and removed, as in burin engraving. It is a specialized and advanced form of the most primitive method of inscribing marks.

A drypoint tool or needle, when drawn firmly across and through the resisting surface of the metal, forces up on one or both sides of the line a ridge or burr. The depth of the actual scratch will be slight; it is the raised burr that collects and holds most of the ink and gives the printed line its distinctive, heavy, rich quality. Drypoint is, therefore, only partly intaglio, and cannot be employed as a straightforward relief printing method.

The burr, lying fractionally above the surface of the plate, is especially vulnerable to the pressure of the printing-press and to the general wear and tear of inking and wiping (printing a drypoint is almost exactly the same as printing an etching or engraving). Consequently, the number of prints that can be taken from a plate is extremely limited. Unless the finished plate is steel-faced, it is seldom possible to take from it an edition of more than about ten good prints; for this reason, proofing the various stages of development is to be avoided.

In principle, the technique of drypoint is simple enough; but to make a 'drawing' on a metal plate, and at the same time inscribe into the metal, throwing up a burr effective enough to stand up to even very limited printing, requires a surprising amount of manual skill. As with any new technique, practical experience on a trial plate is essential before one can plan a work of any complexity and carry out the plan with any accuracy on the metal.

Handling and controlling the point, especially a steel point, may be difficult at first; it seems to skid erratically or drag deeply. The line, whether on plate or print, will often appear stiff and angular. In fact, drypoint can be an extremely flexible and expressive line technique; but it is absolutely necessary to be able to use the point well, at the appropriate angle and with sufficient pressure.

Scored lines can also be deliberately and subtly gradated by carefully scraping and burnishing the burr. A lightly scratched plate, having no significant burr, will give a thin, but characteristic, soft grey line.

Traditionally, pure drypoint has been thought of as a draughtsman's technique, in the sense that it has tended to invite a direct and spontaneous, rather than a methodical or decorative, use of line. And also, since making a drypoint does not require the studio-workshop conditions necessary for etching and engraving, it has been possible to work literally from nature. This, at least to some extent, accounts for the overwhelming number of landscape impressions so familiar in the latter part of the nineteenth century.

THE HISTORY OF DRYPOINT

The relevant technical history of drypoint printmaking begins in the fifteenth century with Dürer. It is doubtful whether before this much drypoint work of any consequence existed. The evolution of drypoint, as an actual print technique, is part of the early mainstream development of intaglio printmaking. It was not until at least the early seventeenth century that its expressive and creative possibilities were fully explored and revealed. Subsequently, its development has been far more closely related to etching than burin engraving.

Rembrandt made comparatively few pure drypoints, but he did employ the method extensively with etching, particularly in the later, more heavily worked and darker toned plates. After Rembrandt it was increasingly and more widely used, but still remained until the nineteenth century merely an additional means of accentuating the tonal areas of etching and scarcely a separate and complete technique in itself.

Undoubtedly the comparative difficulty of the technique and its severely limited print capacity deterred many artists from using it, except as a supplementary process. And compared with the considered and the infinitely more enduring nature of metal engraving, merely scratching into surfaces could well have seemed indecisive, insubstantial and certainly uneconomic.

There was obviously no way of using drypoint for commercial and reproductive work; but, in the nineteenth century, with the introduction of steel facing on copperplates, it became a much more worthwhile proposition for the professional artist. More did not, however, mean better. In spite of the gradual proliferation of drypoints, really distinctive and enduring prints were comparatively rare and, in terms of pure technique, only a few were justified.

There was something of a fashion for drypoint, at any rate in England, from the late nineteenth century to the early twentieth. More pure drypoints were made than at any period before or since. This was chiefly due to a rapidly

(*Opposite*)
Drypoint: *Victor Hugo* by
Auguste Rodin. $5\frac{1}{4}$ in. × $7\frac{3}{8}$ in.
British Museum.

Drypoint: *Annie Haden* by James McNeill Whistler. $13\frac{3}{4}$ in. \times $8\frac{3}{8}$ in. *British Museum.*

increasing interest in the print generally, and etching in particular (the so-called 'etching revival' owed much to Whistler). It was also due to the contemporary emphasis on draughtsmanship in portrait, landscape and architectural studies. This was the opposite of the sterile situation in the development of burin engraving. A leading English exponent in the early twentieth century, typifying the popular, strong and dramatized landscape tradition, was Muirhead Bone.

It is by now generally accepted that with a few remarkable exceptions, the greatest prints have nearly always been made, or at least directed, by painters and sculptors, as opposed to those made by the more specialized printmaker. This could well apply more to drypoint than to any other intaglio process. Drypoint was first and foremost a method of drawing; secondly, it did not require elaborate technical and material expertise to work and print the plate.

Many of the finest modern drypoints were made in northern Europe, particularly Germany and France, by

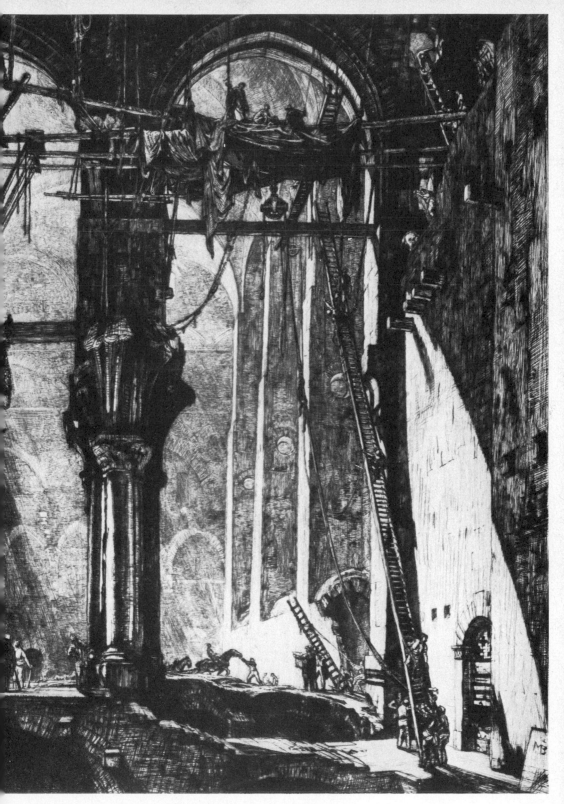

Drypoint: *Demolition of St James's Hall – Interior* by Muirhead Bone.
$15\frac{7}{8}$ in. $\times 11\frac{1}{8}$ in. *Victoria and Albert Museum.*

artists such as Munch, Nolde, Beckmann, Miró, Chagall and Picasso. On the whole, these prints have an essential vigour and directness that was conspicuously lacking in much of the English work of the period. The tendency now is still to regard drypoint predominantly as an adjunct to the etching processes, which is closer, in fact, to Rembrandt's approach.

TOOLS

The only essential tool required for drypoint is the point or needle. It needs to be either of hard steel or of a stone such as diamond, sapphire or ruby.

A *diamond point* is considered the best possible tool, but any of the stone points can be moved over and through the surface of the plate with a greater freedom of direction than the steel point. The manipulative ease of a diamond point on smooth metal is not unlike that of an etching needle used on a wax-grounded plate. With equal pressure, the stone point invariably produces the stronger line.

Usually, the stone is supplied already fixed into a metal or wooden handle, but the actual setting or socket should always be of steel. The stone must be well secured, yet protrude sufficiently from the setting to enable the tool to be held and used at an acute angle. It should also be round and obtuse, rather than fine and sharp. A lengthy, tapering point is too risky; it may, in fact, be safer and more practical, when ploughing up a really strong burr, to use the steel point.

Expense is another consideration; a diamond point naturally costs far more than any steel point and, for most printmakers, could only be justified by a great deal of use.

The *steel point*. A hard-tempered, all-steel tool, if not as ideal as the diamond, is perfectly adequate for most work. It can be bought ready-made in a variety of shapes and thicknesses, or it can be improvised from other hard steel tools, such as an engineer's scriber. A common example of the heavier tool is the Haden point; as with most points, it seems somewhat inappropriate to describe it as a 'needle'. Another lighter version is the Whistler point.

The actual drawing point must be literally needle-sharp and round, without any facets. It is quite possible to inscribe with a flat or angular point, but, since constant adjustment in direction would be needed, there would seem to be no real advantage in this. An imperfect point is extremely difficult to control, and a rough or broken one can cut out and remove metal instead of scoring into it. If used frequently, a steel point (unlike the stone) will require regular sharpening. An oilstone should be available for this.

The choice of which point to use is, in the end, a personal decision. Provided it is strong, comfortable to handle and work with, and will produce the desired burr, the eventual choice is relatively unimportant.

(*Left*) Drypoint needle, 'Haden' type; (*right*) drypoint needle, 'Whistler' type

Both the *scraper and burnisher* (already described) should be on hand, as these may also be needed for specific work; they generally fulfil only minor roles.

Plates can be of copper, zinc, steel, brass, aluminium or magnesium. Copper is as good as any, and is certainly better than most. Zinc is easier to work, but is too soft; and as the burr quickly wears down, the plate yields even fewer good prints than copper. It can be steel faced but at considerably higher cost than copper. Scratching an image into steel is feasible, but achieving a distinctive burr can be gruelling work. A wide range of less conventional materials have also been tried, some quite successfully. Experimenting with different surfaces is to be recommended.

The number of clear, well-defined prints possible from a plate varies quite considerably. While some printmakers can apparently achieve up to thirty or more, others resign themselves to a mere six or eight. It depends, of course, partly on the materials used, but mostly on individual approach and on the quality of workmanship involved in both drawing and printing. When the burr begins to wear down and the printed impression loses its definition and colour, the plate can, to some extent, be reworked. Reworking a pure dry-point plate, to increase the edition, should be done with moderation. The original and traditional directness or spontaneity is all too easily lost. This applies rather less to supplementary work on etchings or plates involving combined processes.

The possible range of variation in drypoint line is infinite and exceeds that normally obtainable from either etching or engraving. The very finest scratch will print for a time, and the most massive printed line can be made by scoring the heaviest of burrs, and not least, by sensitive inking and wiping. Between these extremes, each line – with or without burr – can be refined even further by scraping, or redrawn again and accentuated. Achieving anything like this potential range is not easy. Trial and error work on an old plate helps considerably to get the feel of the point in the metal.

There is no absolutely correct way to hold the point. The grip most usually adopted is similar to that used when writing or drawing; individual variations on this position are endless. A line scored firmly and cleanly into the plate with a point held in the vertical position will have a slight but positive and even burr on both sides and should give a fine printed line. If the point is used at an angle less than vertical, for example, at 60°, leaning back towards the horizontal plate, both line and burr will be correspondingly heavier and rather less even. The burr will then be forced up only on the opposite side of the line to the point. Simplified, the more acute the angle of the point, the greater and more ragged the burr, even when applying the same pressure. Eventually, below approximately 30°, the burr becomes excessively undercut and rotten, and will no longer stand up to the pressure of printing. It is even possible to cut out

fragments of metal completely by scoring the plate with the point used at an extremely low angle. A blunt, steel point used without much pressure hardly raises a burr; but if used with force it also tends to produce 'rotten' or broken lines.

A mechanical section consisting of straight lines can be made by simply employing a metal rule, and using the (steel) point firmly, at a constant angle.

Obviously, not all drypoint work needs to be linear; as with engraving, all kinds of dots, indentations and textures can be scratched and punched into the plate. Punched marks that may or may not carry a burr are in a way, a variation on criblé, the early – possibly the earliest – intaglio technique (p. 135).

The conventional methods of working described here account for the generally recognized and accepted technique; this, in itself, is almost an invitation, if not for conscious reaction, then at least for an examination and reconsideration of the conventions.

Compared with other methods, many drypointed marks are not too difficult to correct or erase. Very little metal has actually been removed. The burr can be burnished back into the lines or scraped off. But it is still a laborious task to erase a scratch altogether, and repolish the area for either further delicate work or clean printing (see Chapter 12, p. 126).

Since proofing is not advisable due to the fragility of the burred lines, a little black ink lightly rubbed into the lines (avoiding unnecessary wiping) will give an accurate idea of how the printed impression will look. Dry pigment and vaseline is softer and therefore gentler on the burr than normal printing-ink. The completed plate is finally printed more or less as an engraving or line-etching (see Chapter 14, p. 163).

A preliminary drawing, if it is considered necessary, can be made on the plate using carbon paper, although a wax crayon or even a soft pencil (on a dulled surface) will suffice.

STEEL FACING

The term 'steel facing' is misleading; in fact, while steel is employed in the process, the plate is actually faced by a thin coating of iron or, more often, nickel or chrome. This is done quite simply, by electrolysis, which is the electrolytic deposition of hard iron, nickel or chrome on copper. In his book *Etching, Engraving and Intaglio Printing* Anthony Gross gives instructions for setting up equipment in a workshop or department. The cost is negligible, but it does demand the use of a large quantity of water and, therefore, perhaps too much space for the individual printmaker to set it up for himself. This is especially so when process engravers can do the job, professionally, at a very reasonable charge.

Regarding the marked prejudice against steel facing that still persists, there is no reason to suppose that the quality of the print will suffer; should the process go wrong, the coating

can be removed and the operation repeated. The main disadvantage is that zinc plates present a risk and a complication in that they have first to be faced with copper and then steel faced. As a result, they can occasionally be ruined. The advantages are that drypoint, aquatint, mezzotint and pale soft-ground areas become realistic processes in terms of large editions, without the customary wear on the plate and the resulting inferior, weaker prints.

CRIBLÉ

In its early form (possibly earlier even than burin engraving as a printmaking method) criblé was primarily a means of engraving by hammering indentations into a soft metal plate, copper or soft iron (zinc can now be used), with a variety of metal punches.

The print was generally taken from the inked surface, the indentations – often made up of elaborate, dotted lines – being the negative areas. By using a number of punches, each with a different shaped point (round, square, curved, oval, and straight), extremely detailed and intricate designs could be achieved. Gradually, the technique became more elaborate, the burin was more frequently employed as a supplementary tool, and intaglio prints, as well as relief prints, were made. The burr thrown up by the driven punch will hold ink in much the same way as a drypoint. The particular 'metalwork' effect achieved by hammering and punching can be well used in conjunction with other intaglio techniques.

Copper and zinc are both suitable metals. Various steel punches can be obtained from tool-shops (or improvised).

(*Left*) Criblé, dotted: *St Christopher*. Anonymous engraving on metal in the dotted manner. $7\frac{1}{4}$ in. × $6\frac{1}{4}$ in. *Bibliothèque Nationale, Paris*.

(*Right*) Niello: *Evangéliaire de la Sainte-Chapelle*. Anon. $6\frac{1}{4}$ in. × $8\frac{3}{4}$ in. *Bibliothèque Nationale, Paris*.

13 Mezzotint

Mezzotint is an entirely separate technique, quite different in character from etching and engraving or any of their derivatives. It is closer in principle, and especially in the quality of its black, to sharply burred drypoint; yet superficially it is often similar in appearance to aquatint (see pp. 57–8).

Briefly, the essential technique of mezzotint involves methodically and systematically roughening the smooth surface of a metal plate with a serrated steel tool or 'rocker', creating a deliberately uniform, dense mass of cuts and indentations. Each of these minute incisions has a small, but significant burr, serving much the same purpose as drypoint burr. An inked and printed impression of this totally, and necessarily, mechanical ground should give a singularly rich, soft and consistent black. This expanse of black will, if the rocking has been competently executed, be incomparably richer and more uniform than that obtainable from any other intaglio method, with the possible exception of fine, close aquatint. The whole point of orthodox mezzotint is that the plate, once prepared, is worked from dark to light. The effect of scraping and burnishing is, in itself, naturally imprecise. It does mean, however, that an extremely wide range of tonal gradations is possible, which explains the soft, murky character of the majority of existing mezzotint work. It is emphatically not, in any sense, a linear technique and is the antithesis of burin engraving.

Laying a perfect mezzotint ground requires patience, perseverance and unquestionable skill. Already grounded plates were, at one time, much more readily available than today. But even then, the 'creative' process of manually scraping a pictorial effect from the close-textured surface precluded work of any spontaneity. It also tended to discourage the decisiveness so typical of most intaglio methods. The advantages of mezzotint, most particularly the ease with which shading can be employed, are obviously ideally suited to work approaching a photographic realism.

ORIGINS AND DEVELOPMENT

The invention of mezzotint is generally attributed to a German, Ludwig von Siegen (1609–1676?). It seems probable that Siegen began to make prints by the mezzotint

method in Amsterdam from about 1642 – well within Rembrandt's lifetime. It was soon introduced into England, where its more obvious imitative qualities were quickly realized and very fully exploited. It became so completely naturalized that it was even referred to abroad as the *la manière anglaise*. With rather more technical relevance it also became known as the *manière noire*.

Before the rocker tool was perfected, in the late seventeenth century, mezzotint grounds were worked into the plate surface with a widely assorted collection of often personal and improvised tools – rollers, roulettes and files were among those most commonly used. Various kinds of engraved marks, especially stipple, were also incorporated. More frequently, the mezzotint ground was laid only where the actual darks were needed and more or less as the drawing progressed. The complete grounded plate was largely a later development, no doubt made possible by the improved mechanical efficiency of the rocker.

Mezzotint was employed with great success as an accurate method of reproducing paintings between the late seventeenth and the nineteenth century. However one regards the original paintings, the finest of the reproduction prints were extremely accomplished and often surprisingly vigorous. The mezzotints of David Lucas from the paintings of Constable were superbly executed, sympathetic interpretations, rather than exact copies. Soft steel partly superseded copper during the first half of the nineteenth century, increasing still further the already considerable output of reproductive work. Unlike the much older, technically

Mezzotint: *Stoke by Neyland, Suffolk* by David Lucas, after Constable. $5\frac{1}{2}$ in. × $8\frac{1}{8}$ in. *Victoria and Albert Museum.*

more difficult and visually more restricting technique of burin engraving, mezzotint was immediately and almost totally negated by photographic-reproductive methods.

All the established intaglio techniques other than mezzotint have passed through periods of both reproductive and creative development. No school or movement, and very few individual artists, has yet convincingly demonstrated that mezzotint has been anything more than a highly effective, and now long obsolete, copying process. This is not to entirely discount the exceptional and isolated work of men such as John Martin.

A number of artists have had the independence and technical initiative to ignore the imitative tradition of mezzotint and to experiment open-mindedly. The majority of these, even if they were not reproducing actual paintings, still tended to make original mezzotints as if they were interpreting the appearance of painting, almost the qualities of paint. Most of the original, as opposed to reproductive, work suffered, perhaps inevitably, from being stylized and laboured and was nearly always, in a pictorial sense, over-dramatic and theatrical.

Like most printmaking techniques, though to a much lesser extent, mezzotint is currently being re-examined. Among the most interesting contemporary examples of original mezzotint is the work of the Japanese artist Hamaguchi. Used with other related techniques, it could conceivably fulfil a specific role. Mezzotint has been well used in this way in the past; perhaps the most objective and constructive way to regard the technique is to consider it merely as one of a large number of intaglio methods.

TECHNIQUE

Mezzotint rocker tool.

The *rocker* is basically a broad, steel chisel with a curved cutting edge. The underside of the blade is serrated with fine, close-set grooves forming an extremely fine-toothed cutting or rocking edge. Rockers are made in several sizes, the size indicating the number of lines to an inch. A relatively wide-spaced or coarse tool could have as few as 40 lines to an inch, and a really fine tool as many as 120 lines. Two or three tools varying between 50–90 and 60–100 are quite adequate for most work; a good general-purpose tool would have about 50 to 60 lines to an inch. A really coarse rocker will tend to cut and throw up a tougher burr, which will print as a correspondingly denser black. This will, however, create a rough and conspicuously textured working surface, less suitable for delicate shading.

Preparing a working surface is the main, but not the sole purpose of the rocker; it can also be utilized as a drawing tool, to make positive, individual marks, not necessarily intended to be scraped into. Used in this way it can be integrated well with other intaglio methods.

The conventional *scraper*, as used for etching and engraving, can be usefully employed on mezzotint ground; but for precise, delicate work, there are numerous smaller scrapers, either flat, pointed or curved. These tools must be kept perfectly sharp and well polished.

It is not always easy to obtain specific mezzotint tools; they are not in great demand and consequently, very few dealers stock a good selection.

There is even less need for specially designed *burnishers* although they do exist, both as separate tools and as combined scraper-burnishers. Burnishers can be the usual spoon-shape or even conical, and made of either steel or agate. Again, these tools should be constantly maintained in perfect condition.

Mezzotint: *Cut Pomegranate* by Yozo Hamaguchi. $11\frac{3}{4}$ in. × $13\frac{5}{8}$ in.

Mezzotint scrapers.

Single- and double-wheel roulettes.

Most *roulettes* used in making mezzotints grounds are identical with those used in etching (on hard ground), stipple and crayon methods. These small mechanical tools can, with careful handling, effectively emulate the rocker and replace – in small areas – an overscraped and incomplete ground. Rolled onto the surface with firm pressure, they will sharply incise and tear up a servicable burr; and they are invaluable – perhaps only in the context of mezzotint work – for completing or accentuating fine texture. The roulette can function equally well as a grounding tool or drawing implement, as it works from light to dark.

For re-laying noticeably larger areas of clean scraped ground, a smaller hand rocker or patching tool, of 120 lines to an inch, is to be preferred to any roulette.

Prepare the ground by systematically rocking across the copper plate, in single, straight, close-laid lines; horizontal, vertical and in both directions diagonal to the plate edge. A few drops of oil may be applied to the plate. The rocker tool should be held in an upright position and worked into the plate with even pressure. During this process, no line must cross or converge with previous lines in the same direction. This is to avoid spoiling the essentially mechanical uniformity of a good ground. The best way to avoid spoiling the ground is to draw preliminary guide-lines on the plate with a wax crayon; complete the rocking in that direction, then repeat the operation, drawing and rocking in another direction.

The working procedure is continued until the face of the plate is totally and thoroughly roughened into a regulated and closely compacted mass of minute cuts and burrs. A good, clean proof of the plate at this stage should give a dense, heavy and unequalled black. Without adequate practice and without experience of the printed impression, it is extremely difficult to achieve sufficient density.

Not all the plate surface needs to be grounded before scraping is begun. It can be prepared section by section, as required. Nor is it necessary with mezzotint to take for granted the pictorial convenience of the rectangular plate.

For a detailed, preconceived design, an engraved or etched outline can be made prior to grounding, but it must be made strong enough to show up under the burr. Alternatively, a plan of work can be lightly indicated by tracing directly (and with minimum pressure) onto the grounded surface with a wax crayon.

Mezzotint grounds can also be applied with the aid of special apparatus. Hand rocking has always been, at best, an imperfect method of laying a ground. This need not always be a disadvantage. Hand rocking does give one complete and direct physical control of each stage of the cutting; and absolute, total uniformity is not, in every case, the only consideration. Should a correct and faultless ground be required, the rocking apparatus, if properly used, undoubtedly produces the best possible result. Normally, the apparatus includes a rocking pole, folding stand and pro-

tractor square. These may vary somewhat, according to the make, but are generally the same in principle. Whenever possible, the manufacturer's instructions should be observed.

The following description of the use of the apparatus is taken from the catalogue of a former dealer (Kimbers Etching Supplies Ltd, London).

'The apparatus consists of a light but rigid rocking pole, at one end of which the mezzotint tool is held, and at the other end is a heavy spherical pivot free to travel in a grooved rail, which is fastened to the table at one end and supported by feet of adjustable height at the other. A special protractor square is included, which enables parallel lines to be ruled with chalk or soft pencil on the plate of greatest width that can be rocked by the usual size ($2\frac{1}{2}$ in.) tool without digging in at the corners. On the head of the square are two tables of angles, suitable for the different classes of mezzotint ground, one for the coarser and another for the finer, so that the plate may be rocked the requisite number of ways without working twice at the same angle. The method of working is as follows: The protractor is set to the first angle in the table selected, and the plate is ruled with parallel lines at this angle, their distance from each other being the width of the protractor blade, and then placed on the bench so that the first space between these lines is straight with the grooved rail. The rocking tool is placed at the nearest edge of the plate and rocked with the hand, so that it just passes each line, and at the same time gently pressed forward to enable it to travel the correct distance according to the coarseness of the tool, this being easily obtained after a little practice. The plate is then moved, so that the second space is straight with the grooved rail, and the rocking done as before. This is continued until the whole plate is covered with the rocking marks in this direction. The protractor is then set to the second angle and parallel lines ruled as before on the plate, and the rocking proceeds as above. The whole is continued until the plate shows a perfectly even ground.'

It may take days to achieve a perfectly rocked ground. Before embarking on such a lengthy and laborious task, it would be as well to consider carefully whether or not another technique would be equally or even more appropriate. The most practical alternative is usually aquatint (Chapter 4), a much more flexible technique. A plate can also be pitted all over by various methods, such as coarse sand-blasting, or even to a lesser degree, by running it through the press under a sheet of gritty sandpaper (p. 63). It can be roughened by abrasives, and carborundum stones.

A modern version of mezzotint was developed in America (Pennsylvania Art Project) in 1939. The entire plate surface is scored with a levigator and carborundum crystals, a mezzotint-ground effect being achieved with much less effort and time than conventional working.

Soft-ground textures (Chapter 3) are also useful for

(*Left*) Drum roulette; (*right*) American roulette.

certain kinds of tonal areas and for scraping into; they can never have the intensity or the uniformity of mezzotint.

A simple and crude means of achieving a large area of tone is by line-etching. This can vary between light, mechanical cross-hatching, and areas of freer, more varied, but closely drawn parallel lines. The tones are dependent on the weight, the density and relative spacing of lines and by controlled biting. As a general rule, this multi-linear tone, at least in a 'pictorial' context, tends to intrude overmuch and at worst looks blatantly contrived.

But none of these more or less tonal or textural methods, with the single exception of aquatint, can be seriously considered as realistic alternatives to true mezzotint.

To create an area of pure white, the ground (at the relevant point) must be completely scraped down and the surface repolished. Between these extremes – the solid black background and the polished highlights – every intermediate tone has to be scraped and in most cases burnished. A normal approach would be to begin with the larger, middle greys, scraping deliberately and evenly to avoid causing scratches and ridges. The action of scraping is similar to that used in etching, but scraping to diminish or erase an etched mark is usually a more straightforward operation than scraping and organizing a tonal 'composition' from a mezzotint ground.

A clumsily scraped area is all too apparent on print. It is almost always better to remove completely all trace of ground, plus a generous margin, in a spoiled area and replace it by hand rocking. A roulette may also be used to reground a very small section.

Scraping, no matter how flat or even, still leaves an unfinished, harsh surface, mostly printing as a dirty grey. Burnishing and polishing are essential in regaining a clean white; and a well-defined white can be further heightened by 'knocking up' from the back of the plate (as in repoussage, p. 99). Soft, merging greys can also be made simply by burnishing. The possible range of tonal variation is enormous, but the actual work of scraping a complex arrangement of light and dark from a rough, black surface can be arduous and involved; and since the process of drawing from dark to light is the reverse of most techniques, it can be visually perplexing. A partially grounded test plate would be useful for experimental scraping and burnishing.

Printing a mezzotint plate involves basically the same technique as printing most other intaglio plates. There are a number of slight differences, mostly relating to the consistency of the ink and the method of wiping. These points are referred to in the section on printing (p. 163).

14 Intaglio printing: monochrome

Assuming that ultimately an edition of identical prints is to be the end-product, it is necessary to take Proofs of each significant stage in the development of the plate.

Proofing is advisable with practically all intaglio plates, with the obvious exception of a drypoint. The number of 'working' proofs will depend largely on the complexity and progress of the plate and the various processes included, but few plates, unless extremely simple and straightforward, can be worked to completion without adequate state proofs being taken. It is most essential that each proof is carefully and evenly wiped and printed, no less than the final print. A rough proof, often hurriedly made on cheap paper, is quite pointless. The whole purpose of taking a proof is to record exactly the true state of the plate and its printed impression at that stage. Only then can further work be carried out or corrections made.

The time and the effort involved in making a plate are entirely wasted if the eventual print fails to bring out the qualities of the drawing and etching. Conversely, a feebly etched plate is not going to be drastically improved by clever printing. A plate can, to some extent, be 'doctored' and touched up by tactful inking and wiping and the print may look to the inexperienced quite convincing. But to print consistently even a relatively small edition, is quite another matter.

Printing is not a separate activity or technical chore added on to the work of making the plate; the two are inseparable. For as the plate progresses and proofs are taken, studied and even worked upon, and the plate re-etched accordingly, the print becomes the final, but also an integral part of the whole sequence. And if good working proofs can be made, then so can good finished prints.

There is always the possibility of having one's plates printed as an edition by a professional printer, although it must be said that, for most etchers, this is extremely unlikely. Professional printers do exist, but they are few and far between; the great majority of etchers have no choice but to print their own plates. And even if the plate is to be printed professionally, the artist must make his own final print as a guide for the printer to work from.

Obviously, larger editions, of, say, one hundred, are neither practical nor realistic for most etchers. Smaller editions, at least at the present time, are generally acceptable in

terms of galleries and dealers, and should not, therefore, require too much effort. In any case, although it is essential to know, not only how to take prints, but also how to take identical ones, whole editions need not necessarily be made until required. The size of the edition indicated on each print, e.g. 10/45, and the number of prints actually taken is a matter for each individual artist, depending on his own estimation of how many he is likely to need. On the whole, if the edition is small, twenty, for instance, it is perhaps better to complete the work of etching and printing while the idea is still reasonably fresh and the interest remains.

There are many factors involved in making a good print; for instance, the depth of bite, consistency of the inks, evenness of wiping, dampness of paper, correct pressure of press and condition of blankets. All must be considered if an identical edition of clearly defined and evenly impressed prints is to be made.

THE PRINTING-ROOM

Planning the ideal press-room, like the etching-room, is easy enough if one has some experience of making and printing an etching. Most etchers will make their first plates in an existing workshop or college department, the layout of which may or may not be well designed. Even if one does have the opportunity to design or arrange a workshop, the conditions can vary so much that it is mostly a question of making the best of far from ideal accommodation. For instance, it is not always possible to find sufficient room to divide printing from etching, but they should be as far apart as the room permits, and preferably in adjacent rooms. Where several heavy presses are housed together, perhaps in a combined printing department, the press-room is generally on the ground floor, but with a single, small to medium-sized copperplate press this is not so necessary.

Excellent lighting is essential, both natural and artificial (the latter evenly spread), particularly over the press, inking-slabs and hot-plates. Other services such as electric points, gas-rings and a water-supply are equally important. Separate sinks for soaking papers and for washing hands are advisable. A 'hand cleanser' fixed above a sink is useful. Adequate ventilation is another requirement; if the room is also used for etching, ventilation such as a fume-extractor is even more crucial.

Reasonable but not lavish working space is needed round the press, although there should not be more than a few feet between the press and the main working areas; between the press and the sinks or bench where damp paper is kept; between the press and the hot-plates, where the plate is wiped; and between the press and the inking-slabs. The number of benches or tables obviously depends on the space available, but if space is restricted, benches for damping paper and rolling up plates should be given priority. The

other essential working area, the cleaning bench, can be further away from the press.

Used muslin, scrim or tarlatan if not too thickly covered with ink, can be opened out and hung to dry, well away from any exposed flames and heaters. Wet prints, if they are to be dried between boards, can be stacked under benches. Papers in fairly constant use, such as tissue-, blotting- and printing-papers, can also be kept under benches.

Cupboards are needed for consumables – solvents, oils, dry colours, tinned inks, clean tarlatan – and smaller items of equipment, such as inking-dabbers, and especially composition and gelatine rollers. The latter should, of course, be cleaned, maintained and stored in perfect condition. The room will function more smoothly if materials and equipment all have their own place and, in a communal workshop, are labelled where necessary. Boxes or bins for various cleaning-rags and waste paper should also be available.

A fire-extinguisher should be strategically placed near to the gas-rings, hot-plates and heaters. Failing this, buckets of sand and water can be kept in the room.

The actual procedure for printing an intaglio plate in black and white is not, in itself, complicated, nor need it be slow or messy. Even so, there are a number of factors that can drastically affect the quality of the print. Things will inevitably go wrong with the early prints. But, by the time several progressive state proofs have been made, one's competence as a printer should have improved considerably. It will then be possible to analyse obvious printing defects and, to a large extent, prevent them from recurring (see p. 167 for common printing errors).

Good printing demands organization and preparation. The experienced printer will damp his papers, if necessary adjust the pressure of the press, arrange the blankets and prepare the tarlatan, before he inks and wipes a plate. All this is easy to do in the privacy of one's own workroom, but it is always a problem in a busy communal workshop.

In the following section, the methods and materials used when printing an intaglio plate are considered stage by stage, from mixing ink to pulling the print.

INKS

There are several formulae for good copperplate (intaglio) printing-ink; to some extent these vary according to the availability of materials and the etcher's individual requirements. The essential ingredients – oils and powdered pigments – have remained much the same for centuries, but a few of the finest pigments mentioned in the early formulas, such as real Frankfort black, now seem completely unobtainable. Fortunately, there are excellent alternative black pigments that can be readily obtained.

As a rule, most etchers who make their own inks use a formula consisting of varying proportions of two or three

blacks mixed with a copperplate oil, i.e. linseed- or burnt-oil. In this way, the strength, consistency and colour can, if necessary, be adjusted for each plate. One advantage of the powdered, home-made ink – and for many etchers, students particularly, it may be the only advantage – is that it costs significantly less than the manufactured inks.

Most of the following pigments should be obtainable from dealers: imitation Frankfort black; imitation heavy French black; heavy French black; lamp black; vine black (USA); light French black.

The recipe for powdered ink most commonly used nowadays consists of two-thirds imitation Frankfort black and one-third heavy French black. If either of these is not available, the following may be tried: to two-thirds imitation Frankfort black add one-third of lamp black, vine black or lake black (probably synthetic). Ivory or lamp black can be substituted for Frankfort. Vine black can be replaced by lake black. (See Peterdi's *Printmaking*.) Coloured pigments (e.g. various blues or siennas) are sometimes added to the black to create a warmer or colder tone, although a certain weakening in the intensity of the black is inevitable.

OILS

There are three copperplate oils, of light, medium and heavy viscosity, and raw linseed-oil. Copperplate oil is made by burning linseed-oil to a certain temperature – thus light oil is lightly burned, heavy oil is burned until it becomes thick and sticky. Boiled linseed is far too thick to use with ink, nor are varnishes and driers to be recommended.

Raw linseed-oil can also be added to the ink and the copperplate oil in varying amounts. This enriches the black in lines and aquatint and increases the tone of the print. Too much raw linseed can result in a gradual yellowing or staining of the print, especially where there are deeper lines holding a larger quantity of ink. If too much light oil is added, the ink will be too liquid and wipe too easily from the lines, leaving an uneven film, rather than a consistent 'plate tone'.

Room temperatures can affect the ink when printing; for instance, it is advisable to use heavier oils in hot weather, but more raw linseed can be added to the ink in cold weather.

On the whole, it is preferable to begin with a heavier oil and add to it medium, thin or raw linseed-oil, depending on circumstances but mostly on the character of the plate itself.

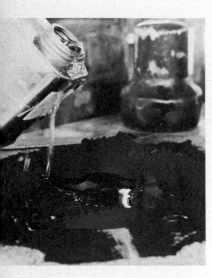

Adding copperplate oil to powdered pigment.

MIXING AND GRINDING

The dry pigments are well mixed on the inking-slab; they are then methodically ground with oils until the correct consistency is achieved. Inking-slabs are made from old litho-stones, thick marble slabs, or sheets of thick plate-glass. Some etchers deliberately roughen the surface of the slab or glass with carborundum powder and water. Two palette-

knives, spatulas or printer's knives (e.g. 8 to 10 in.) and a broad push knife (about 4 in.) would be useful.

First the powder is tidied into a small hollowed-out mound and heavy copperplate oil poured in sparingly. Using both knives, the powder is worked repeatedly into the oil, which is continuously added, until the substance becomes a coarse and turgid mass. At this stage a little light oil or raw linseed can be added. Again, the mixture is force-fully worked into and turned with the knives. Periodically, the spreading ink can be scraped off each knife in turn and gathered in from the edges of the slab. All lumps of dry powder and grit must be crushed and dispersed into the oil. Any grit left in the ink can badly scratch a plate surface. Avoid using unnecessarily large amounts of powder; it is easier to build up the quantity by adding small portions of both pigment and oil. On the other hand, the total amount should never be so large that it cannot later be properly ground with the muller.

A moderately stiff paste is needed before the actual grinding begins; grinding will progressively loosen the mixture. It must be emphasized that, although the ink could be used in this condition, the quality of the printed line, especially in fine work, would be poor. Mixing with palette-knives alone, however thorough, cannot possibly break down all the grit. If this unground ink is stored, even correctly, it may, when eventually used, disintegrate, the powder separating from the oil.

Mullers are usually made of marble, granite or glass (traditionally porphyry). They need to be about three to four inches across at the base or grinding surface, which may also be slightly convex. To grind the coarse oil down, grasp the muller in both hands and work it backwards and for-wards across the slab, over and through the ink. Put as much body weight as possible on to the muller, perhaps inclining the angle of it a little, so that it pulls and pushes the ink on the slab as well as crushing it. Mulling is slow, hard, mono-tonous work, but it does produce better ink. Grinding ink by machine is not particularly recommended because it is so easy to overheat and overgrind the ink.

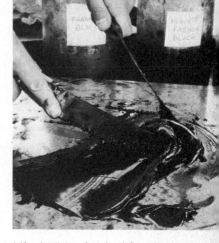

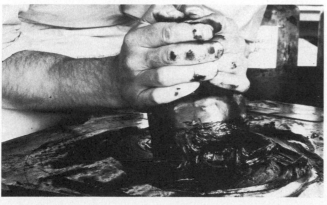

(*Above*) Mixing the ink; (*left*) mull-ing the ink.

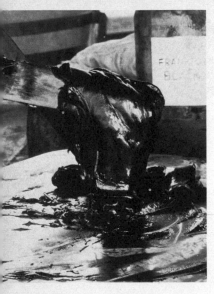
Judging the consistency of the ink.

When examined on the knife, a good general-purpose ink should look and feel more like a thick black cream than a black clay. If the knife is turned over or held blade down, the ink, by its own weight, should fall slowly but cleanly, without leaving any connecting strands of ink hanging from the knife. Ink that runs freely off the knife is far too thin for normal use; more powder should be added and the mixture reground. Finally, the ink can be scraped up and piled in a corner of the slab or stored for future use.

Ink is usually stored in sealed jars and covered by a little water to prevent a skin forming. When required, the ink should again be briefly mixed.

MADE-UP INKS

Black copperplate (intaglio) ink can also be obtained made up in tins or tubes from a number of ink-manufacturers (see pp. 195–7) and etching-suppliers. These inks may vary in quality somewhat; experiment is therefore advisable. Made-up inks are now relatively widely used, though many etchers are understandably, but unnecessarily, wary of tinned ink. The best of these inks (those from Usher Walker in the UK) are perfectly adequate for all intaglio work. They cost more than home-made inks, but have the decided advantage of coming in a reliable and more convenient form.

There is no need to mull made-up ink, but it often tends to be rather stiff. It can, before use, be given a further mix on the slab with a palette-knife, and perhaps a drop of medium copperplate oil added. Altering the consistency depends very much on the nature of the etched plate and the printed effect desired.

To prevent the ink from drying out, lids should be firmly replaced on tins after use and preferably sealed with tape. The contents can, like inks home-made from dry colour, be covered with a little water to prevent a skin forming.

INKING THE PLATE

No plate should be inked and printed without first being cleaned and bevelled.

A plate can be inked when warm or cold, depending on the depth and extent of the etching, and the printed effect required. A cold plate will, as a rule, print with a greater contrast than a warm plate, the blacks being deeper and the white comparatively, though not absolutely, free from 'plate tone'. It is certainly easier to ink and often overwipe a warmed plate. If, however, it is allowed to become too hot, the oil will burn and dry out, giving a weak, toneless print. Only experiment can determine at what temperature a particular plate should be printed.

Proofing is a good opportunity to try various approaches. The first proof, for instance, can be made with a lightly

warmed plate (warm means not too hot to handle comfortably); this is probably the most usual method.

The ink can be applied with a dabber (shaped like the wax-ground dabber, but with a felt or cloth base), dauber or dolly (made of rolled felt, or fronting and tied round with string), or a roller (made of wood, with a felt outer casing). All should be cleaned after use, or kept soft in a tin lid or saucer of oil. Daubers can be recut from time to time. A leather roller can be employed on very large plates.

Whichever article is used, it should never be rubbed or scraped heavily across the plate surface, in case it carries any hard grit. It may be more practical to roll the ink on first, then rock, dab or push it well down into the etched lines with a dabber (a dolly can also be quickly improvised from a piece of tarlatan). Be generous with the first application of ink and gently remove the surplus with a palette-knife.

Inking the plate with a muslin 'dolly'.

Spreading the ink on with the knife is too risky; the knife should never, on any account, be used when inking drypoints and aquatints.

Ink all the plate, even where it is unetched, otherwise the print will be uneven, possibly streaky. All lines must be completely filled; uninked surfaces invariably show up as bright lines or portions of bare metal when examined. Superficial inking will cover many lines, especially deep, fine lines but need not necessarily enter and fill them. This can create a skin of ink over the line which is easily removed during wiping, resulting in a white printed line.

Once a plate is correctly inked and is entirely black, the surface can be wiped progressively clean with a series of muslin rags. Ink is removed from the plate, except where it collects in the cuts, etched cavities or indentations below the surface level.

WIPING THE PLATE

Tarlatan (also known as gauze, scrim, muslin or even starched cheese-cloth) can be bought from most suppliers. It needs to be fairly stiff, but if too hard or coarse, it will merely scrape the ink abruptly off the plate, rather than smoothly and evenly wiping it away; it may even scratch the metal surface. Stiff, starched tarlatan should be thoroughly rubbed until it is quite soft; it may be necessary to wash and dry it first. Unstarched tarlatan and cheese-cloth are far too soft and flabby for wiping.

Three pieces of tarlatan are required, each piece roughly 2 to 3 ft. square – more than 3 ft. square would be too unwieldy. By partly rolling and partly folding inwards, the tarlatan is lightly compressed into three flattish, round pads, rather larger than the hand, but not so large that they cannot be comfortably held. All folds and creases are tucked under the hand, leaving only a compact, smooth, wiping surface. A tight, screwed-up ball is inappropriate, and so too is an untidy, shapeless rag.

Wiping the plate with 'tarlatan'.

Different sizes of mesh can be employed, although one quality is quite adequate for a complete wipe. Lumsden advises beginning with a more open mesh and finishing with a close mesh. Hayter recommends three pads, but of two qualities for easier wiping. An open mesh (already well covered with ink) is used first to complete the inking; a second and cleaner open-mesh pad is used to begin the wiping, and finally, the third pad, of finer, softer muslin is used.

The simplest method is to wipe with three pads of identical mesh (i.e. moderately fine). Ideally, all three pads should, to a varying degree, be already impregnated with ink. A perfectly clean pad, used at any point in the wiping, will tend to overwipe too abruptly.

Wiping is begun while the plate is still on the hot-plate or heater. The first pad contains the most ink (but not hard, dried ink). This heavily inked pad used with a slowly circulating motion, removes some ink from the surface, but at the same time it also ensures that all lines and marks do contain ink. The second pad removes the bulk of the ink from the surface more quickly, leaving the etched work distinctly visible – avoid overwiping the often warmer centre of the plate; the third pad completes the rag wipe, polishing away most of the surface ink. No strong pressure is ever needed on the pads; forcing them down into the line will only drag out the intaglio ink. A thickly inked pad, dragged heavily over the surface, can practically re-ink the plate.

Most of the plate is supported by the hot-plate. One hand operates the pad, while the other steadies the plate by holding it just under the near edge.

Every etcher will naturally evolve his own method of wiping. Initially, movements can involve wiping not too slowly across the plate, from top to bottom, then turning the plate and repeating the action, until it has been wiped equally, in each direction. When a certain amount of the excess ink has been taken up on the first pad, the second pad is brought in, but this time it is used with a rhythmic, circular or rotary motion, gradually working round the whole plate.

Another method is to wipe, from the start, with a circular motion, all over the plate, which is itself constantly turned; or it can be wiped from the centre out, then in from the edges.

This is one aspect of printing that should never, on any account, be hurried. As experience is gained, the movements can be rather less methodical and a little more flexible, according to the worked surface of the plate. If an edition is intended, the prints and therefore the inking and wiping must be as uniform as possible. But the wiping can sometimes be more concentrated around the unbitten portion of the plate, pushing the ink into the etched work so as to avoid any occasional tendency to overwipe.

As each pad becomes clogged with ink, a new layer of muslin can be unfolded and then stretched over the face of

the pad. This is preferable to opening up the whole rag and again compressing it. The rags should be kept and used in the same order until too saturated to be of further use.

If the plate has been uniformly wiped it will show no irregular tonal streaking, and a print can be taken. A rag-wipe print has a consistent, over-all tone, with a trace of shadowy ink clinging to the edges of the lines or areas. Heaviness and intensity can be emphasized by printing the plate warm. An edition of rag-wiped prints may be perfectly acceptable, but a reasonable degree of uniformity can be difficult to achieve.

Two of the main points to bear in mind when wiping a plate are, first, that an edition of prints must be consistent throughout, and therefore a very complicated wipe – especially for a large edition – is simply not practical; second, if the edition is to be printed by a professional printer, it would be equally impractical and unreasonable to expect him to work from anything but the most straightforward of proofs, and the clearest of instructions.

Leaving a film of ink, in varying amounts, over the whole surface or parts of the surface of the plate, is quite normal practice; indeed, it is often essential to the character and quality of a print taken from an etched plate. But as a general rule, it is almost always better to etch the tones into the plate rather than rely on elaborate wiping and surplus ink.

One of my etchings illustrated here necessitated consider-able variation in wiping; the lighter 'water' areas in the centre and the scraped aquatint 'hollows' had to be wiped much more generously than the dark 'earth' areas, particularly those containing deep etch and soft-ground impressions.

Detail of the plate of the subject below.

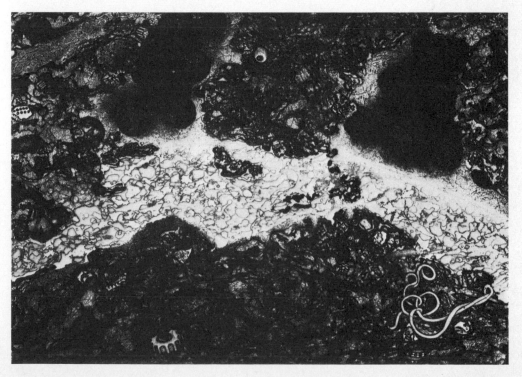

Etching, soft-ground impressions and aquatint: *Water, earth and fragments* by Walter Chamberlain, 1968. 26 in. × 19 in.

Before printing, all bevelled edges and the underside of the plate must be cleaned with a cloth rag.

If a particularly clean, bright, contrasting print is wanted, do not try to rub the plate with a new pad. This will simply increase the surface streakiness and remove too much ink from the etched work. A much more efficient method is to remove the film by hand-wiping.

First, the plate is allowed to cool, by being placed on to the near-by *jigger*, a rectangular wooden box, roughly the same size as the hot-plate, but open at one end. A jigger serves as a handy platform for the plate during the etching processes, e.g. wax grounding, as well as for cold inking and wiping. It can also contain various cleaning cloths.

During the hand wipe, only the flat, lower part of the palm should touch the plate surface; fingers and thumbs are held more or less straight, out of the way. Wiping is done with a fairly fast, but extremely gentle brushing action; the movements are effortless and brisk, rather than tentative or heavy. Minimum pressure only with a dry hand is needed, the sweep of the hand making a brief, hissing sound as it brushes the metal. Too much pressure will mean that the hand will jar and stick on the surface, and squeak as if being rubbed on glass. Each long stroke starts off the plate, and is carried through clear of the plate, otherwise the plate will soon become smudged and handmarked. When the hand becomes too inky or too greasy, it will not wipe the surface clean. Deeply scraped areas to be printed as whites, can also be additionally wiped with a clean cloth, but this must be done carefully and consistently for each print.

It is common practice at this point to complete the hand-wiping with a little whiting powder or french chalk (talc). Work the palm of the hand into the powder, rub off all the surplus dust – well away from the plate – and continue wiping until the plate tone disappears entirely. Use only the smallest possible amount, but add more to the hand from time to time. If any white powder is allowed to enter the lines, it will either badly discolour the ink or prevent the lines from printing altogether. Powder will ensure that the faintly oily plate tone is finally removed. Without this tone, the white of the print will be stark, and the lines and edges most sharply defined.

Jigger.

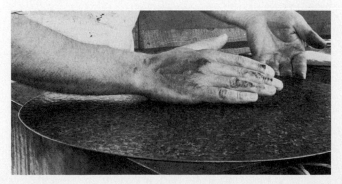

Hand-wiping the plate.

Isolated areas, perhaps within deep, heavily inked work may be further cleaned of plate tone by lightly rubbing over them with a small piece of tissue-paper or newsprint.

Another aid in achieving a particular quality of rich lines and clear whites is to use a soft muslin (a washed cheese-cloth) to draw the ink out of the lines. The method is known as *retroussage* and is employed after the final hand wipe. A neatly folded strip of muslin, slightly soiled with ink, is dragged evenly over the whole surface. No pressure is used; its own weight is sufficient. Unless the lines are very deep and full, the 'liquid' intensity of the blacks can be further increased by previously warming the plate fractionally on the hot-plate. Retroussage is only appropriate on etched and aquatinted plates.

Wiping with tissue.

PAPER

An intaglio print is made by heavily impressing a thoroughly damp and thus softened sheet of paper into the ink-filled lines, pits and hollows of an incised metal plate. The print is virtually a cast taken from the plate, with the ink lying on the surface of the paper in faint relief. Dry, stiff or thickly 'coated' papers are obviously not pliable enough to be forced down evenly, especially into a deep etch or aquatint, nor do they have a surface suitable for picking up and re-taining the oily ink. Many, but by no means all, thin, fragile papers do not have long enough fibres to endure the massive pressure of the printing-press, particularly at the plate edge. A general-purpose printing-paper would, therefore, be thick, strong and unsized. Before it can be printed on, it must be well soaked, possibly for several hours (depending, for example, on the amount of size it contains), and the surface wetness dried off with blotting-paper.

A good printed impression can be taken on the most inexpensive and readily available of wood-pulp papers, such as thin cartridge-paper; even blotting-paper makes an excellent printing surface. Frequently, the cheaper the paper, the quicker it is to prepare, and the easier it is to print upon. This is useful, if only for an urgent working proof or a quick demonstration. But cheap papers invariably look and feel cheap. They often yellow surprisingly quickly and are not, understandably, acceptable to dealers or collectors. Although initially, as wet proofs, they may from some plates give excel-lent printed effects, when dried and flattened they seldom enhance the etched or engraved work. Whenever possible, avoid taking all – and preferably any – proofs on inferior papers. If a proof is to serve any purpose, it should be carefully made on paper similar to that used for the final prints.

The choice of which paper to use, especially when an edi-tion is intended, is of some importance; in etching, the quality of the paper has a great deal to do with the quality of the printed image. E. S. Lumsden gives a first-rate, com-prehensive account of printing-papers for etching in his

book *The Art of Etching*; much of his information on the making of hand-made papers and sizing, especially of Japanese papers, is still useful and relevant today. This account would be well worth reading before buying an amount of expensive paper.

Many of the finest hand-made papers of the kind mentioned in the older handbooks are becoming increasingly difficult, if not impossible, to obtain. It is not likely that the etcher will find a large selection to choose from anywhere; it should, however, be possible to obtain a few really good papers, suitable for any intaglio work, from the main dealers in etching materials.

Ideally, the best papers to use for intaglio printing are the old hand-made papers of pure linen fibre (flax) or cotton rags. Using both linen and cotton gave the paper durability and softness. Also, this paper which was made with relatively short fibres was originally strengthened by sizing. As the paper aged, the size decayed, leaving the paper pliable for impressing. This combination of factors resulted in a perfect intaglio printing-paper. Although this paper is now extremely difficult to obtain, several of the present-day hand-made etching-papers compare favourably with it. Rags are now considered unsuitable for making hand-made papers, since they tend to contain too many synthetic fibres; chemicals or bleach are also detrimental. Raw cotton fibre is more widely used in the manufacture of hand-made paper.

A certain amount of size was considered necessary to make the relatively short-fibred European papers more durable. Too much size, however, prevented the paper from being pushed evenly down into the intaglio areas. An etching paper with only half the normal amount of size·was produced; this was known as 'soft-sized paper'. This naturally required longer to soak than the completely unsized or water-leaf paper. The slightly firmer surface of soft-sized paper, however, is often preferred to the more absorbent and rather vulnerable surface of the water-leaf, which behaves somewhat like thick blotting-paper. At present, the majority of hand-made papers available would seem to be either the unsized, porous water-leaf, or rather well-sized water-colour papers.

Papers are either 'laid' or 'wove', depending on the texture of the wire gauze they were originally placed upon as wet pulp. Laid paper has a slight ridged texture, while wove, being less linear, is rather more suited to tonal areas, such as aquatint.

The surfaces of paper range from smooth or hot-pressed, to medium, or either hot- or cold-pressed, and rough. All are good printing surfaces if used for the appropriate plates – for instance a rough surface is obviously less suitable for fine work. Some hot-pressed water-colour papers may be too hard for intaglio printing, unless soaked for many hours.

Paper also varies in weight; a heavy, soft paper, e.g. 140 to 200 lb., would be needed for a deep, rich, tonal etching. A

light paper is suitable for a clean-wiped, finely worked plate.

Sizes or dimensions of paper are usually royal, 24 in. × 19 in.; imperial, 30 in. × 22 in.; double elephant, 40 in. × 27 in.; antiquarian, 53 in. × 31 in.

'Retree' paper and 'outsides' are the terms used to describe hand-made paper that is very slightly imperfect and sold at less than the normal cost; in all other respects, it makes a first-rate proofing-paper.

The weight of paper is based on the weight of a ream, i.e. 500 sheets of any given size; thus one can refer to imperial 90 lb., double elephant 200 lb. An average-weight imperial paper would be 120 lb., and a large or heavier paper for aquatint or deep etch could be 140 to 200 lb. Smaller, finely worked plates may also require a thin, light paper, e.g. of 40 to 70 lb. If necessary, this paper (especially Japanese) can be strengthened during printing by backing with soft paper or even blotting-paper.

Mould-made papers consist of the same materials as hand-made papers, but are manufactured in rolls on a machine and later cut into sheets. Generally, mould-made papers are easily recognizable by their cut edges, as opposed to the 'deckle' edges of the hand-made.

Among the finest intaglio papers are the Japanese and Chinese (or Indian) papers, made chiefly from mulberry pulp and rice. Generally, these are soft and unsized, but contain longer fibres than European papers, and are often surprisingly strong. Lumsden groups the Japanese papers in the following three categories: white hosho (mostly used for European wood-cuts); torinoko (the best of these vellum-type surfaces, ideal for intaglio work); mino or usumino (a warmer toned paper, rather thin, but with a slightly firmer surface, which may not need sizing). These unsized papers will soon tear if soaked in water. It is essential to dampen them by interleaving them with sheets of damp blotting-paper.

Lumsden also describes a method for sizing Japanese papers (and also English water-leaf paper). Briefly, it involves making a liquid size of well-diluted cooking gelatine and a minute amount of alum, and either dipping the sheets of paper into a bath containing the size, or brushing it on.

Paper is prepared and dampened for printing according to the weight, thickness and the amount of gelatine it contains. For instance, a Japanese paper should not, as a rule, be soaked or even sponged directly with water; whereas thick, well-sized papers may need a generous soaking and should then, while still wet, be kept flat and under pressure for several hours.

Thick, sized papers can be soaked in a sink, dish or bath of water. This should, if possible, be large enough to take the papers unfolded. Both sides of each sheet of paper are passed under a running tap, until any shiny or waxy looking spots and patches disappear; the sheets are then fully and separately submerged in the bath. Air-pockets, bubbles or dry swellings remaining on the surface of the paper or between each

sheet will cause uneven damping, subsequently resulting in a poor printing surface.

The length of time paper is immersed depends almost entirely on the amount of size it contains. A fairly thin, soft-sized paper would probably require no more than a few minutes, or half an hour at the most. In extreme cases, thick, well-sized paper could even be left overnight to soak.

With most intaglio papers it is enough either to soak briefly or dip them separately into water a number of times, or even simply sponge them with a real sponge.

As each sheet is made thoroughly wet, it is stacked neatly between two heavy pieces of plate-glass (or perhaps weighted zinc). Some etchers wrap the paper in a plastic sheet to contain the moisture. Heavier papers, if sponged, may take a little time to swell, and a swelling on one sheet can be built up and increased by each successively placed sheet. Paper must, therefore, be flat before being laid down. The stack is then kept under weights for between six and twenty-four hours. Papers kept in this way for more than a few days can become mouldy.

A little while before printing, the weights and glass are removed and the sheets are interleaved with either clean blotting-paper or medium thick water-leaf paper – the latter being stronger than blotting when damp, and therefore easier to handle and use again. This is not essential; instead, as each sheet of paper is taken from the damp paper stack, it can be blotted separately.

An alternative method is to interleave the damp sheets immediately after damping, with dry sheets and leave overnight; the dry paper will absorb moisture from the damp paper and should, by the next day, be uniformly damp and ready for the day's printing. The edges of the paper retain less moisture and often dry out, in which case the edges can be redamped just before printing.

Paper can be made more receptive to the impressed ink by lightly brushing up the nap of the printing surface (the side where the watermark or printer's name can be read when held up to the light) with a moderately soft, clean brush.

Japanese (and water-leaf) papers, being porous, should only be subjected to the minimum of damp. The safest damping method is first to prepare a number of sheets of well-damped blotting-paper; a single sheet is then placed over several sheets of printing-paper, gradually forming a stack of alternate dry printing-papers and damp blotting-paper. Two or three thick pieces would be quite sufficient between the blotting, but up to six sheets of thin paper can be laid down before being covered with blotting. When left overnight under pressure, the moisture should permeate equally throughout all the paper.

In principle, the etching-press is an extremely simple machine, consisting of a rectangular steel bed-plate or plank driven between two heavy rollers. Bed and rollers are contained by a rigid, often cast-iron frame or stand. The whole machine is necessarily heavy and stable (it can be as much as 2 to 3 tons), since the full length of the heavy bed, holding the intaglio plate and printing-paper, has to be squeezed through the rollers, and extend out in either direction. A bed-plate needs to be $\frac{3}{4}$ in. to 1 in. thick. Small stops are usually fixed under both ends of the bed-plate, to prevent it from sliding completely through.

Some etchers cover most of the steel bed-plate with a sheet of zinc, supposedly to create a base of greater resilience for the intaglio plate. Others use several sheets of blotting-paper, partly for the same reason and partly to avoid altering the set pressures.

The maximum size of a plate – if it is to be printed – should be roughly 3 to 4 in. less than the width and 1 ft. short of the length of the bed-plate. This allows $1\frac{1}{2}$ to 2 in. on either side for the paper and 1 ft. for the roller at one end.

The lower roller, which is more a hollow cylinder or drum about 12 in. in diameter, turns freely on bearings to support the sliding bed-plate. (The bed-plate must be level on the lower roller.) The upper roller is made of solid steel, about 6 or 7 in. in diameter, with a spindle of at least $1\frac{1}{2}$ in., and supplies the massive, downwards pressure onto the bed-plate. Pressure on this roller can be adjusted at both ends by means of a screw mechanism.

The actual drive can be either direct or geared; but with a fairly large bed-plate, that is, over 20 in., a press is extremely difficult to turn unless geared. In most cases, a larger direct drive (direct to the upper roller) has a star wheel-type handle, whereas the geared mangle presses, whether single or double geared, are turned by a flywheel. Direct-drive presses, turned by star wheels, are sometimes preferred because the amount of pressure on the plate can be felt more accurately. Large presses with longer rollers are invariably double geared, in order to turn both ends of the upper roller equally.

Generally, the larger and therefore the heavier the upper roller is, the more powerful the press, regardless of the width of the bed-plate, and, theoretically, the finer the printing quality. Presses with small (less than 6 in. diameter) upper rollers, such as the portable or table kind, are not widely recommended for serious intaglio work. These are, in a comparative sense, inferior presses, but nevertheless they can, with care and effort, be usefully employed for smaller plates.

A press, particularly a geared press, can also be motorized. It need not, apparently, be a very costly or complex job. Peterdi gives a very useful account of how his press was

motorized. He points out, however, that although it eases considerably the sheer labour of printing editions, it can only really be justified by a great deal of printing, or if the etcher simply cannot physically cope with the work of printing. A group workshop or college, however, could well consider such a press.

Some quite successful home-made etching-presses have been built, usually by converting large mangles. Anthony Gross gives a brief but interesting account of how two presses were recently made by an American printmaker, one converted from an old visiting-card press.

Comparatively few etchers actually own a printing-press; most have to rely on presses provided by group workshops and fine art or graphics departments of colleges.

A number of good etching presses are now being made in Europe and the USA, in most, though not all, cases, they are based on traditional, proven designs, but these are expensive to buy. To take the largest sheets of hand-made papers (in England, antiquarian, 53 in. × 31 in.) a press would need to have a roller of at least 36 in. with a correspondingly longer bed-plate. This would be regarded as large, although there are presses with rollers of 50 in. Presses with rollers of 19, 23 and 28 in. are standard, and are in fact made to take the appropriate sizes of hand-made papers (e.g. a 23-in. roller would take an imperial sheet of 22 × 30 in.). Anyone ordering a new press would reasonably expect most manufacturers to deliver, assemble and set up the press.

The demand for second-hand copperplate presses, especially reconditioned models, capable of taking relatively large plates, is far greater than the supply.

Blankets (or felts) are essential in that they provide the necessary soft, almost elastic layer between roller and plate. Without this layer, the roller, regardless of pressure, could not evenly and fully impress the damp paper into the ink-filled intaglio work.

The number of blankets employed for printing varies between two and five although three to four are more common. There are several variations on the number and type used, but generally one can print with either three blankets of medium thickness and identical quality or four blankets, one or two of these being of the thinner, fronting material. The main advantage of using a number of identical blankets is that they can be constantly interchanged, and so kept soft and reasonably dry.

The best material to use is pure, soft wool, preferably as closely woven and of as fine a quality as possible. The thicker blanket is generally known as swan-skin or swan-cloth, and the thinner material as roller cloth, cylinder blanket or, more commonly, fronting. Only the finest, closely woven blankets are placed next to the paper (a coarse woven blanket would produce an uneven print, especially on a tonal area). The quality of the print depends to a large extent on the quality of this front blanket. Closely woven, wool blankets

are expensive, but at least one is essential in a set if the coarser material is used. Pressed wool is a useful, cheaper, but inferior substitute.

All blankets must be kept perfectly clean, soft and resilient and so need fairly frequent washing. Stiff, unyielding blankets, caused by constant pressure and by absorbing the damp size from the printing-papers, will mean poor, ill-defined prints. Trying to protect the blankets from damp and size by covering the printing-papers with a sheet of blotting is not recommended. This backing may be necessary on extremely fine printing-papers, such as Japanese mino, but with most papers, it will only reduce the soft, malleable surface of the fronting.

Blankets are all too easily cut by excessive pressure, unbevelled plate edges or extra thick plates etc. Some alternative form of blanket could be tried, such as thick rubber, for heavy embossed plates, e.g. welded or built-up plates. A smaller set of conventional blankets should also be kept purely for small-sized plates, as a full-size set constantly used over small plates will gradually become worn in the centre.

Damp blankets should be hung up to dry overnight and never left on the bed of the press or under the roller. Two sets of blankets are useful if much printing is likely, as one set can then be washed and left to dry while the other is in use. Stiff, dirty felts should be washed in warm water and left to soak for a few hours; a little soap-powder and a drop of ammonia can be added. They should then be rinsed and the water carefully squeezed out, perhaps by rubber rollers; they are dried not by hanging up – this can spoil the shape – but by separately laying them flat on sheets of absorbent paper, which is renewed as it becomes sodden.

ADJUSTING AND SETTING THE PRESSURES

First the bed-plate is reasonably extended. Both set screws or gauges are firmly tightened down. These are then unscrewed equally, on both sides of the press. When sufficient space is visible between roller and bed-plate, the blankets are laid down, one by one. Fronting is laid first, then the covering blankets, each one slightly stepped back to allow the roller to grip and ride easily and smoothly over them. All blankets should be neatly and squarely placed flat on the bed-plate. If necessary, the bed-plate is moved in slightly until the blankets are just under the roller. Both screws are again tightened equally, until some resistance is felt; the pressure is then approximately correct.

At this point, the pressure can be tested with an un-inked trial plate. It is preferable to use an old, etched plate, containing varied work and some deep etch across the whole plate surface.

The blankets can be folded back over the roller (a blanket 'rail' across the top of the press may be fitted for this purpose), taking care, especially with full-length blankets, to keep them clear of any grease or oil on the runners. The trial plate is placed centrally on the bed-plate and covered by a sheet of damp printing-paper (dry blotting-paper may also be used). Each blanket is lowered onto the plate and all are smoothed down. The press is turned and the plate taken fully through. If it seems that unreasonable effort is required to turn the handle, do not persist; return the bed-plate and release the screws a little more. Brutal, excessive pressure can cut right through a set of blankets. If the pressure is even on both sides of the roller, the blank print, when examined in a side light, will show a clear, embossed and uniform impression, the intaglio work showing as relief. A slight adjustment can be made to the appropriate set screw should the print betray any unevenness.

If an already marked plate is not available, a new (but bevelled) plate can be used. A line is drawn diagonally across the plate with coloured chalk or litho-crayon; any marked inconsistency in the printed chalk mark will denote uneven pressure.

An apparent hollow in the centre of a marked plate, showing as an unaccountably paler area on the print, may be due to faulty setting of the lower roller or even a worn roller, although it is more often the plate itself or the condition of the blankets. This is usually remedied by packing under the plate with various thicknesses of paper. A precise area can be built up by cutting the appropriate area out of several proofs and sticking these successively onto the back of the plate. Prints are taken until the desired thickness is obtained.

It should be emphasized that only the minimum effective pressure should be used. Unnecessary pressure will prematurely wear out the plate (and in extreme cases even warp it) and ruin drypoint and aquatint. It will also tend to produce a shiny surface on the print and poorly defined, blotchy lines. Insufficient pressure over the entire plate is easily solved by uniform adjustment.

TAKING THE PRINT

When all possible preparations have been made, and in the most practical order; i.e. once the paper is already sufficiently damp, pressures on the press have been suitably adjusted (fine adjustments may be made during printing), blankets have been neatly arranged over the roller, and the plate is inked and wiped, then the actual print (or proof) can be taken.

To ensure that the printing-paper is placed squarely and accurately over the inked plate (especially when several prints are to be taken), first mark out the bed of the press with a crayon or pencil. This is easily done by drawing round a spare, dry sheet of identical printing-paper, carefully placed with the long edge in line with the edge of the

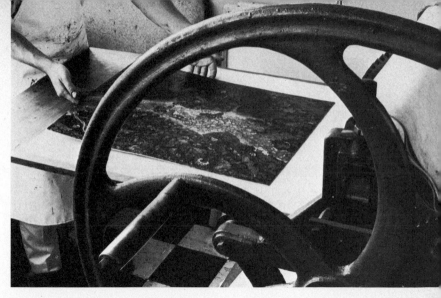

bed-plate. Alternatively, first tape a sheet of blotting-paper down as a base, and indicate on this the position of the plate and printing-paper.

The plate can be warmed very slightly on the hot-plate (which should be kept warm for this purpose) so as to loosen the ink and give a richer, darker tone to the print. This may not be necessary, although it is best to try out both warm and cold printing and compare the results. Make sure that the underside and edges of the plate are clean.

The bed-plate is sometimes covered with tissue-paper or newsprint to keep the printing-papers perfectly clean. Place the plate face up and square onto the marked bed-plate. A small thick plate may need a sheet of blotting-paper placed under it; this allows the plate to sink fractionally into the soft blotting under heavy pressure, taking some of the strain off the blankets. A larger plate is normally placed in line with the long edge of the bed-plate and not across it. This is un-avoidable when working with the maximum size of plate and paper the press can contain. However, a small plate – one that fits easily within the width of the bed-plate – may be placed across the bed. In theory, there is then less risk of the paper moving or stretching, or the plate curling up. In fact, if the press has been correctly set up and the pressures correctly adjusted, this should not happen, even with the longest of plates. Although it is advisable to position the plate reason-ably centrally on the bed of the press, the actual direction in which it is printed may depend on the kind of work it contains. For instance, a plate with deeply etched or engraved lines running predominantly along the length of the plate, may print perfectly well in one direction, but quite disastrously in the opposite direction. It often happens that the ink contained in the lines is squeezed out in the direction of the rolling. A smaller plate with similar work can always be placed across or even, if necessary, diagonally on the bed-plate for printing.

The printing-paper is finally checked by drying off any remaining water spots or shiny damp surface with clean

blotting and gently brushing up the nap; above all, the paper must be uniformly damp. Small folded hinges made of card or thin metal (already prepared) should be used when carrying the damp paper. The paper is lifted by holding it from corner to corner (diagonally), and is held fairly loosely with the printing side face down. In this way, the paper can be carried across to the press without tearing or creasing it. Also, it is easier to lower it down exactly onto the plate. (Once the paper is laid onto the plate, it is very unlikely that it can be moved again without being smudged by ink.)

A sheet of tissue-paper is sometimes placed over the printing-paper, partly to protect the paper from any mark on the blankets, and partly to prevent the blankets from absorbing too much damp and size. But if blankets are frequently washed, protective tissue is unnecessary.

The blankets are rolled down onto the bed-plate. They are then pulled taut and carefully smoothed down over the plate. The plate is then taken through the press. Avoid stopping (unless the pressure seems excessive) until the plate passes under and clear of the roller, otherwise an obvious stripe may appear across the print. It is advisable to keep the blankets flat and taut as they are driven under the roller. Turn the press quite slowly, extending the bed far enough to allow the print to be taken out.

The print is removed from the plate by holding a corner, or preferably two corners, with the hinges, and lifting it slowly, carefully and very gradually off the plate. Pulling it too hurriedly can cause the paper, especially the surface of soft paper, to tear as it clings to the ink-filled intaglio plate.

In a few cases, a second printing or a 'double run' can be made to ensure a really positive print. This may be tried out on a particularly rich, heavily embossed and dark toned plate, where the deep intaglio work will serve to grip the impressed paper firmly. But a fine, delicately bitten plate would almost certainly show signs of a double image.

Removing the print from the press.

With a straightforward black and white intaglio plate, there is certainly no need to clean the ink completely from the plate after each print, although it occasionally happens that ink can build up after a number of prints, and thicken inside the lines, thus reducing the strength of the intaglio printed line. In this case the plate must be cleaned and the ink re-mixed – presuming it is the ink that is at fault.

PRINTING OTHER INTAGLIO PROCESSES

All intaglio plates are printed in much the same way, whether they are deep etched, finely engraved, drypointed or worked entirely in mezzotint. But every plate must be individually considered, and there are a number of variations on the normal printing procedure, peculiar to each technique or process. For instance, an engraved plate often needs a heavier printing pressure than an etched plate, and a drypoint plate needs less pressure than an etched plate. Most variations are, as a rule, quite minor but they can make all the difference to the quality of the print.

Engraving. As a general rule, engraved lines are cleaner and smoother than etched lines. A rag-wipe print would tend to cloud what is essentially a cut, as opposed to a scored or corroded, incision; retroussage would make the printing line even more heavy and imprecise. Hand-wiping the plate, probably helped by a little french chalk (talc) would be more appropriate.

The consistency of the ink should be liquid and rich, rather than stiff and heavy, but not so oily that it leaves an uneven film round the lines. A little raw linseed can be added when mixing the ink.

A plate that has been extensively and deeply cut will print better on a moderately heavy paper. Printing pressure also needs to be greater for an engraving than for most etchings.

With a *drypoint* plate, the whole printing process, from inking and wiping the plate to running it through the press, needs to be carried out with the utmost gentleness. For instance, it is essential that the blankets are soft and fluffy. Printing-paper should be heavy and soft, to bring out the characteristic burr.

The ink needs to be more dense and sticky than the ink used on an engraved plate; it must not be stiff and heavy, nor too thin or liquid. Thin and medium oils are quite adequate for the ink mixture.

A careful rag-wipe print is advisable; hand-wiping, particularly with french chalk, is not sympathetic to the qualities of drypoint (nor to the durability of the burr).

Pressure on the press should also be considerably reduced.

Areas of *aquatint* require both rag-wiping and hand-wiping, most probably with french chalk, otherwise areas of varied tones will often merge, lose their definition and transparency and become muddy. Retroussage can be used to enrich dense tones, usually after hand-wiping.

A heavy (preferably wove) paper takes aquatint better than a thin paper, although thin, soft paper can always be backed with water-leaf.

The ink should be heavy, but not stodgy. If, when wiping a plate, an area of aquatint is streaky in the direction of the hand-wipe, it is usually because the ink is too thin.

In *mezzotint*, rag-wiping should, whenever possible, be avoided; the mass of tiny burrs will constantly catch and tear away the muslin threads. If too much ink is applied, the surplus can be lightly removed with an inking tarlatan, but normally the plate is hand-wiped only. Initially, the plate will need a very thorough inking in order to fill in all the indentations equally. An ink made with heavy oil is used.

A grey or murky print is either due to the ink containing unsuitably thin oil, or it may be that the burr is not positive enough.

DRYING AND FLATTENING

By far the simplest, most convenient and most sympathetic method of drying and flattening an intaglio print is to compress a whole stack interleaved with dry blotting-paper and boards under moderately heavy pressure. But as with most accepted methods there are several versions of how to proceed.

The usual method involves leaving all new prints to dry for twelve to forty-eight hours (they can be left much longer, perhaps for three to four weeks to ensure that the ink is completely dry). As the prints are taken, they can be stacked loosely between dry blotting, to absorb excess water, or placed on open racks.

If a fresh print is put straight down under blotting and weighted boards, any raised emboss and plate mark will be crushed, and the wet ink may offset onto the blotting. Newly pulled wet prints are sometimes protected with tissue-paper before pressing, but this can also stick to the ink, and later, when the ink has dried hard, the tissue may have to be removed by gently soaking. Tissue-paper also restricts flat drying. It can, however, be more safely used on prints after twelve hours.

When the ink and the emboss are sufficiently dry, the prints – which will, meanwhile, have buckled – are all moderately redamped. Water-leaf or Japanese paper, even after twelve hours, can be pressed with only the minimum of damping. Thick, sized paper may need completely resoaking for a number of hours; these take longer to soak and longer to dry.

Each print is carefully dried off by blotting, and the dry-inked printed area is covered with a sheet of tissue-paper. It is then neatly laid between sheets of clean blotting-paper and completely covered with a board ($\frac{1}{4}$ in. chipboard or 3-ply is preferable to thin cardboard). This is repeated until the

(*Opposite*)
Etching: detail of *Labyrinth in Nature* by Rowland Box, 1967. Single zinc plate etching – intaglio and stencilled relief. $26\frac{1}{2}$ in. × $17\frac{3}{4}$ in.

stack is complete. Pressure should be fairly light at this stage, but it can be gradually increased during the next day or so.

Blotting-paper must be changed fairly frequently. Prints left for any length of time (a full day or more) between damp blotting, may not dry flat.

A slightly more elaborate version suggested by Gross involves resoaking the dried prints and leaving them – the print area covered by tissue-paper – under heavy plate-glass for possibly several hours, until the fibres are thoroughly wet and soft. They are then placed between dry water-leaf paper until suitably damp. Finally, they are stacked in the normal way, under pressure, covered with tissue, clean blotting and board. This is repeated on the next day and, if necessary, on the day after that.

Most prints should be reasonably dry in twenty-four hours, although some, especially on thick paper, may need three to four days of drying and flattening. Prints prematurely removed from the stack will soon start to curl up.

A system of clamping down the boards with steel bars and some form of easily adjusted screw attachments at each side should not be too difficult to make. The whole object of pressing prints is to even out the pressure over the whole paper area. A heavy object, placed in the centre of the top boards, will not provide the essential, even distribution of weight.

A print can, if necessary, be quickly dried by the same method used for stretching water-colour paper; that is, by laying the damp print flat on a stiff board and taping firmly round all the edges. There must be no gap in the taping, or a crease will form and the print will have to be soaked again. The disadvantages of this method are that much of the emboss, including the plate mark and any white relief, will completely disappear, and even the admittedly slight contraction of drying paper can affect fine, close work; the taped edges of the paper will have to be cut off, which would spoil a good print on hand-made paper; and it is obviously not practical to stretch and dry an entire edition in this way.

ERRORS

If a faulty print is pulled – and occasionally this is inevitable, especially when trying out new materials and methods – it is always worth while trying to trace the fault in order to prevent it from recurring. Assuming that the plate itself has been adequately prepared, i.e. worked, inked and wiped, the following obvious sources should first be checked.

A poorly defined, disappointingly pale impression could be due to stiff blankets, inadequate or uneven pressure, dry or even unnecessarily wet paper or thick ink. Blankets are easily checked; pressures can be verified by examining the emboss – or running the plate through uninked. Paper is less accountable, but take the next print on paper which is more or less damp. A lighter oil can be mixed in with the ink.

(*Opposite*)
Etching: detail of *Labyrinth III* by Rowland Box, 1968. Single zinc plate etching – intaglio and relief, employing three colours of different viscosity. 18 in. × 14 in.

Ink running out of deep-etched or engraved work and onto the print is usually a result of the ink being too liquid, the pressure being too great and, in certain cases, deep intaglio lines running off the plate enabling the fluid ink to be squeezed along. The remedy is less pressure and heavier ink, if possible, printing the plate in another direction.

A print can sometimes stick to the plate and tear when removed (more common with two or more plate colour prints). This might be because the ink was too tacky or insufficiently wiped, and again the pressure may be too great. If the print cannot be removed without tearing it, gently rewarm the plate on the hot-plate until the ink is loosened; the print should then peel off easily. Try more pigment with the ink and perhaps a thinner oil. Avoid warming the plate before printing. Pulling the print too abruptly can also cause tearing. Very damp paper is sometimes inclined to leave strips of surface paper adhering to the plate.

A shiny print surface is usually due to excessive printing pressure and possibly to hard, sized blankets.

If a large plate fails to print well in the centre, it could be due to an uneven plate, or possibly to overheating that portion of the plate and/or overwiping. An uneven, hollowed plate can be backed with areas of paper or old proofs.

Doubling of lines can be caused by the plate, perhaps slightly buckled, moving fractionally sideways or undulating, on the bed. It may also be a result of unequal pressures on the set screws.

Creases in the print are generally caused by poorly prepared paper or by wet or stiff-sized blankets. As the blankets actually move an inch or so during printing, they could, if particularly stiff or damp, drag the paper into a pressed fold or pleat.

Lines that fail to print consistently may be due to several factors, such as inadequate inking, dry ink or paper, or insufficient pressure. Both plate and print should be examined. In the case of the plate, if wet ink is still in the line, the pressures can be increased. The paper should be checked again for its suitability for intaglio printing and whether or not it is too dry. Also, check the emboss; if this is adequate, then the bad printing could be due to dry ink rather than to inadequate pressures.

15 Intaglio printing: colour

An intaglio plate can be printed in a coloured instead of a black copperplate ink, simply by using the normal inking, wiping and printing methods. The single-colour intaglio print is, however, quite rare. The majority of colour prints are made up of a minimum of two colours and frequently involve more than one plate.

Printing a plate in a single, dark colour – e.g. an ink made from a mixture of blue and black or brown and black – is not, in the accepted sense, colour printing; such prints still depend primarily on monochromatic tonal values.

The main disadvantage of printing with a single, lighter toned colour, such as a pure blue, is that the colour will actually appear darker on the heavier, deeper work; reasonably true or pure in the more medium range of bites, such as open bite; but will be pallid and anaemic in the lighter, shallow bites. The tonal values will, therefore, appear to be extreme, even discordant, and yet, at the same time, more limited. This is more obviously seen when printing with a primary colour from a plate that has been conceived, drawn and etched entirely for black on white printing; although it is unlikely that such a plate, especially a linear plate, would print successfully in colour, whatever method is employed.

As a general rule, copper is a much more suitable metal for colour printing than zinc. Very few coloured pigments react badly to copper, whereas a number of colours are changed by contact with zinc. Mild steel is even more reliable than copper. All should be tried out; even with zinc, there are some colours that are more or less unaffected. To some extent, the consistency of the ink and the type of etched or engraved work, are factors to be considered. Inks applied by roller even on zinc are seldom affected.

A traditional approach (used extensively on hand-coloured engravings, aquatints and mezzotints) was to apply several colours (intaglio) to various parts of the plate surface by separate dollies, then wiping each area clean. Some overlapping or merging of ink is inevitable and indeed, may be deliberately sought; but for conventional editions, and unless the inking and wiping are extremely well done, this method is generally considered too imprecise, and the prints too variable.

A simpler and normally more accurate way of combining two or more colours is to use separate plates for each colour, overprinting on to the same paper.

The quickest and most effective way to apply two different colours to a single incised plate is to ink and wipe as normal, then roll a second colour over the raised or unetched surface (as in surface printing, p. 176). An additional colour is introduced, but the intaglio quality is, more or less, retained. A good many modern colour prints have been made by variations on this method, i.e. by combining intaglio printing and surface relief printing on one or more plates.

Another useful variation includes rolling ink through cut stencils laid over the plate surface, so that colour can be confined to specific areas.

The viscosity of inks can also be varied; these are then applied by hard and soft rollers to different levels of bitten plate.

An intaglio colour print can also be made by incorporating other autographic printmaking methods, such as screen printing, lithography and woodcutting. The possible combinations on all these methods seem to be inexhaustible.

Practically all contemporary methods now in use were developed between the twenties and the mid-fifties (simultaneous printing from intaglio and surface was practised at Atelier 17 in the late 1920s). Experimentation with colour printing, particularly with inks, pigments and oils, has increased over the past two decades, but judging by work from many countries in the major international print *Biennali*, printmakers still employ techniques based closely on one or other of the methods already referred to.

The range of colours obtainable from predominantly intaglio plates depends, to a great extent, on the range and distribution of etched or incised marks on each plate. It may, therefore, be even more necessary to employ a greater number of different intaglio techniques for a complex colour print, than for a black on white print.

Most of the apparent development in colour etching can, in fact, be attributed to other factors, not necessarily related to colour work, e.g. a more liberal use of shaped as opposed to rectangular plates, and the distribution of these over the paper; the inclusion of photographic images, often in combination with other autographic processes; a greater resourcefulness in the substances and surfaces used to print from; a wider range of inks (e.g. metallic) and materials for printing on and embossing into.

Recently, the intaglio colour print has been much less in evidence in the galleries than, for example, the screen print, particularly the photo-screen print. The qualities of an impressed print taken from an incised plate and especially a linear plate rarely have the immediate visual impact of contemporary screen prints.

The preoccupation of a good many present-day etchers with the technical complexities of viscosities and overprints has, in many ways, restricted intaglio colour printing to a rather narrow area of private and esoteric research, which has little, if any, relevance to wider developments in art.

The introduction of the photo-etched image to the colour print may, to some extent, inject some life into what has already become an over-refined and rather precious art form.

The following methods are here simplified and separated into a number of possible approaches to colour printing. Various combinations of these methods may be used on each print.

1 *The application of two or more intaglio colours to a single plate (based on the traditional 'à la poupée' or 'dolly' colour method)*

A specific area of the plate surface (etched, aquatinted or engraved) is carefully inked up with a dolly (dabber) con-taining a coloured ink. The area is rag-wiped and hand-wiped, as normal. Separate tarlatans are used for each colour. A second colour is then applied to another area; the process may then be repeated until the plate is completely inked and wiped.

The number of colours involved will depend on the nature of the plate and on the manipulative skill of the printer. Each colour can either be confined to a certain area, which may or may not be dictated by a drawn contour on the plate (difficult to do, but easier to repeat), or it can be deliberately merged with another colour. In the latter case, the overlapping of wiped colours will produce characteristic plate tones or tints. When wiping colours, with maximum separation desired, try to wipe away from, rather than towards and over an adjacent colour.

It should be remembered that shallow bitten lines, aqua-tints and open areas tend to print exceedingly pale, regardless of the intensity of the coloured ink.

This so-called 'dolly' (dabber) colour approach is the most obvious and direct way of applying colour to a plate, but it is not by any means the easiest method to control.

Multiple plates can also be employed; it is worth bearing in mind, however, that when more than one plate is used, overprinting can (but need not) further reduce the trans-parency of the colour and progressively flatten all previous embossing.

Coloured inks. Dry powdered pigments mixed and ground with oils (in much the same way that blacks are made) are generally used. Usually, with coloured pigments, a more generous (and depending on the colour, probably more varied) combination of thick or heavy plate oil and raw or light linseed-oil is needed. The consistency of the inks should be rather more oily than the normal intaglio black, but it should not be too liquid. Colour pigments may not need mulling to the same extent as black pigments.

Coloured ink, however, is more difficult to wipe from a plate than black ink; hand-wiping is often impossible, especially with a sticky ink (e.g. lake colours) on a cold plate. A little copperplate reducing medium is also useful for mixing in with dry colour, especially when these contain

white pigment and are difficult to wipe. If a certain colour will not wipe reasonably well when cold, it should be gently warmed up, and if possible the wiping completed with the muslin only. Darker colours containing an amount of black pigment tend to be easier to wipe.

Dry powdered pigments are readily obtainable from most etching-suppliers and artist's colourmen. When sold in this form, many of the pigments, especially the earth colours, are reasonably inexpensive and provide plenty of body in the intaglio work.

A few good made-up coloured inks are sold by printer's ink suppliers. It is also quite possible to print with artist's oil-colours, by adding dry pigment to thicken the fine consistency. This would, however, be an expensive way of printing.

Although *water-colour inks* are understandably difficult to use for intaglio printing on damp paper, they can provide extremely strong, clean transparent colours. The paper needs to be suitably damp and soft enough to take an over-printed intaglio plate, but not so sodden that it allows the colour to spread. Water-colour ink would normally be applied to the plate, rather than the print, by rolling through stencils, or even offset from another surface. A rubber roller is used, in preference to a gelatine one, which is adversely affected by the water-based pigment.

There are also several *dyes* – usually in powder form – that can be mixed with oils and used for both intaglio and surface printing, producing an essentially chemical range of strong, luminous colours.

There are no set rules to follow when printing with coloured inks. The characteristics of each raw or mixed colour should be noted; for instance, whether it reacts in any way when applied to copper or zinc (yellow will turn greenish on zinc while certain reds, especially vermilion, are affected by copper); how well it mixes with or overprints onto another colour – wet or dry; its impact in the different kinds and depths of intaglio work; its suitability for wiping, and even, later, its durability; finally, if a specific and essential colour reacts badly on copper it may be worth while steel facing the plate.

2 *Cutting the plate into sections, applying a colour to each separate section and reassembling*

This is a rather more flexible alternative to the first method and is based on the woodcut method, used by Derain. It involves cutting the plate into simple sections or complex shapes, and inking each shape with a different colour. The ink is applied intaglio with a dolly or dabber, or on the relief surface by roller or both (see method 4). The coloured sections are then reassembled. By this method the areas of colour can be kept apart and clearly defined; there is no merging of tones.

Where there are numerous sections or an elaborate assembly of shapes, it would be as well first to mark out a sheet of paper on the bed of the press. The sections can also be fixed to the paper by a suitable gum or adhesive, so as to prevent movement during the printing, although this really should not be necessary.

One of the characteristics of this method (which may or may not be restrictive), is the inevitable white line visible between each section. This is, perhaps, a drawback only on a conventionally cut, rectangular plate. One way to overcome this, is to print a second intaglio plate (e.g. in black) onto the first assembly of printed shapes. This second plate can be intact and completely cover the whole area of the assembly, or it can be shaped to cover only a part – depending on how much white line is to be covered.

As a rule, this woodcut method is usually confined to the single cut plate or a group of shaped plates, rather than over-printing. Rolling up a surface colour, however, is quite common. Again, the usual way is to roll colour only onto the surface, but the technically more complex method of using two colours and hard and soft rollers can also be used (see method 4).

3 Printing from two or more intaglio plates

The main problem with multiple-plate printing is achieving exact registration. The main advantage is that it enables an enormous range of colours to be combined on the print. Multiple-plate colour printing has been extensively used, particularly in France (notably by Villon) to reproduce modern paintings.

The simplest approach is to prepare a number of plates (say three) cut to the same size and apply a separate primary colour to each, printing each plate in turn. A fourth plate overprinted in black will then give a full range of colours. If, instead of thoroughly and uniformly wiping each plate, a film of ink is left on the unetched surface (perhaps varying with each plate) the accumulated plate tone will be much more emphatic and effective. Several colours can, of course, be applied to each plate by the dolly (dabber) method.

Plates can be worked in one or more etching or engraving processes and ink applied to the intaglio as normal, or to the surface with a hard roller, and even partially into suitably bitten areas with a soft roller (see method 4). Areas can also be inked by rolling through cut stencil, and an offset impression, picked up on the roller from another inked surface, can be rolled directly onto the plate.

Plates may be cut into shapes other than rectangles, but unless they are all uniform, the problems of registration (presuming that accurate, repeatable registration for con-ventional editions is desired) becomes even more involved.

Generally, when printing wet on wet, the more deeply worked plates or darker colours are printed later; black is

usually last. When a deeper cut plate is printed first, any subsequent plate will progressively flatten the emboss and may even force the wet inked lines to spread. Many of the finest intaglio lines and delicate textures would, in any case, be lost when printed over densely worked areas.

Paler ink, for example made with white pigment to create an opaque colour, is more effective in the heavier, deeper, intaglio work – especially when printed wet on dry.

If the first plate contains heavy, dense intaglio work, a second plate can be printed over this, provided the print is allowed to dry for a minimum of twenty-four hours (several days may be preferable). The first colour will probably take a second colour without being crushed or spread. The print must, of course, be resoaked and returned to its original state of dampness before printing. If this is not done, the print will not register accurately.

An oily ink will usually take on top of a drier ink, but seldom the reverse. Therefore, with a multiple-plate print, the sequence of colours should be carefully planned, and the inks mixed accordingly.

Simple but effective experiments can be made by printing the same plate successively, but with a deliberate, fractional error in registration. For this a separate colour is normally, but not necessarily used.

The first and usually the key plate is drawn out and etched (or drypointed). A black ink impression is taken and the paper – before it has time to dry and shrink – is placed over the second, clean plate and again printed. It may be easier to place the fresh print face up on the bed on top of one blanket and to lay the second plate upside down over it, and then print. Alternatively, the print can be trapped by one edge under the blanket and roller as described below. Either way, a more or less accurate impression is offset onto the new plate in black ink, which can then be lightly etched (oxidized rather than bitten) or painted with varnish. This offset impression method can also be used on a hard ground – with the pressure slightly reduced by removing one blanket. A wet print can probably be used on three plates. For even greater accuracy of registration with two or more plates, tracing and carbon paper can also be employed.

Registration. To register the plates on the print, several methods are possible. If all the plates are identical in size, a small hole can be drilled through either side of each plate in exactly the same position (preferably when all plates are clamped together) into the least conspicuous part of the plate. As the printing-paper is lowered onto the first plate, it is positioned by inserting two needles through the paper into the holes. This is repeated on all subsequent plates.

A second method of registration, normally used when printing wet on wet from a number of plates, is to work the first plate and print it in black. The wet print remains on the bed of the press, trapped by one edge under the blanket and roller. Both printing-paper and blanket must be long enough

Print held firmly under the roller for registration.

to fold back over the roller. The first plate is removed and a new plate is laid on the extended and marked-out bed-plate. Print and blankets are then pulled down onto the plate, smoothed over and taken through the press.

Once the first print has been taken, the paper will soon dry out and shrink. It will have dried out completely if printed from an excessively warm plate. To ensure maximum accuracy of registration it is, therefore, advisable to ink and wipe all the plates before the printing sequence is begun. This will save considerable time when printing. If there is any delay (normally there is enough time to ink and wipe at least a second plate), cover the print, as it lies folded back over the blanket and roller, with a sheet of damp blotting-paper.

Conventional, rectangular plates can be additionally registered by placing pieces of heavy, straight metal along two sides or corners. As soon as the first plate is printed, and before it is removed, its exact position is fixed by the heavy metal straight-edges. The plate is then replaced by the second plate, straight-edges are removed and the print – either trapped under the roller or even taped to the bed-plate or a mat – is laid over the plate and again rolled through the press. The operation is repeated with each plate.

One of the most reliable and accurate of registration methods is to fit the inked plate(s) into a cut-out mat of thin card or tin (22-gauge).

A sheet of damp printing-paper – preferably one of those already prepared for printing – is placed onto the mat. A line is drawn carefully round the paper onto the card mat; the mat is then trimmed down exactly to the paper size.

When cutting out a tin mat, leave two strips or tabs pro-jecting near the corners of two sides. These will serve as stops to fold down and hold the printing-paper. Even on a card mat, these metal tabs could be fitted. If there is sufficient room on the bed-plate, and if the paper is large enough out-side the plate edge, the tabs will not be absolutely flattened each time a print is taken.

Next, a shape, corresponding exactly to the plate(s), is cut out of the mat (easier with a card mat). Each plate is fitted into the mat, in turn, for printing, the paper being held by the folded tabs.

There is also another quite different registration method, developed some years ago by Mauricio Lasansky. Briefly, this involves printing the first plate (or colour) in the normal way, but printing the second and any subsequent plates upside down and onto the print, which is placed face up on top of a single blanket. (It is possible that two blankets may be needed.) At least two blankets (and a sheet of cardboard to prevent the plate from curling) are placed over the plate, and the print is taken through the press. Sometimes a second printing is made with the plate under the print in the normal way. This counteracts the tendency of the plate to curl (due to being under fewer blankets) and also ensures a good printing. (One printing upside down seldom gives a good print.)

Lasansky gives his own detailed account of this method in Peterdi's *Printmaking*.

4 *Printing from a single-plate inked intaglio and surface.*

First ink and wipe the suitably worked plate in the normal intaglio manner. Then apply a second colour to the un-worked surface by roller.

There are several versions of this method (all can be combined with the other main inking and printing methods just described); the simplest way, however, is to ink the intaglio with one colour and apply a second colour only to the relief surface with a hard roller.

The hard roller is usually made of rubber or composition, and is preferably large enough in circumference to run the entire length of the plate with one roll. A smaller roller, when run repeatedly over the surface, would soon pick up the intaglio ink and offset this onto the relief colour. A soft roller would deposit surface ink into the intaglio areas.

Coloured inks made from dry pigment and oils are generally too gritty, even when thoroughly ground, for rolling onto relief surfaces. The ink used should be a good copperplate or gravure printing-ink, but letterpress or typographic blockprinting (typographic is more expensive than letterpress, and has few real advantages) and lithographic inks can all be tried out.

As a rule, few of the inks used for machine printing and the planographic processes are suitable for use in intaglio work, being either too stiff or sticky. It is necessary to experiment with the various kinds and makes of ink in order to arrive at the most suitable ink for the particular plate. For instance, only light-fast, and never fugitive, colours should be used for rolling.

A thick, opaque or excessively oily ink applied by roller will partially or wholly prevent the intaglio ink from impres-

sing clearly onto the print. A thin, even (porous) film should be sufficient. This should be rolled onto a clean surface, prepared by hand-wiping (possibly with french chalk) after the intaglio inking. No pressure should be put on the roller, which should deposit the film by its own weight.

Julian Trevelyan (*Etching*) recommends mixing a little lithographic reducing medium (Tintex or lithographic transparent white) with the ink to obtain a smoother roll-up.

A later development of the simultaneous intaglio and surface printing method involves etching the plate to create an intermediate area between deep intaglio and original surface. First, the deep intaglio (e.g. dark blue) is inked and wiped in the normal way. A soft gelatine (or plastic) roller (e.g. yellow) is then passed over the plate; this penetrates as far as the intermediate bitten areas. The relief surface is carefully cleaned and a hard roller is finally passed over the plate, depositing a third colour (e.g. red) on the higher areas only. This method can be restricted to two colours, i.e. original surface and one (or more) bites, but leaving out the deep intaglio.

On the other hand, there are more ingenious versions involving the use of inks made of different viscosities. For instance, a hard roller is passed over the relief surface depositing a thin coating of oily or low viscosity ink. A soft roller (somewhat smaller in circumference than the hard roller) is then passed over the plate, depositing a stiffer ink of high viscosity into the bitten areas which is, more or less, rejected by the oily relief.

To make a less viscous ink, add more thin oil, such as raw linseed; although it will probably become necessary to try out, methodically, a number of oils and pigments.

As with the earlier, simpler methods, a third colour can be introduced to the plate by making use of deep intaglio work.

The most obvious way to confine rolled colours to precise surface areas is to apply additional colour to the plate by rolling through cut stencils. It is generally more applicable to plates containing predominantly intaglio work, although, by adjusting the viscosities, inks can also be applied through a stencil onto an already inked (rolled) surface colour.

Using stencils necessitates fairly simple cut shapes. On finer work, especially linear or engraved plates, these flat, and all too often blatantly contrived, shapes can appear incongruous. Colour applied through stencils generally integrates more with heavier intaglio colour work.

Paper used for cutting stencils should be strong, hard and smooth but not particularly thick (e.g. printing-paper). It may be possible to obtain a specially made, heavily oiled, stencil paper. Finely cut, intricate shapes are not suitable for rolling ink into; elaborately cut sections or long strips of stencil paper often cling to the roller and tear. The actual shape cut should be a fraction larger than the area to be printed to allow for the thickness of paper (and flexibility of the roller).

Gelatine roller.

Ink is normally applied with a gelatine or plastic roller or brayer, although certain soft composition rubber rollers may be tried. Lithographic and hard rubber rollers are not usually suitable. The roller should be large enough to cover the area exposed by the stencil with one roll (and with minimum pressure); repeatedly rolling over the area, especially with a small roller, is to be avoided.

Where an absolutely clean, precise area is needed within, for example, a densely worked and heavily inked intaglio plate, the area can be protected after inking, and before the print is taken, by a cut-out paper mask.

Colours can also be applied directly on the clean, dry printing-papers by rolling through stencils. This is a particularly useful way of building up strong, thin, transparent colours under the intaglio work. The prints are subsequently soaked and dampened before being printed. If the stencil is cut from a large enough sheet, with straight edges, it can be registered for each print by lining it up and taping along one side of the marked-out bed-plate.

Of all the methods of uniformly applying colour to a plate surface, the offset method produces the most transparent and brilliant. A colour is picked up on the roller from an already prepared and inked surface (a linocut for example); it is then deposited onto the plate. The roller (normally gelatine or similar) needs to be the same width as the plate, and its circumference should be such that the image can be laid down with one roll.

In spite of the essential difference between intaglio and other main printmaking processes, such as lithography, screen print, woodcut or linocut, practically all – in the past thirty to forty years – have been successfully combined in various ways on a single print.

The simplest way to introduce marks, textures and colours to the print by using another process, is to print the process first, e.g. screen printing directly onto dry paper, allowing the ink to dry, and then dampening the paper and over-printing with an intaglio plate. Wetting a previously printed paper will obviously cause some registration problems.

Colours can, however, be printed onto the plate through a silk screen and to some extent, by wood- or lino-block. Combining lithography (zinc plate) and etching is usually a much more complex procedure and is generally less suitable. Some interesting work in this field (using lithographic stones) was carried out in the latter half of the nineteenth century by Rodolphe Bresdin and later by Käthe Kollwitz.

Most, if not all these methods (particularly involving the techniques of applying colours by roller, the use of stencils, varying the viscosity of inks and offsetting images from the roller) originated or were at least developed, at the Atelier 17 and have since been perfected largely by printmakers associated with the Atelier. S. W. Hayter in *New Ways of Gravure* has given the most authoritative account so far of contemporary work in the field of intaglio colour printing.

16 The finishing touches

CLEANING AND STORING THE PLATE

When printing has been completed for the day, the plate is thoroughly cleaned with a fairly stiff bristle brush and turpentine. If a plate is not cleaned, the ink will dry, even when left overnight. It may by then be difficult to remove with turpentine, but a little caustic soda in water (used pure if the ink is really stubborn) and a clean, soft rag should get rid of it. When an inked plate is left for a long period the ink will dry extremely hard, and can only be removed by boiling it out with caustic soda (paint-remover may also be used).

Steel plates must be thoroughly dried after being cleaned off with turpentine, otherwise they will soon rust. Any plate that is stored for a lengthy period should first be well protected from rust, corrosion and tarnish. This is easily done by coating the plate either with vaseline, grease or varnish, or wrapping it up in greaseproof paper.

It is most important that all printing equipment, bed-plate, inking-slabs, hot-plate, jigger, palette-knives and rollers, should be well cleaned after use. Unused ink, needed for further printing should be correctly stored (see p. 148). For short periods, e.g. a day or two, it can be kept in thin dust-free polythene bags. Tarlatans that are still serviceable should be scraped free of waste ink, opened out and hung up to dry. Pour away water for soaking papers (probably containing size), and lay any spare printing-paper flat between clean blotting-paper. Blankets are removed from under the roller and hung up separately to dry out. The pressure screws on the press are relaxed. All small tools, equipment and materials such as solvents, tissue-paper and blotting are returned to their correct place.

PLASTER PRINTS

An accurate and finely detailed printed impression can be made from an intaglio plate (etched, engraved, drypoint, etc.) by taking a plaster cast of the inked surface. This is probably the best way to make an exact impression without a press. The plate can, of course, be printed uninked, thus making a white relief.

If the plate is inked, a slightly oily ink, leaving a heavier tone on the plate, is generally more effective on plaster; avoid, therefore, the use of whiting powder when wiping.

A rather oily surface is also useful when removing the plate from the plaster.

A simple frame is prepared from, perhaps, 2 in. or 3 in. × 1 in. wood strips. Three-quarters of an inch is the minimum thickness of plaster to cover a plate, depending on the size of the plate. A few nails can be driven right through the wood strips, so that the points project inside the frame. These will serve to hold the frame to the plaster cast. The frame is placed on a larger, thick sheet of glass, and is firmly secured there by placing a couple of heavy objects against it. Place the inked plate face up and squarely inside the frame.

A wire-type armature, some metal strips, jute fibre or similar, should be prepared in order to reinforce the cast. Next, the plaster is mixed (plaster of paris or cement plaster). This should not be too thin, or it may not take the ink, and will probably run under the frame. The correct consistency should be similar to thick cream. It should contain no lumps, and as few air bubbles as possible. Any surplus water should be poured off the mixture. Pour the plaster into the frame as soon as it begins to warm and set. Start at one corner and make it flow evenly across the plate and glass.

Before the plaster sets, the armature is embedded in. A further layer of plaster is then poured into the frame. When the cast is finally cold and set, the frame is turned over and any excess plaster that may have leaked under the plate is scraped off the back of the plate with a sharp knife. To separate plate from cast, insert the knife just under one or more parts of the plate edge and gently prise it up. A plate, especially a sizeable one that sticks firmly to the cast, may be loosened by applying moderate heat to the back of the plate (usually by electric flat-iron).

If the plaster cast is to be worked upon, it is better to cut into it while the plaster is still slightly damp.

EDITIONS

The problem of what constitutes an edition of original prints can now only be finally resolved by the individual artist to satisfy his own purposes, according to his own artistic and political integrity. He might choose to take a few impressions only from each plate or, if the plate is suitably worked and suitably prepared, to run an edition into the hundreds.

In fact, at present, the practical limit for an edition in England is usually seventy-five. Beyond that the Inland Revenue imposes its own restriction, and claims tax on the understanding that the 'original' print has become a reproduction. An engraved copper plate will usually take seventy-five prints, but aquatint, drypoint and mezzotint would need steel facing. However, there is no technical reason, other than convenience, for printing a complete edition at one time; and a relatively small edition of ten or twenty prints or a moderately large one of fifty prints would be considered conventional.

When the edition is complete the plate is cancelled. S. W. Hayter now does this by engraving his signature over a chosen worked area – thereby leaving the plate undamaged – an object in itself – and at the same time ensuring the collector of an honest first edition. More usually, the plate is cut up, drilled through or scored over.

The accepted procedure for signing a print is as follows. The number of prints in the edition is written on the bottom left-hand side and immediately above it, or to the left, the number of that individual print ($\frac{1}{75}$, $\frac{2}{75}$, $\frac{3}{75}$, or 1/75). The title is usually written in the middle and the artist's signature on the right-hand side is normally written in pencil.

In theory, a formal arrangement exists whereby the artist is also entitled to pull a further percentage of prints, over and above the edition, for his own use; these are termed 'artist's proofs'. At present, this also becomes a personal matter, depending on circumstances. The British Section of the International Association of Plastic Arts recommends limiting the number to 10 per cent of the total edition. The artist would, most likely, also keep a few prints of the plate in an earlier state, marking them 1st state, 2nd state, etc.

While it is open to the artist to decide whether he should sign the prints in the edition or limit the edition in any way, he should remember that if he is his own printer, it can become very tedious and frustrating to produce print after print of an early work when there are other ideas more urgently requiring to be worked upon. The lack of some methodical organization can result in time wasted. A record must be kept of each print made – its process, size, dates and destination.

Official bodies, both throughout Europe and America, are still adamant in their rejection of images made by photo-mechanical means (which are appearing more often now in intaglio work), the proliferation of works produced by an artist-printer alliance, and the concept of the computer graphic. A document published by the Third International Congress of Plastic Arts in Vienna in 1960, entitled *The Definition of an Original Print*, laid down clear conditions, and in France (in December 1964) the National Committee on Engraving issued the following:

'Proofs either in black or in colour, drawn from one or several plates, conceived and executed entirely by hand by the same artist, regardless of the technique employed, with the exclusion of any and all mechanical or photomechanical processes, shall be considered original engravings, prints or lithographs.

'Only prints meeting such qualifications are entitled to be designated Original Prints.'

Suggested further reading

BRUNSDON, John: *The Technique of Etching and Engraving.* London, 1965.

BUCKLAND-WRIGHT, John: *Etching and Engraving. Techniques and the Modern Trend.* London, 1953.

CLEAVER, James: *A History of Graphic Art.* London, 1963.

EICHENBERG, Fritz: *Artists' Proof Annuals.* New York, 1960.

FAITHORNE, William: *The Art of Graveing and Etching.* London, 1662; New York, 1970.

FURST, Herbert: *Original Engraving and Etching. An Appreciation.* London and Edinburgh, 1931.

GILMOUR, Pat: *Modern Prints.* New York, 1970.

GREEN, John: *Papermaking by Hand.* Maidstone, 1967.

GROSS, Anthony: *Etching, Engraving and Intaglio Printing.* London, 1970.

HARRIS, Tomás: *Goya. Engravings and Lithographs.* Oxford, 1964.

HAYTER, S. W.: *About Prints.* London, 1962.

HAYTER, S. W.: *New Ways of Gravure.* 2nd edition, London, 1966.

HELLER, Jules: *Printmaking Today.* New York, 1958.

HIND, Arthur M.: *A History of Engraving and Etching.* London, 1923; New York, 1963.

HIND, Arthur M.: *Guide to the Processes and Schools of Engraving.* London, 1933.

IVINS, William M., Jnr.: *Prints and Visual Communication.* New York, 1969.

LALANNE, Maxime: *A Treatise on Etching* (transl. S. R. Koeler). London, 1880; Boston, 1885.

LUMSDEN, E. S.: *The Art of Etching.* London, 1924 and 1962.

MUNZ, L.: *A Critical Catalogue of Rembrandt's Etchings.* London, 1952.

PETERDI, Gabor: *Printmaking.* New York, 1959.

STUBBE, Wolfe: *History of Modern Graphic Art.* London, 1963.

TREVELYAN, Julian: *Etching.* London, 1963.

WOODS, G.: *The Craft of Etching and Lithography.* London, 1965.

ZIGROSSER, Carl, and GAEHDE, Christa M.: *A Guide to the Collecting and Care of Original Prints.* New York, 1965; London, 1966.

(*Opposite*) Etching: detail of colour etching by Helen Taylor, 1968. Two zinc plates, intaglio and surface relief, in three colours. 20 in. × 14¾ in.

(*Overleaf*) Colour etching: *Le merle blanc du canari jaune aux plumes bleues* by Joan Miró. 15 in. × 11 in.

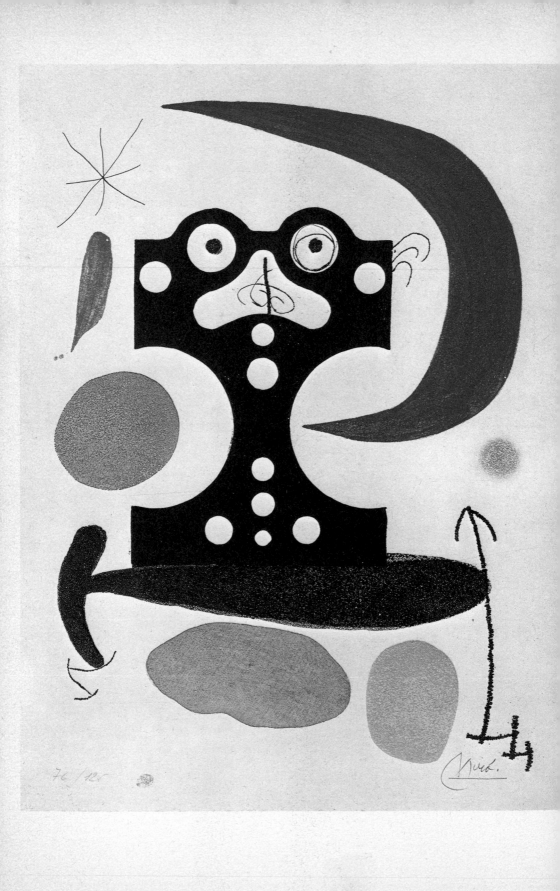

76/125

Glossary

Practically all acid solutions (mordants) employed by the **ACID**
etcher are made from the following: nitric acid (HNO$_3$);
hydrochloric acid (HCl); ferric chloride (FeCl$_3$). The
formulae for each of the solutions may vary slightly accord-
ing to the character of the drawn work, type of metal used
etc. Acetic acid, though too mild to have much effect on
metals used for etching and engraving, is frequently used for
cleaning lines drawn into a hard wax ground prior to etching.

A term generally applied to the various methods used to **AQUATINT**
etch, through a porous ground, areas of granulated texture
printing as areas of tone. The term also refers to the printed
impression taken from a plate etched solely or predominantly
in aquatint.

See Dust Box. **AQUATINT BOX**

Before inking and printing a metal plate, the sharp edges **BEVELLING**
round the working surface are filed or scraped to an angle
of approximately 45°; the corners may also be very slightly
rounded off. Bevelling prevents damage to the blankets and
paper, and makes inking and wiping much easier.

The corrosive action of a solution of acid on lines or areas of **BITING**
exposed metal.

A set of felts – usually three or four – uniformly cut to fit on **BLANKETS**
the bed of an etching press, where they provide the neces-
sary cushioning – strong but pliable – between the printing
paper, lying on the intaglio plate, and the pressure from the
roller.

Oil spreading out from a printed line. **BLEEDING**

A small hand tool, consisting of a few inches of steel rod, **BURIN**
square or lozenge-shaped in section. The cutting point is
formed by sharpening one end to an oblique section; a
wooden handle, generally half-round, fits over the opposite
end. It is also known as a 'graver' and is the principal tool
employed by the line-engraver.

Small hand tool made from a rod of highly polished steel, **BURNISHER**
oval in section, tapering at one end to a point. The burnisher
can be perfectly straight or turned up slightly at the pointed
end. Used for smoothing the rough surface of a metal plate

after scraping or to lighten textured areas of the plate, for example aquatint and mezzotint.

BURR Ridges of metal forced up by the sharp, heavy point of a drypoint-needle scoring through the surface of a metal (usually copper) plate. The consequent build-up of ink round a prominent burr creates the rich, warm black characteristic of drypoint.

CREEPING BITE Achieving a more or less graduated etch – particularly over an area of aquatint ground – by submerging the plate, in stages, into a bath of acid.

CREVÉ A common fault occurring when biting closely drawn lines on a hard ground. The ground is apt to break down – especially in nitric acid – at the point where lines converge or cross, leaving small open corners of exposed surface which invariably print pale.

CRIBLÉ See Dotting.

DABBER A small leather- or silk-covered pad, held by a wooden handle, similar in shape to an inverted mushroom. Used for laying wax grounds on plates. A felt-covered dabber is generally used for inking intaglio plates.

DEEP ETCH Employed most frequently in colour etching, for example when both deep intaglio and surface relief are printed simultaneously. Deep etch may also be used to create a heavy embossing effect – often uninked.

DIAMOND POINT A drypoint-needle fitted with a diamond – as opposed to steel – tip. The diamond is generally regarded as a much more versatile drawing point than other stones, such as sapphire or ruby, although both of these are to be preferred to steel.

DOTTING Also known as 'criblé'. Design indented into metal and made up predominantly or wholly of dots. Tools most commonly used to create dotting effect are the punch (round, flat and hollow) and hammer. A traditional method much employed by goldsmiths and niellists.

DOUBLE RUN Running the inked plate twice through the press before removing the print, in order to ensure a really heavy impression.

DRYPOINT The technique of scratching or scoring an image into the surface of a metal (or plastic) plate with a steel or diamond point. The delicate grey and the rich black lines – created by the burr – characteristic of drypoint are obtained by varying the pressure on the point. A drypoint plate wears rapidly during printing, seldom lasting for more than ten to fifteen prints. The term 'drypoint' also refers to the printed impression.

Generally, a solid, tapering steel point – much heavier and sharper than an etching-needle – used to inscribe or score lines, etc., into metal. DRYPOINT NEEDLE

A small bag of silk, nylon, etc., containing powdered resin, used for laying aquatint grounds. The size of the mesh determines the fall and size of resin dust grains. DUST BAG

A simple mechanical device employed to lay resin or asphaltum aquatint grounds on metal plates. Usually, an enclosed wooden box in which a small quantity of powdered resin is blown about in such a way that the fall can be more or less controlled to form a uniform and even coating on a plate placed momentarily inside the box. Various methods of activating the dust are used, for example bellows, or an integral revolving shutter. DUST BOX

A solution of hydrochloric acid and potassium chlorate, used mainly for etching fine work on copper. DUTCH MORDANT

An etching-needle with a point ground to an oval section. Frequently employed by early etchers, such as Callot, to imitate on a hard ground the swelling line made by a burin. ÉCHOPPE

A limited set of identical prints taken from a worked plate in its final state. Each print is individually and consecutively numbered; the number also shows the total number of prints in the edition, so that 10/75 is the tenth out of seventy-five prints. The plate is then cancelled, as for instance with a line scored or engraved across it to prevent further printing. EDITION

The act of incising lines, dots, etc., into the surface of a normally hard substance such as metal, wood, plastic or glass. In the context of intaglio printmaking, the term 'engraving' refers specifically to the technique of incising lines into and through the surface of a flat metal or plastic plate with a tool known as a 'burin' or 'graver'. The term is sometimes used, however, in a general sense, and may then refer to all intaglio techniques where it is necessary to employ a press for printing. Engraving is essentially a line technique and is, in fact, often referred to as 'line-engraving'. It is also normal practice to apply the term 'engraving' to a printed impression on paper taken from the plate. ENGRAVING

An intaglio process where the image is corroded into metal by the action of acid, in order to obtain that image on a printed impression. With the traditional method, such as line-etching, the drawing is made with an etching-needle directly onto a metal plate evenly coated with a wax ground. Where the needle penetrates the wax, it exposes the metal surface to the subsequent action of the acid. The term 'etching' also refers to a printed impression taken from an etched plate. ETCHING

An acid-resistant substance made from various mixtures of wax, gum, asphaltum, resin, etc. Applied to the surface of a ETCHING GROUND

warm metal plate with a dabber or roller, it forms a stable, durable ground, suitable for drawing through with an etching-needle.

ETCHING-NEEDLE · A light, round steel point, generally set into a simple wooden holder. For normal purposes, such as drawing through the wax ground, the actual point is kept blunt, rather than needle-sharp.

ETCHING-PRESS · Also known as a 'copperplate printing-press'. The principal feature of the etching-press is the sliding steel bed or plank (on which the plate lies) travelling, with direct or geared drive, between two heavy rollers. One, below the bed, supports it; the other–with adjustable screws at both ends–is directly in line above it, and provides the downward pressure essential when printing intaglio plates. The bed and rollers are usually suspended on a metal frame large enough to permit the bed to be fully extended in either direction.

FEATHERING · When etching into metal it is sometimes necessary to remove gas bubbles and, to a lesser extent, sediment from the corroding lines or areas. The most effective–and on delicate work the safest–method is to wipe away bubbles at frequent intervals with a feather, cotton-wool swabs, or a brush. Feathers may also be used when applying acid–especially strong acid–to certain areas of the plate, rather than immersing the whole plate in a bath of acid.

FERRIC CHLORIDE · See Acid.

FOUL BITE · Unintentional corroding or pitting of plate surface occurring during biting–often a result of faulty grounding.

GRAVER · See Burin.

HAMMERING UP · See Repoussage.

HOTPLATE (heating box or heater) · A low, flat-topped metal box or table, upon which a plate is heated prior to wax grounding, or warmed before inking, etc. The heat is supplied either by a gas-ring, or an electric heating unit placed underneath the box.

IMPRESSION · An individual print taken from a worked plate, block or stone, whether intaglio (which may be printed uninked), relief or surface.

INK-SLAB · Lithographic stone, thick plate-glass, marble slab, etc., on which printing ink is prepared.

INTAGLIO · A line, cavity or textured effect, incised, scratched or corroded down into the surface of a hard substance, normally metal.

INTAGLIO PRINT · An impression made on relatively soft (damp) paper or cloth from an incised plate, usually, but not necessarily, inked.

A low, flat-topped wooden box–open at one end, usually placed close to the hotplate–which in size and proportion it resembles–so that a warmed plate may be easily transferred onto it for inking and wiping.

JIGGER

Method of etching positive images, drawn freely and directly onto the metal (or, if tone is required, on to a rosin aquatint ground) with a water-soluble pigment, for instance one containing sugar and indian ink. The plate is varnished and soaked in water (or placed directly into a bath of acid). Gradually, the pigment swells and lifts off the plate. The exposed metal may then be bitten as a positive image.

LIFT GROUND

See Engraving.

LINE-ENGRAVING

Essentially a tonal method, in which the surface of a metal plate is systematically roughened into a mass of close-cut, regular indentations. For this, a serrated steel tool known as a 'rocker' is usually employed. When printed, the textured ground reads as a uniform dark; lights are then obtained by scraping and burnishing into the ground–working from dark to light, the reverse of etching and engraving. The term 'mezzotint' applies also to the printed impression.

MEZZOTINT

See Acid.

MORDANT

A fairly heavy knob of stone (usually marble) or glass, the base of which is flat or slightly convex, and often slightly roughened; used for crushing dry pigment and grinding it with plate oil into a suitable consistency for intaglio printing.

MULLER

A multiple-point graver. The steel shaft is rectangular in section and has a flat base, threaded with fine lines. Designed to facilitate the engraving of close, parallel lines.

MULTIPLE LINE GRAVER
(lining tool or threading tool)

A method of embellishing a metal surface by incising or engraving into it fine, linear decorations; the lines are then filled in with a black, metallic amalgam. Silver, which provided the maximum contrast for the fine, grey-black lines, was generally considered to be the most suitable metal, although gold and even bronze were also used. The art of niello has been widely employed by artist-goldsmiths at least since Roman times, but especially in Florence during the fifteenth century.

NIELLO

See Acid.

NITRIC ACID

The imprint made by the outer edge of a flat metal plate when impressed heavily into paper–especially the damp paper essential for intaglio printing.

PLATE MARK

A printed impression intended as a progress report of a stage in the development of a print (trial proof). An impression that has been worked upon, for example with notes or

PROOF

drawing, indicating alterations or the next stage of the work, is commonly referred to as a 'working proof'. One of a limited number of final prints kept by the artist in excess of the edition (artist's proof).

REGISTRATION Ways and means of ensuring an accurate and consistent positioning of the plate on the press and the print onto successive plates, during multi-plate colour printing.

RELIEF ETCHING Etching a plate in such a way that only the drawn or positive image stands out in relief: the rest of the plate surface – the negative area – is bitten down. With a straightforward black and white relief print, the raised surface of the plate would normally be inked with a roller, and the intaglio areas would be left to print white.

REPOUSSAGE Forcing up the depressed surface of a deeply etched or scraped area in a metal plate to its original level, either by hammering the back of the plate, or by pressing it up on a printing-press.

RETROUSSAGE Increasing the richness and density of an intaglio print by drawing the ink fractionally out of the lines, pits and hollows of an otherwise normally inked and cleanly wiped plate. The most effective way to achieve this is to trail, briefly and gently, a soft muslin over the inked intaglio work.

ROCKER The principal tool employed to cut into a metal plate the regular indentations of a mezzotint ground. It consists of a broad and fairly heavy steel blade – the actual cutting edge of which is curved, bevelled and serrated – fixed centrally into a wooden handle. The indentations are achieved by rocking the cutting edge across the plate in many directions.

ROLLERS Various types, including leather, felt, rubber, composition or gelatine. Mainly used (instead of dabber) for applying wax grounds to etching plates and printing ink to plates or blocks, both intaglio and surface. The wax-ground roller consists of a cylindrical wooden core covered with a layer of felt and an outer skin of leather. The inking roller used on intaglio plates (instead of felt dabber or dolly) is similar to the grounding roller, but has an outer skin of felt or – less usually – rubber. Gelatine or plastic rollers (brayers) are often employed for stencilling. Large rubber or composition rollers, capable of covering a sizeable plate within one full turn of the roller, are widely used for intaglio and surface colour printing.

ROSIN–GROUND AQUATINT This involves covering the plate surface – or any section of the surface – with powdered rosin; the rosin dust is fused onto the plate by careful heating, which produces a stable but porous ground. The plate is then bitten in a solution of acid. Tonal variation depends on several factors, such as relative density of rosin; strength of solution and length of bite; application of stopping-out varnish; scraping and burnishing after etching.

The roulette tool is a small revolving wheel fitted to a simple holder. Several versions exist, for example a thin wheel with a single, serrated edge or a relatively thick wheel with a granulated surface (drum). Roulette wheels are chiefly used for perforating wax grounds and in mezzotint, for cutting 'mechanical' textures into small areas of plate surface. ROULETTE

Small hand tool, similar in size and shape to the burin. The blade is either completely square (or rectangular) in section, or square except for the underside or belly, which may be half round; it is also sharpened to give an oblique face. Used by the engraver for scooping out broad or textured lines and—with the broad, flat graver—for gouging out areas. SCORPER

A small hand tool consisting of a length of steel, triangular in section, hollow ground on each side and tapering at one end to a point. All three edges need to be sharp. The scraper is usually fixed into a wooden chisel-type handle. Mainly used for removing burr or spikes of metal from an engraved plate and for digging out faulty etching. Special scrapers are employed to lighten mezzotint and aquatint grounds; these are generally flat, with only one or two cutting edges. SCRAPER

A softer, non-drying version of hard wax ground. Used chiefly as a coating for impressing textured materials into; as a method of offsetting textures onto the plate surface; to imitate grainy lines by drawing with varied pressure onto paper placed on the grounded plate. SOFT GROUND

It is normal practice to take a printed impression of each significant change or stage in the development of a print. These impressions are known as '1st state', '2nd state', etc. STATE

A process for increasing the durability—and consequently the edition of prints—of an intaglio copper plate, by electrolytically depositing a thin coating of iron or, more usually, nickel or chrome onto its worked surface. STEEL FACING

Traditional method of achieving tonal effects—roughly similar to half-tone—by engraving or etching numerous small dots and flicks into a metal plate. STIPPLE-ENGRAVING

An acid-resistant varnish (frequently a mixture of asphaltum and turpentine), used primarily to protect the back of a plate or to cancel out faulty areas of drawing before etching; also used for stopping-out completed sections of the work in stages during the biting. STOPPING-OUT VARNISH

See Lift Ground. SUGAR AQUATINT

Also known as 'muslin' or 'scrim'. A fairly stiff (starched) fabric of open mesh, used for wiping away the ink from the surface of an intaglio plate. TARLATAN

UNDERCUTTING A deeply etched cavity, wider at its base than may be apparent on the surface of the plate; caused by the action of acid corroding sideways as well as down, especially under a hard ground.

Appendix 1 : tools, materials and equipment

METALS Copper, zinc, micrometal: 16 or 18 gauge. Alternatives include mild steel, iron, aluminium and magnesium. Plexiglass and similar substances may be used for engraving.

TOOLS Burins, square section: sizes 6–12 should be adequate for most purposes; Nos. 7, 8, 9 and 10 are probably the most commonly used.

Burins, lozenge section: same sizes as above.

Stippling tool.

Multiple or lining tool: generally available in several sizes, and 12 grades, from 25 to 200 lines an inch.

Flat gravers: sizes vary from the smallest, No. 36, to the largest (widest), No. 49. Three flat gravers, for example sizes 36, 44 and 49, would be useful.

Round gravers or scorpers: sizes vary from No. 50, the smallest, to No. 63. Three scorpers, for example sizes 50, 57, and 63 would be useful. (All sizes are based on E. C. Muller's and E. C. Lyons's current lists.)

Draw tool (primarily for cutting plates).

Various etching points or needles, for example fine, coarse, multiple and échoppe; of various materials, such as steel, wood or bone.

Steel burnisher.
Steel scraper (triangular): both of these can be single or combined.
Agate burnisher.
Engineer's scraper.
Assorted flat scrapers for mezzotint work.

Drypoints: all steel 'Haden' type, 'Whistler' type or diamond point.

Mezzotint rocker: usually, the available sizes vary between a 'coarse' tool at 40 lines an inch and a 'fine' tool at 80–90 lines an inch. An even greater range of rocking tools was used in the past; it may still be possible to find or even buy more extreme sizes than 40–90.

Steel punches, assorted shapes.

Hammer, for repoussage.

Files, assorted, for bevelling or cutting into plates, for example Abrafiles.

Callipers (for repoussage).

Hacksaws, various.
Fretsaws, various.

Power-drill: $\frac{1}{4}$-h.p. type, with various attachments for polishing.

Bench vice and clamps.

Abrasives, oilstones, polishing and cleaning agents. MATERIALS

Carborundum powder (for roughening surfaces of plates, glass slabs or mullers).

Snakestone or water of Ayr stone (Scotch hone).

Engraver's or willow charcoal.

Pumice powder.

Rotten stone powder.

Jeweller's rouge.

Oil rubber.

Liquid metal polish.

Whiting powder.

Emery paper: grade 0000 for polishing tools (burins).

India oilstone, round, combination, Norton list No. 1B64 (USA).

Aloxite stone (used with oil for grinding).

Arkansas oilstone (used with oil for honing and polishing).

Potassium chlorate ($KClO_3$). CHEMICALS

Potassium bichromate ($K_2Cr_2O_7$) for photo-etching.

Ammonia (NH_4OH).

Caustic soda (NaOH).

Acids
Nitric acid (HNO_3).
Hydrochloric acid (muriatic acid) (HCl).
Ferric chloride ($FeCl_3$).
Acetic acid (CH_3CO_2H).

Acid trays and containers
Plastic, hard rubber, glass, porcelain, stainless steel, or home-made of fibreglass or well-varnished wood.

Glass bottles with glass stoppers or plastic screw tops.

Glass or polythene measures.

SOLVENTS Turpentine, paraffin, kerosene, alcohol, petrol, gasoline, methylated spirit.

Rags, assorted, for wiping, cleaning and polishing.

Stiff brushes, for cleaning ink and varnish out of etched or engraved plates.

GROUNDS Hard wax – dark, solid.

Soft wax – dark.

Liquid ground.
Transparent ground (liquid).

Transparent ground (solid).

Basic materials for making grounds are as follows:

'Double boiler' saucepan or heater.

Beeswax

Asphaltum or bitumen powder (Gilsonite, Egyptian, Syrian).

Tallow or axle grease, for soft ground.

Rosin – powdered resin (colophony for aquatint).

Fine, powdered bitumen (for aquatint).

Syrup, sugar, gamboge or gum arabic for 'lift-ground'.

Leather rollers and dabbers for laying grounds.

STOPPING-OUT VARNISH Asphaltum powder or Gilsonite powder, used with turpentine for stop-out solution.

Saturated solution of resin and alcohol.

Straw hat varnish.

Brunswick black.

PRINTING EQUIPMENT Inking slabs: litho stones, marble slabs or thick plate-glass.

Muller: marble, granite or glass.

Palette-knives (spatulas) and push knives.

Starched muslin, tarlatan, gauze or cheesecloth, for wiping the plate.

Soft, unstarched cotton gauze, for retroussage.

DRY PIGMENTS AND INKS Imitation French black.

Imitation heavy French black.

Heavy French black.

Vine black.

Light French black.

Coloured dry pigments.

Made-up copperplate inks (colours and black).

Plate oils (light, medium and heavy), and raw cold-pressed linseed-oil. OILS

Gelatine roller (brayer): soft, synthetic rubber, hard rubber or composition, various sizes and diameters. ROLLERS FOR PRINTING

Blotting-paper, white, large. PAPERS

Tissue paper.

Various hand-made and mould-made printing papers.

Oiled or stencil paper.

Waxed paper (for covering soft ground).

Sponges (for damping printing paper).

Soft brushes (for brushing up the surface of damp printing paper).

Normally 4 per set, but 3, 4 or 5 can be used. BLANKETS OR FELTS

2 'thick' blankets of fine, close wove 'Swancloth'.

2 'thin' blankets of pure, soft, woollen roller cloth or fronting.

Appendix 2: some suppliers in Britain and the USA

A number of useful suppliers listed in recent books (published during the past fifteen years) are no longer in business. Also, a number of the larger firms have actually asked to be omitted from 'lists'; others have ignored enquiries. It can, therefore, be assumed that the latter either no longer exist or no longer supply print-makers' or artists' materials. It may be that they are simply not interested in being listed as direct suppliers for what are invariably small individual orders.

Ault and Wiborg, Standen Road, Southfields, London SW 18. ENGLAND
 Rollers—leather, hard and soft rubber—at any length or diameter and composition.
J. Barcham Green Ltd. London agent: R. K. Burt & Company, 38 Farringdon Street, London EC4. New York agent: Andrews, Nelson, Whitehead, 7 Laight Street, New York, N.Y. 10013.
 Hand-made and mould-made printing papers, which are also obtainable direct from T. N. Lawrence & Sons Ltd (see below).

Buck & Ryan Ltd, 101 Tottenham Court Road, London W1.
Tools, including callipers, files, engineer's scrapers, punches etc.

L. Cornelissen & Son, 22 Great Queen Street, London WC2.
A limited range of tools and materials, including inks and dry colours.

Hunter-Penrose-Littlejohn Ltd, 7 Spa Road, London SE16.
Tools, equipment and materials. They have also recently purchased the manufacturing rights of Argus Engineering (Kimber's successors) and now make copperplate presses. The No. 8, double-geared press-plank size 48 × 28 in. (122 × 71 cm) – was at that time the largest. A motorized model is available.

The Inveresk Paper Company Ltd, Sales Division, Clan House, 19 Tudor Street, London EC4.
Hand-made and mould-made printing papers by T. H. Saunders and W. S. Hodgkinson & Company.

T. N. Lawrence & Sons Ltd, 2–4 Bleeding Heart Yard, Greville Street, Hatton Garden, London EC1.
Supplies practically all the essential tools and materials used in etching and engraving – including papers, inks and dry colours.

C. Roberson & Company Ltd, 71 Parkway, Regents Park, London NW1.
A limited range of tools and materials.

Thomas Ross & Son (London) Ltd, 5 Manfred Road, London SW15.
Professional printers – occasionally undertake to print editions of intaglio plates, also 'steel face' copper plates.

Studio Prints, 159 Queen's Crescent, London NW5.
A group of young printmakers who have recently opened a printing workshop and undertake to print editions of artists' prints.

Usher-Walker Ltd, Chancery House, Chancery Lane, London WC2.
A range of made-up copperplate inks – colour and black.

USA Almac Plastics, 47–42 Thirty-Seventh Street, Long Island City, New York.
Plastics and plexiglass.

Andersen & Lamb, 48 Fulton Street, Brooklyn, New York.
Undertakes printing of editions and steel facing.

Andrews, Nelson, Whitehead, 7 Laight Street, New York.
Domestic and imported paper.

Apex Printers Rollers Co., 1541 North 16th Street, St Louis, Missouri 63106.
Rollers.

Bond Metal Surplus Co., 321 Canal Street, New York.
Copper plates.

The California Ink Co., 2939 East Pico Boulevard, Los Angeles, California.
Felt blankets and plates.

Charles Brand, 82 East 10th Street, New York, N.Y. 10003.
 Intaglio presses and rollers.
Continental Felt Co., 22 West 15th Street, New York.
 Felt blankets.
Craftools Inc, 1 Industrial Road, Woodridge, New Jersey.
 Intaglio presses, engraving and etching tools, mezzotint
 rocker, grounds, oils, jeweller's rouge, charcoal, polishing
 stones.
Crestwood Paper Corp., 263 Ninth Avenue, New York.
 Domestic rag paper, proofing paper and blotters.
Cronite Company, 5 Beekman Street, New York.
 Inks.
Fezandie & Sperrle Inc, 103 Lafayette Street, New York,
 N.Y. 10013.
 Dry colours
Graphic Chemical and Ink Co., P.O. Box 27, 728 North
 Yale Avenue, Villa Park, Ill., 60181.
 Intaglio presses, inks, grounds, oils, jeweller's rouge,
 charcoal, polishing stones, acids, chemicals, rosin, asphal-
 tum trays.
Gross, Cobrick Inc., 370 West 35th Street, New York.
 Tarlatan.
King & Malcolm, 57–10 Grand Avenue, Maspeth, N.Y.
 Carborundum.
William Korn, 260 West Street, New York.
 Lithographic crayons and tusche.
Lindenmeyer Schlosser Corp., 5301 Eleventh Street, Long
 Island City, New York.
 Blotters.
Edward C. Lyons, 16 West 22nd Street, New York, N.Y.
 10010.
 Etching and engraving tools and mezzotint rockers.
Edward C. Muller, 3646 White Plains Road, New York,
 N.Y. 10467.
 Etching and engraving tools and mezzotint rockers.
New York Central Supply Co., 82 Third Avenue, N.Y.
 10003.
 Webbers, Lefranc and Charbonnel inks.
Harold Pittman Co., 515 Secaucus Road, Secaucus, New
 Jersey.
 Acids, chemicals, rosin, asphaltum trays and micro-metal
 plates.
Pratt Graphics Center, 831 Broadway, New York, N.Y.
 10003.
 Undertakes printing of editions.
Printers Service, 225 South Street, New York.
 Solvents.
Rembrandt Graphic Arts Co. Inc., Stockton, New Jersey.
 Intaglio presses and felt blankets.
Siebold Ink Co., 150 Varick Street, New York.
 Lithographic offset inks.
Treck, 1 West 39th Street, New York.
 Photo-etch and photo-film supplies.

Index

Page numbers in italics refer to illustrations

printing, intaglio (monochrome), 143–68; printing room, 144–5; inks, 145–6; oils, 146; mixing and grinding, 146–8; inking the plate, 148–9; wiping the plate, 149–52; paper, 153–6; press, 157–60; taking the print, 160–3; printing other intaglio processes, 163–4; drying and flattening, 164–7; errors, 167–8

printing, intaglio and surface (colour), 168–78; à la poupée or 'dolly' method, 170; coloured inks, 171; cutting the plate into sections and applying a separate colour to each, 172–3; multiple plate printing, 173–4; registration, 174–6; printing from single plate, intaglio and relief, 176–8

proofs (working or state), 134, 143, 145, 148, 153, 155; artist's, 181

pumice stone, 36

pumice powder, 36

RAIMONDI, Marcantonio, 110

reducing medium, 171

registration, 174–6

relief etching, 51, 65, 72–5

relief, printing, 32, 70, 71, 74, 135

Rembrandt van Rijn, 14, 15, 16, 17, 40, 113, 129, 132, 137

repoussage, 97, 99, 100, 126, 142

repoussé hammer, 99

retroussage, 153, 163

rocker, mezzotint, 138–41

rocking apparatus, 140–1

Rodin, Auguste, 22, 128

roller, leather-covered, 41–3, 52

roller, rubber, hard, 170, 173, 176–8

roller, rubber, soft, 170, 172, 173, 176, 177

roller, composition, 145, 176, 177

roller, gelatine, 145, 172, 177, 178

Rops, Félicien, 22

rosin, colophony, 32, 39–41, 48, 57–66, 73, 93–7; common or white, 48

rosin bag, 58–9

rosin sieve, 59

rosin dust box, 59–62

rottenstone, 36

Rouault, Georges, 24, 50

roulette tools, 125, 126, 137, 140, 141, 142

Rowan, Dennis M., 77, 78

Rowlandson, Thomas, 18

Royal Society of Painter-Etchers, 24, 28

SANDBAG, 121

sandpaper, aquatint ground, 141

Schöngauer, Martin, 12, 103

scorpers, 100, 118

scraper, 97–100, 117, 122, 126, 129, 133, 139

scraper-burnisher, combined, 98, 117

scraping, 33, 39, 58, 96–101, 126, 134, 136, 139, 140, 142

scraper, mezzotint, 98, 139

screenprint, 170, 178; photo, 77, 103, 170

scrim, see tarlatan

scrimshaw, 104

Seghers, Hercules, 14, 15, 49

Segonzac, Dunoyer de, 24, 25

shellac varnish, 48–9

Short, Sir Frank, 24, 40

soft-ground etching, 18, 33, 52–7

soft-ground wax, 52

soft-ground impressions, 53–67, 64, 66, 86, 126, 135, 141

Sickert, Walter, 24

Siegen, Ludwig von, 136

Skiold, Birgit, 28

Smillies bath, 85

snakestone, 36, 37, 97

Society of American Graphic Artists, 29

spitbite, 95

steel, soft, 33–5, 69, 74, 83, 89, 92, 119, 133, 137, 169, 179

steel facing, 120, 127, 129, 133, 134, 172

stencils, 170, 172, 173, 177, 178

St. George's Gallery, 28

stipple engraving, 125, 126, 137, 140

stippling tool, 125, 126

stopping out, 46–51, 53, 61, 62, 64, 70, 71

stopping-out varnish, 44, 45, 46–51, 61, 62, 64, 65, 70, 71, 73, 82, 91

stopping-out varnish, transparent, 48, 65, 94

Strang, William, 24

straw-hat varnish, 48, 62

sugar aquatint, 24, 64–6

sulphur tones, 63

TALLOW, 40, 52

tarlatan, 145, 149–52, 171, 179

Taylor, Helen, 183

Tiepolo, Domenico, 17

Tiepolo, Giovanni Battista, 17

Tillyer, William, 27

Tornero, Sergio Gonzalez, 29

tracing, 44

Trevelyan, Julian, 9, 28; Etching, 177

Turner, J. M. W., 15

turpentine substitute, 38, 41, 44, 48, 62, 65, 70, 71, 179

UNDERCUTTING, 85, 87

VAN GOGH, Vincent, 22

vaseline, 52, 134, 179

ventilation, 84, 144

Vieillard, Roger, 114

Villon, Jacques, 27, 173

Vollard, Ambroise, 24

WATER-COLOUR INK, 172

wax, bordering, 91; Gambia, 39, 40; tapers, 43; white, 40, 41; virgin, 39, 40

welding, 74, 75

Whistler, J. A. M., 22, 24, 25, 28, 130

whiting powder, 37, 179

woodcut, 170, 178

woodcut method (colour printing), 172

XYLENE (Xylol), 41, 48

ZINC PLATE, etching, 33, 35, 70, 71, 83, 86, 88, 89, 90, 92, 93, 100; engraving, 119, 120; drypoint, 133, 135; printing from, 169, 172

Zwemmer's Gallery, 28